PASSAGE TO CUBA

Opposite: A dancer representing Yemayá, a folkloric
Yoruban sea goddess, performs at Callejón de Hamel
(Hamel's Alley) in Havana, in front of wall art made by
Cuban painter and muralist Salvador González Escalona.

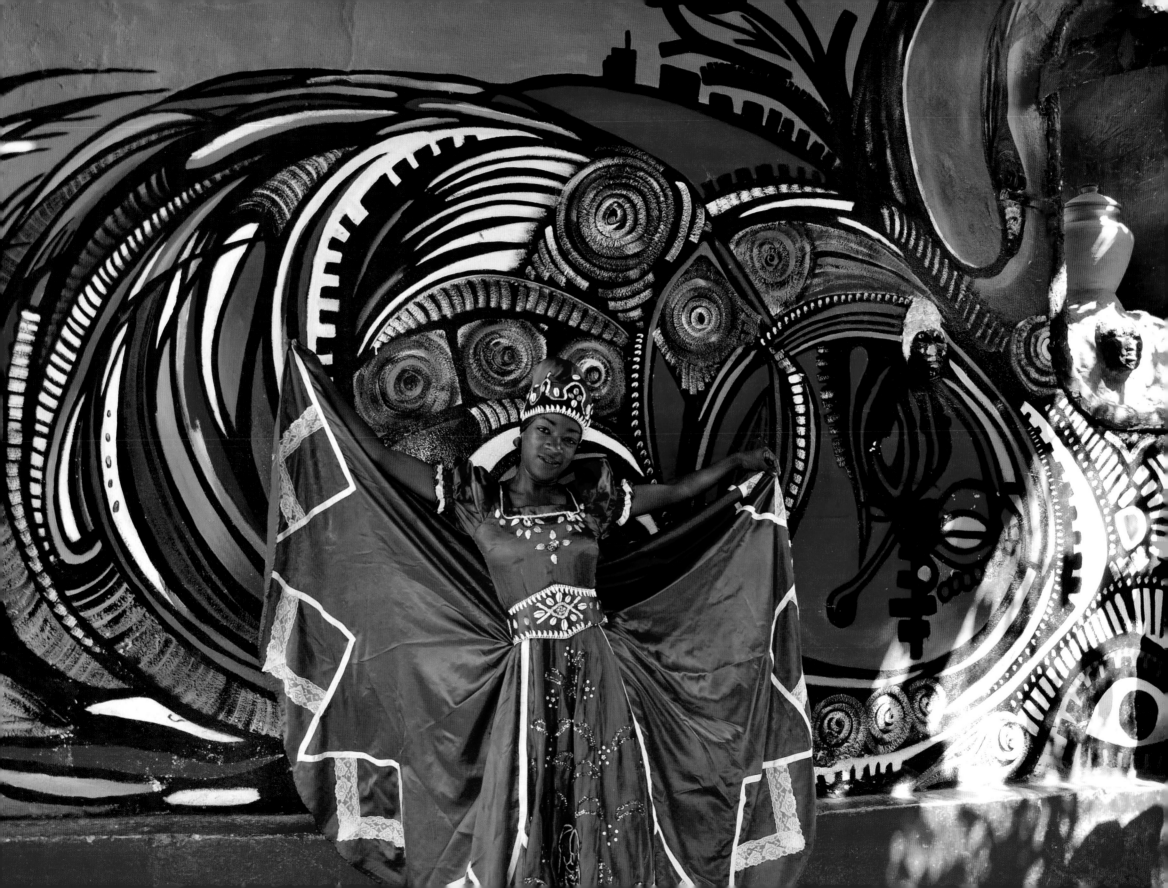

Library of Congress Cataloging-in-Publication Data is available on file.

Cover design by Brian Peterson

Cover photographs: Cynthia Carris Alonso

ISBN: 978-1-63220-652-7

Ebook ISBN: 978-163220-848-4

Printed in China

Contents

PASSAGE TO CUBA

AN UP-CLOSE LOOK AT THE WORLD'S MOST COLORFUL CULTURE

CYNTHIA CARRIS ALONSO

Skyhorse Publishing

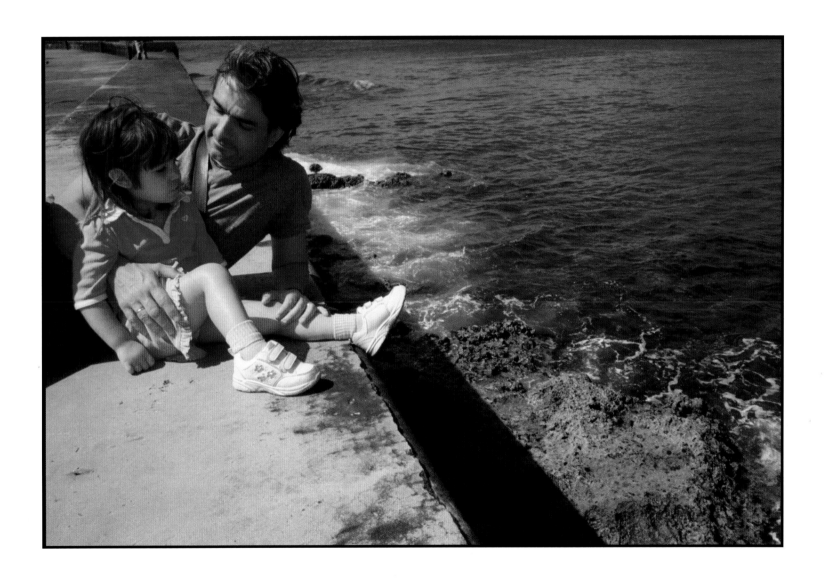

José Luis and Alicia at the Malecón with Yemayá, goddess of the sea; Havana, 2004.

For my husband, José Luis, and our daughter, Alicia.
Thank you for all your love, support, and inspiration.

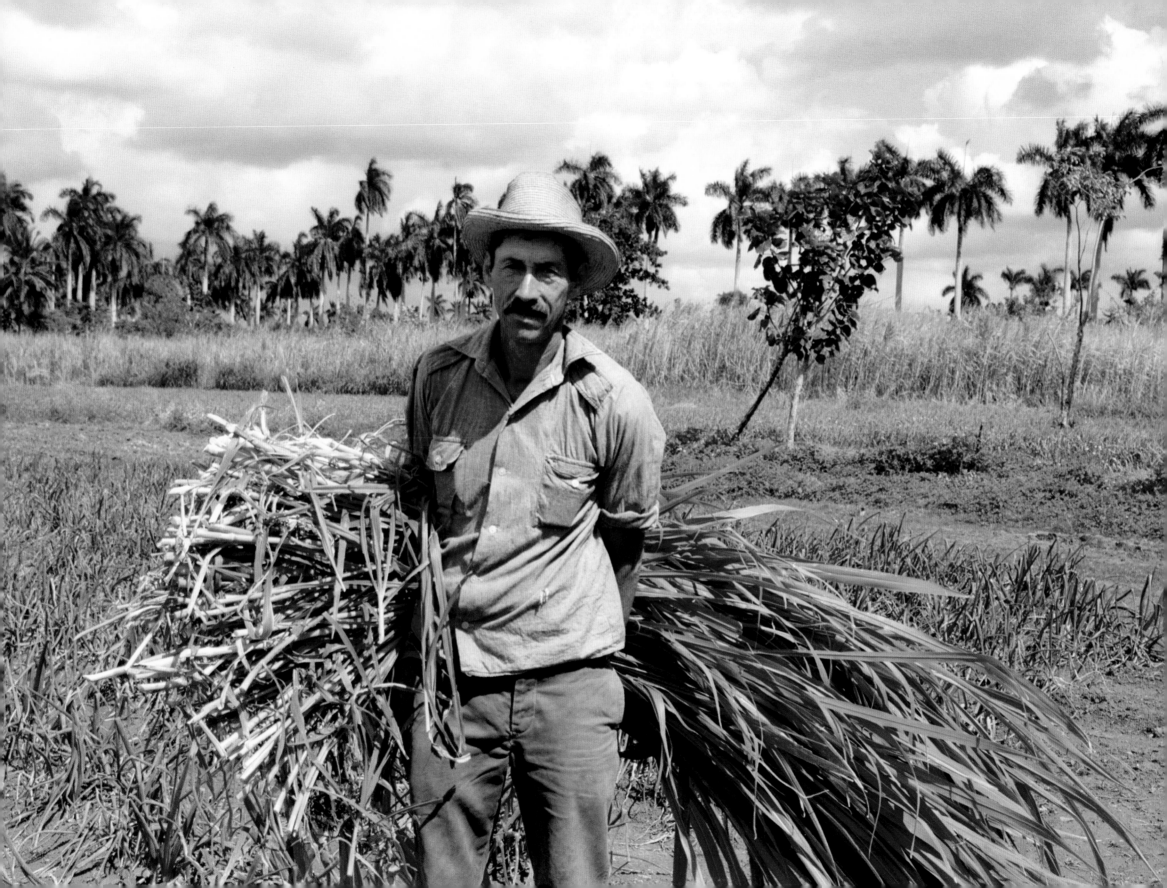

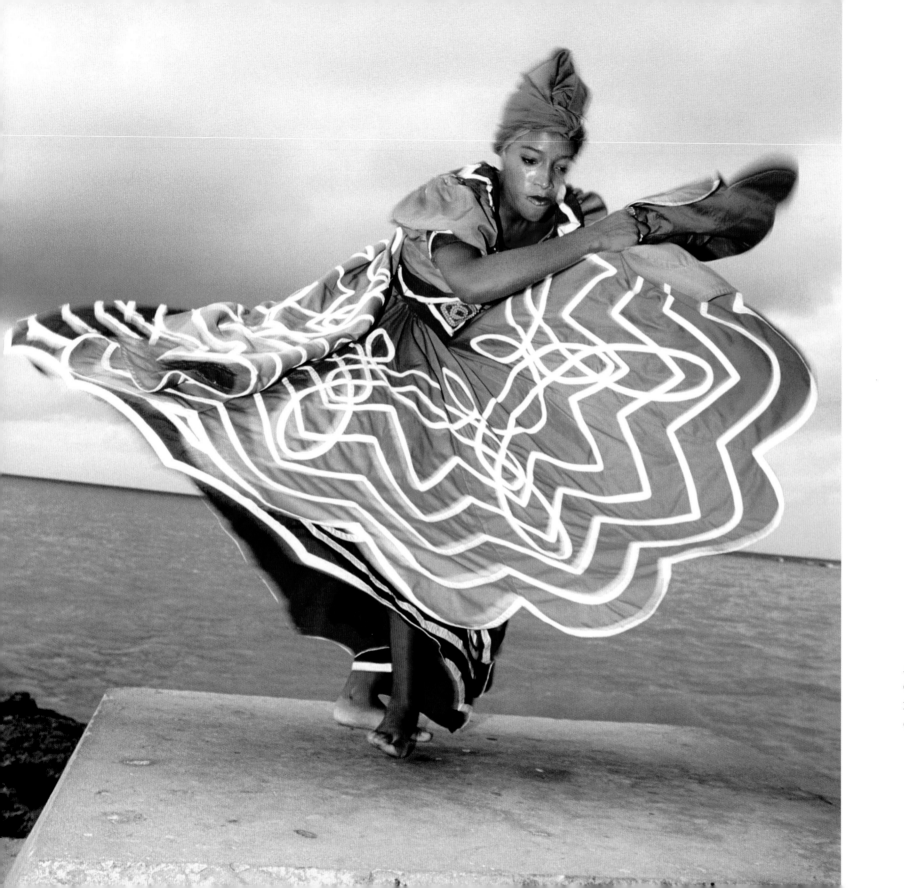

A dancer performs the rhythms of Yemayá, wearing her representational blue colored dress at the Malecón, Havana.

Introduction

My Passage to Cuba

A momentous transformation of diplomatic relations between the United States and Cuba happened on December 17, 2014. After months of secret talks and negotiations, United States President Barack Obama and the President of Cuba, Raúl Castro, simultaneously announced to the world that after more than fifty years of alienation and hostility between the two neighboring countries, they would work together toward normalizing relations. Among other initiatives, President Obama pledged to "cut loose the shackles of the past" by easing restrictions on finance and travel to Cuba for Americans. Obama also encouraged Congress to end the decades-old US economic embargo against Cuba initiated by US President Dwight Eisenhower in 1960, during the height of the Cold War. When I first discovered the mysteries and magic of Cuba, nobody could have predicted this dramatic development.

My own passage to Cuba began in December 1992, on a dark, cold, wintry night in New York City when I saw the Cuban rumba and folkloric group Los Muñequitos de Matanzas give a historic and magical performance. It was the first time in many years that a group of Cuban musicians had been granted visas from the United States, made possible by increased cultural exchange encouraged by US President Bill Clinton's policies. The group seemed to bring all the vibrancy and energy of the Caribbean sun to their performance. It was a night that would change the rest of my life.

Acclaimed music producer Rachel Faro was one of the pioneers in the early 1990s who produced Cuban music for American and other foreign audiences outside Cuba and the Eastern European bloc. Rachel, who would later give me many opportunities to photograph Cuban musicians, had invited me to photograph the extraordinary Muñequitos concert in Harlem. I felt a powerful and moving warmth, passion, enchantment, and spirituality invoked through these musicians and dancers. After the show, I met the group's esteemed Cuban representative, Caridad Diez, at the after-party hosted at the Center for Cuban Studies. By then it was clear to me that I had to go to Cuba and experience more of its enticing and mysterious musical culture, one so accessible to Americans before the US economic embargo, but now like forbidden fruit as a result of politics—isolated and far from our world, yet so close geographically to US shores.

In the late 1980s–early 1990s, country names, borders, and leadership of the Communist bloc in Eastern Europe were changing rapidly. Countries formerly part of the Soviet Union were surprising the world by becoming independent through peaceful revolutions inspired by Mikhail Gorbachev's political and economic reforms. Yet Cuba, just ninety miles south of Florida, but still connected to Russia for economic support, seemed unaffected by the distant uprisings. When the Berlin Wall came down in 1989, there was a feeling of global celebration. Hope and happiness were contagious. It was an exciting time to be working in the news as a photo editor and photographer at the internationally prominent *Newsweek* magazine. I worked with some of the industry's most talented photo editors, and with exceptional and experienced photographers who had taken me under their wing and taught me how to work in the field. I became increasingly curious and drawn to Cuba's unique culture that seemed immune to the changing world politics.

In 1992, very little was known to those outside the Soviet bloc about Cuba, except that its Russian sponsor of nearly thirty years was pulling out its economic support. I wondered why there was so little news coverage from Cuba; why it was illegal for Americans to travel there and spend money; why if the Russians were pulling out, there was still an economic embargo against the country. None of the newspapers or television news programs seemed able to answer these questions. Canadians, Europeans, and Russians travelled to Cuba's notorious beaches like Varadero and worked in Cuba on educational programs and research. Yet for American citizens, Cuba remained off-limits, except for those travelers with US Treasury Department licenses, special entrance visas, and letters of invitation from the Cuban government. Amazingly, I soon became one of them.

It all happened fast and seemed so surreal. Rachel Faro arranged for me to travel to Cuba with her and her production partner, the renowned Latin percussionist Sammy Figueroa. I would photograph various Cuban musicians for a German record label. On the Cuban side, Caridad Diez from its Institute of Music, who had seen and appreciated my photographs from the Muñequitos' New York show, helped us with the letters of invitation. Cary, as she is informally known, immediately became my angel in Cuba, making many of the photographs in this book possible by helping with the necessary documents for most of my trips to photograph Cuban musicians. Within a couple of weeks of the mesmerizing Muñequitos performance in New York City and with all the proper paperwork in order, we were flying to Havana in a special charter plane from Miami. The plane was full of Cubans visiting their families, wearing layers of clothing, jewelry, and multiple hats piled high on their heads. These items were exempt from flight baggage weight limits since they were worn on bodies rather than packed and checked in weighed luggage, which families secured tightly with layers of plastic wrapping done on site at the Miami airport. These Cuban family members were also carrying bags of over-the-counter medicines and other items considered necessities and in shortage on the island and, therefore, also exempt from the weight restrictions. I immediately felt as if we had entered into another world, one with people who had a contagious and unusual sense of humor as they shared stories about family members struggling to survive on the island we were about to visit. With this, my Cuban experience became increasingly more intriguing and enlightening.

Shortly after we arrived in Havana, realities of Cuba emerged. We learned that for a variety of very "Cuban" reasons, I couldn't photograph the musicians. To begin with, it was nearly impossible to call the musicians to make arrangements prior to our arrival. At the time, personal phones were scarce in Cuba. Landlines were old and barely functional, and cell phones were not available. If one person in a building or neighborhood had a phone, everyone shared it. The result was that Cubans did not often communicate by phone. If a Cuban wanted to reach someone in the US or an American wanted to reach someone in Cuba, it was not only difficult to get the calls through, but also hard to find the person you were trying to reach. One group of musicians didn't even know we were coming from New York to photograph them—no one had been able to reach them to let them know.

Another group couldn't be found on our arrival. Its members lived in various towns across the country and because gasoline was scarce and public transportation was sporadic, they couldn't power their vehicles, if they had them, and had no other means of transportation to get to Havana for the photo shoot. The last group we intended to photograph had just lost one of its guitar players; he had defected in Mexico during the group's recent tour abroad. Needless to say, our group's photography goals quickly became impossible. I had been invited to Cuba to photograph specific groups of

musicians, but they were not available for me to photograph. While the music producers met with the Cuban Institute of Music to discuss how to salvage their musical recording issues, I took the opportunity to explore.

I wanted to see and photograph the "realities" of Cuba that few outsiders experienced. Serendipitously, a Cuban musician invited me to stay with his family. I had learned from previous travels and photography assignments that to really get to know a place, it's best to live with someone of the culture, so I eagerly and gratefully accepted the invitation. The musician and his family lived in the heart of Havana, just blocks from Plaza de la Revolución (Revolution Plaza Plaza). It was much more central and far more interesting living with a Cuban family, than staying in the remote tourist hotel on the outskirts of the city.

Soon it was New Year's Eve, a very important time of year in Cuba. Apart from the natural propensity to celebrate the coming of a new year, the date is also the anniversary of the 1959 Cuban Revolution. After seeing a passionate and massively attended concert in Revolution Plaza and then enjoying time at a party with various wonderful and welcoming Cuban musicians and government officials, I wandered down to the Malecón, the famous wall that wraps around Havana along the Caribbean Sea, host to many locals who come to socialize and enjoy the beautiful views and sounds of the sea splashing on the natural rocks. As I looked at the mesmerizing moon and listened to the rhythms of the waves, I reflected on my life and career and the changing politics of the world. The sounds of New Year's celebrations reverberated in the city of Havana, a place seemingly paused in time and unchanged for decades.

I realized then that I was ready for a change. At midnight, I made a wish that in the year to come I would find a romantic partner. I later learned about the Cuban folkloric beliefs in gods and goddesses (called orishas). I believe that Yemayá, who represents the ocean, was present with me that New Year's night. Like a guide or muse, Yemayá has been with me my whole life, intertwined with my love for and connection to seashores and the ocean. Although I was physically alone at the Malecón, I didn't feel alone. I had Yemayá and I had my cameras, which were not only the tools of my work, they were also a powerful ticket to connect with others and develop relationships. My connection to Cuba became lasting and profound at this moment.

On New Year's Day, I was awakened by the calls and sounds of roosters. Where was I? Rooster sounds in the middle of a city? I went for a walk with two cameras, one filled with black and white film and the other with color. I felt incredibly excited, inquisitive, and grateful to be witness to a land so exotic and hardly known, especially for Americans. It was like a secret world for me to explore. I wandered the streets photographing my surroundings with unusual and unexpected freedom, invigorated by the novelty of my environs and the responsiveness of the people I met and photographed. I became so immersed in capturing situations on film that when I finally paused, I realized I was completely lost.

Due to a paper shortage in Cuba, and the not-yet-developed tourism industry, I hadn't found any maps to assist me. Trying to figure out where to go, I stood for a moment on a busy street corner under three majestic ficus trees, with their mysterious and magical banyan roots above ground. I asked a man passing by for directions to the hotel where the rest of my group was meeting. This man, I would later learn, had seen me from across the street, thought I was an interesting looking Cuban photographer, and passed me three times trying to think of something to say to meet me. On

his third pass, I asked him for directions. Neither of us knew that New Year's Day morning, that this encounter was the beginning of a future life together.

My new acquaintance, José Luis Alonso, invited me to visit the roof of the notorious Hotel Nacional, where his friend had been one of the architects during recent renovations. I did not find the rest of my travel group that afternoon. They were busy with meetings in Miramar, a well-preserved and beautiful neighborhood of Havana where many wealthy Cubans lived before the Cuban Revolution. Its stately mansions are home to many government officials, embassies, and institutions, including the Institute of Music. I was enjoying learning more about Cuba by walking around other neighborhoods. Through José Luis and his friends, I found a key to open Cuba's guarded boundaries. I learned about the values, history, politics, economy, art, beliefs, and traditions that make Cuba so intriguing and unique.

The more people I met and the more places I saw in Cuba, the more determined I became to use my camera as an introduction to special people and places, as well as a device for sharing scenes and stories with others who could not otherwise experience them, for economic or political reasons. I was inspired by their constant good humor—their optimism, passion, generosity, curiosity, compassion, and seemingly unlimited survival skills. The spirit of the Cuban people moved me: their love of life and laughter in spite of dire circumstances and uncertainties, their strength, resilience, and values of education, research, family, friendship, art, community, and hard work. This culture and Cuban spirit was a perspective that I aspired to share through my photography.

José Luis and his friends asked me to use my lenses to show the world the realities of Cuba: the grim circumstances of living with uncertainty after the loss of Russian economic support. It was the beginning of what President Fidel Castro termed "*período especial*" (the special period), a time spent living without the resources and basic necessities that many of us take for granted in the developed world, such as electricity, gas, and foods like meat—things considered by many Cubans to be luxuries. I responded that I couldn't fly into a place for a brief amount of time, take photographs as if the camera was a weapon, and publish a story with limited reporting and just a partial perspective. I said to José Luis, "You are a writer; let's work together. Show me the realities, write the stories, and I'll document what you describe with my camera. The text and the visuals will go hand in hand, and, in time, we will share our experiences with others." With this creative commitment to each other, our bond was forged. The more time we spent together, the more the bond grew.

My next trip to Cuba was to photograph the Plaza Havana Jazz Festival, just six weeks after my original journey. Once again, Rachel coordinated the paperwork with the Cuban Institute of Music, whose staff granted José Luis permission to work with me as my translator. This was the opportunity we needed. By day we worked on our personal project, documenting Cuban culture, and by night we covered the jazz festival. During this week, we both recognized our mystifying and eternal connection, and we became engaged. This commitment was the beginning of my many years of work as a photographer in Cuba, documenting its people and culture.

Less than six months after my first trip to Cuba, José Luis and I were invited to participate in an art show in New York; the exhibition would include his writing and my photographs. Since José Luis had been working for the Ministry of Culture in Cuba as an art critic and cinema director, and due to José Luis's family connections in the arts, he was granted permission by the Cuban government to leave Cuba and travel to the United States for our exhibit. As my fiancé, he

was granted permission from the US government to enter the country. One month later, we were married. Soon after, however, José Luis was diagnosed with type 1 diabetes. Due to an insulin shortage in Cuba, we decided to live in New York, where he could get better access to needed medical supplies and I could continue my travels to Cuba.

As time passed and the world continued to change quickly, I was even more curious to learn about Cuba, to experience more of the Cuban culture, and to pursue answers to my questions about this distinctive, effervescent, and surreal Caribbean country, still a mystery to most Americans. However, for every question that was answered about Cuba, more questions arose. I had tasted the forbidden fruit and wanted to share the wonders of Cuba with others who could not experience them firsthand. As an American journalist with family in Cuba, I was now able to travel between the United States and Cuba with invitations from the Cuban government and credentials from international recording labels and media outlets. This was the means, impetus, and motivation that fueled my passion for doing more photography in Cuba, and I would return again and again over the next twenty years.

In 1992, I witnessed and captured Cuba on film while it was still a closed society. Those who did visit were either on controlled official visits or restricted to tourist areas. Later in the mid-1990s, the Cuban government changed policy and opened its borders to general tourism in an effort to grow the economy. However, the experiences of a visitor in Cuba were still very different from the everyday lives of the Cuban people. As an American photographer, accredited journalist, and member of a Cuban family by marriage, I had access and permission to go in and out of these two very different worlds with an up-close and insider view. I was able to visit, photograph, and enjoy the famous and pristine beaches and beautiful hotels, which back then were only accessible to foreign tourists. Being part of a Cuban family, I was also able to photograph and experience the resilience, passions, struggle, and survival of the Cuban people that was usually kept separate and isolated from tourists' eyes.

On official assignments, I was fortunate to have access to incredible Cuban dancers, artists, and musicians, to photograph them for their CD cover art or international magazine articles. Additionally, I covered memorable moments of news in Cuba, such as the first shipment of US farmer foods to the island as a result of an amendment to the US trade embargo; Elian Gonzalez's return to his father in Cuba; and Pope John Paul II's historic tour of the country, giving mass in public to hundreds of Cubans in a land whose leader had banned Catholicism for decades.

I used my lenses to capture moments seemingly paused in time, showing views of the beautiful cities and countryside. I tried to represent the Cuban culture that continues to value art and its artists, its musicians and performers, the classical and the modern, all while withstanding the intricacies and ironies of the politics within Cuba as well as internationally, particularly with my own country, the United States.

The more I learned, the more I loved both the man I met that early New Year's Day morning and the culture he came from, with its vibrancy, creativity, passion, and pride, as well as its skilled and talented laborers who practiced and continued the spiritual beliefs and traditions of the generations before them.

Many of the images in this book have appeared on CD album covers and booklets for Cuban music recordings. Other images were published with journalistic reporting both in print and online, while others reflect personal moments of

inspiration. Exhibitions of my photographs paired with José Luis's text have been shown in the United States, Canada, and Latin America. It has been a fascinating journey, and I look forward to returning to Cuba in the future, documenting the country as it transitions with the United States on new terms.

For this book, I spent an extensive period of time going through all of my negatives, slides, and digital photographs from many trips over the past twenty-two years. I selected the images that I thought were most representative of the Cuba I experienced—the land, art, and lives of its people.

May the photographs in this book entice you to learn more about Cuba, a unique and mysterious island in the Caribbean; and may you also be inspired by the resilient, vivacious, and continuous Cuban spirit.

Opposite: Young boys play with pebbles in Guanabacoa.

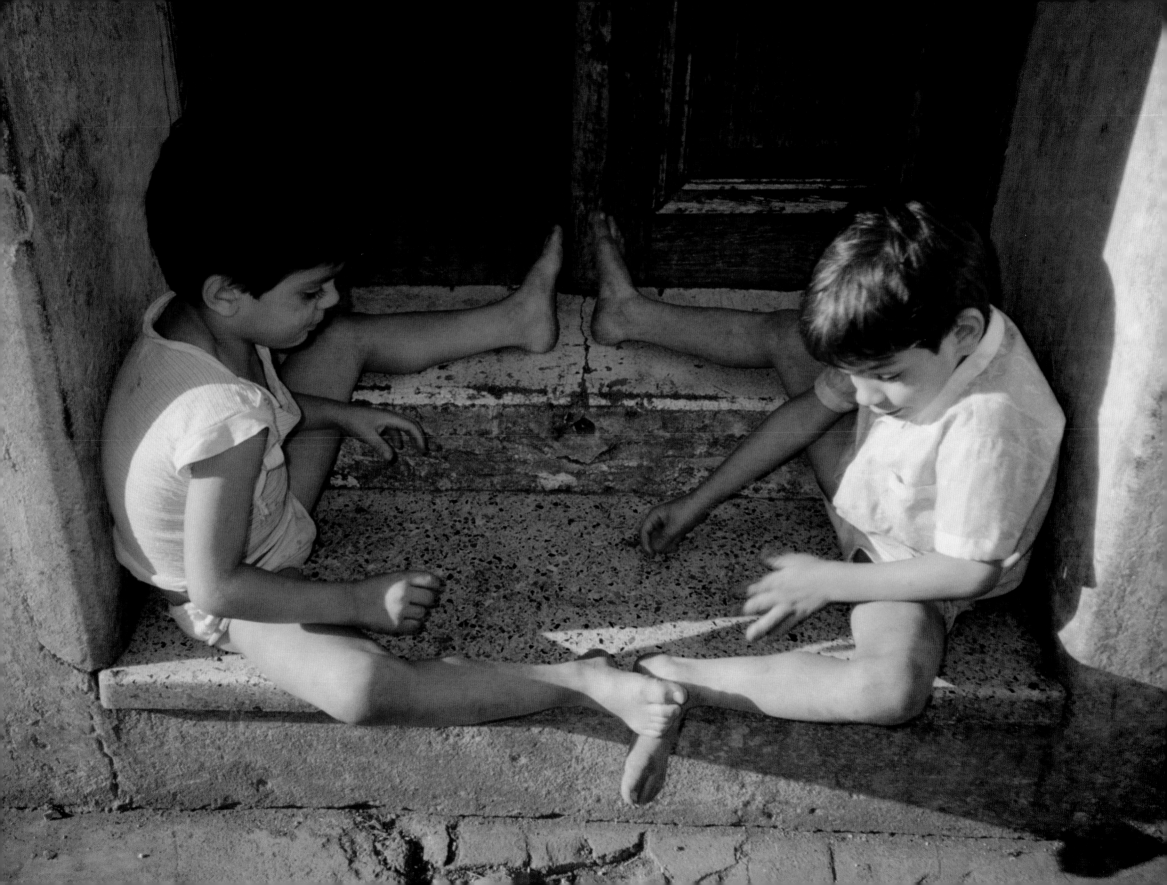

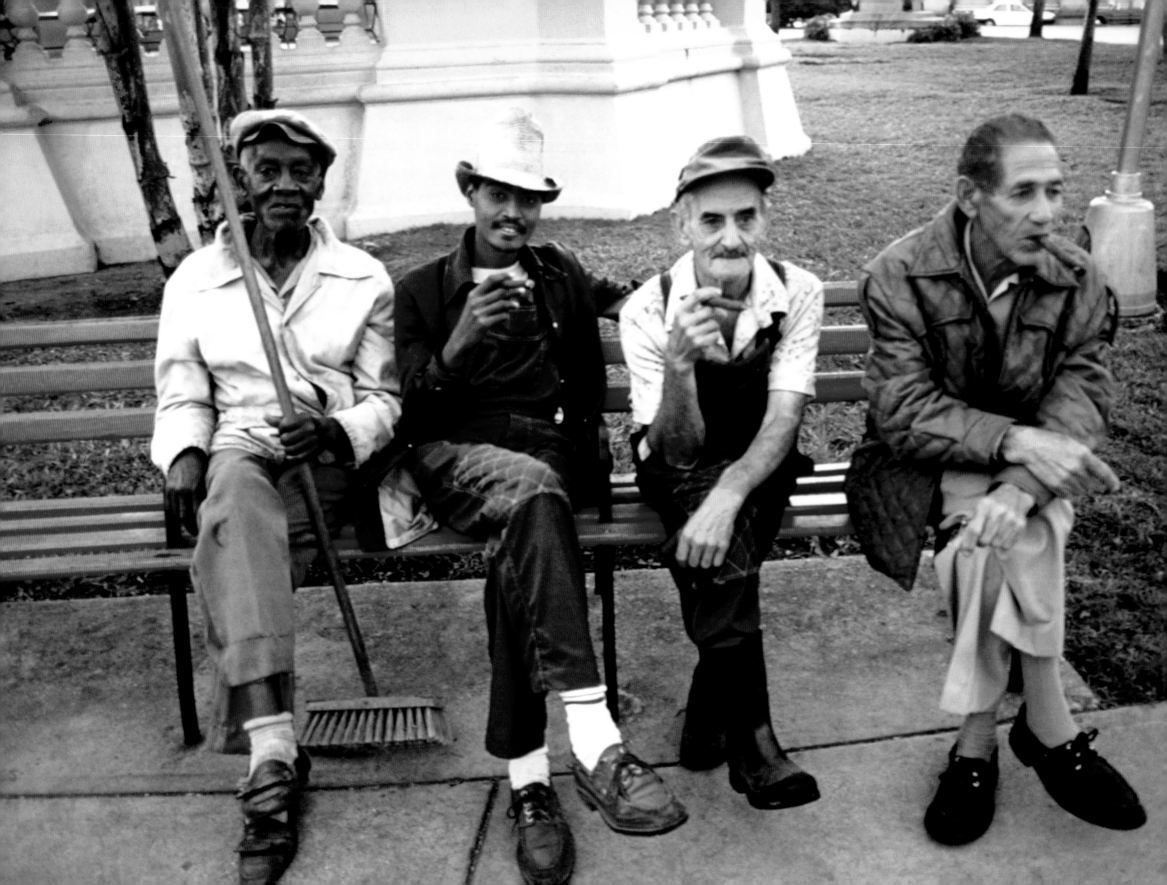

CHAPTER ONE

Paused in Time / Tiempo en Pausa

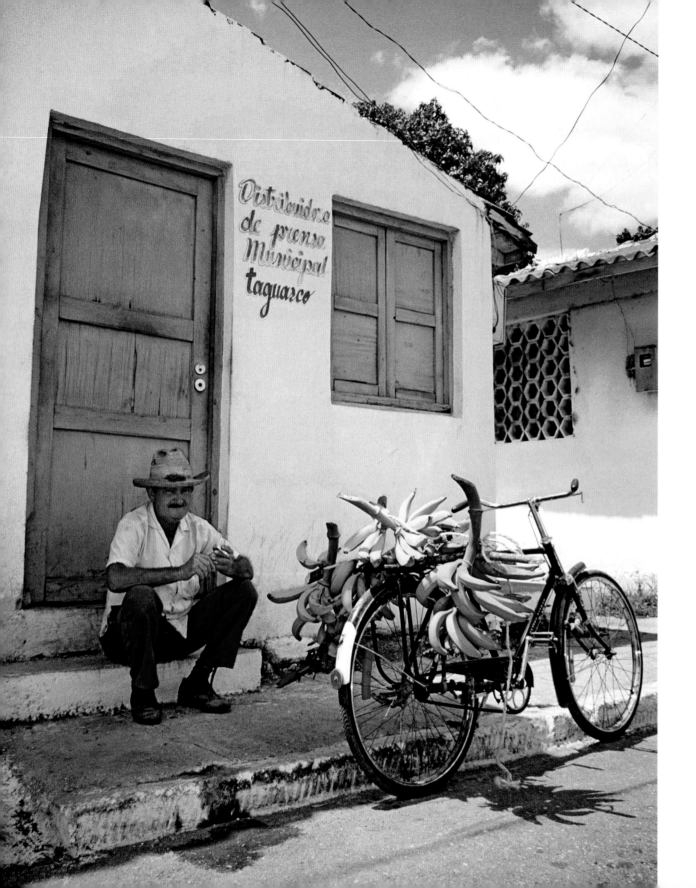

Black market banana sale in Taguasco, Camagüey.

Opposite: A bicyclist passes a national mural promoting the usage of bicycles donated from China due to the gas shortage in Cuba after the loss of economic support from Russia.

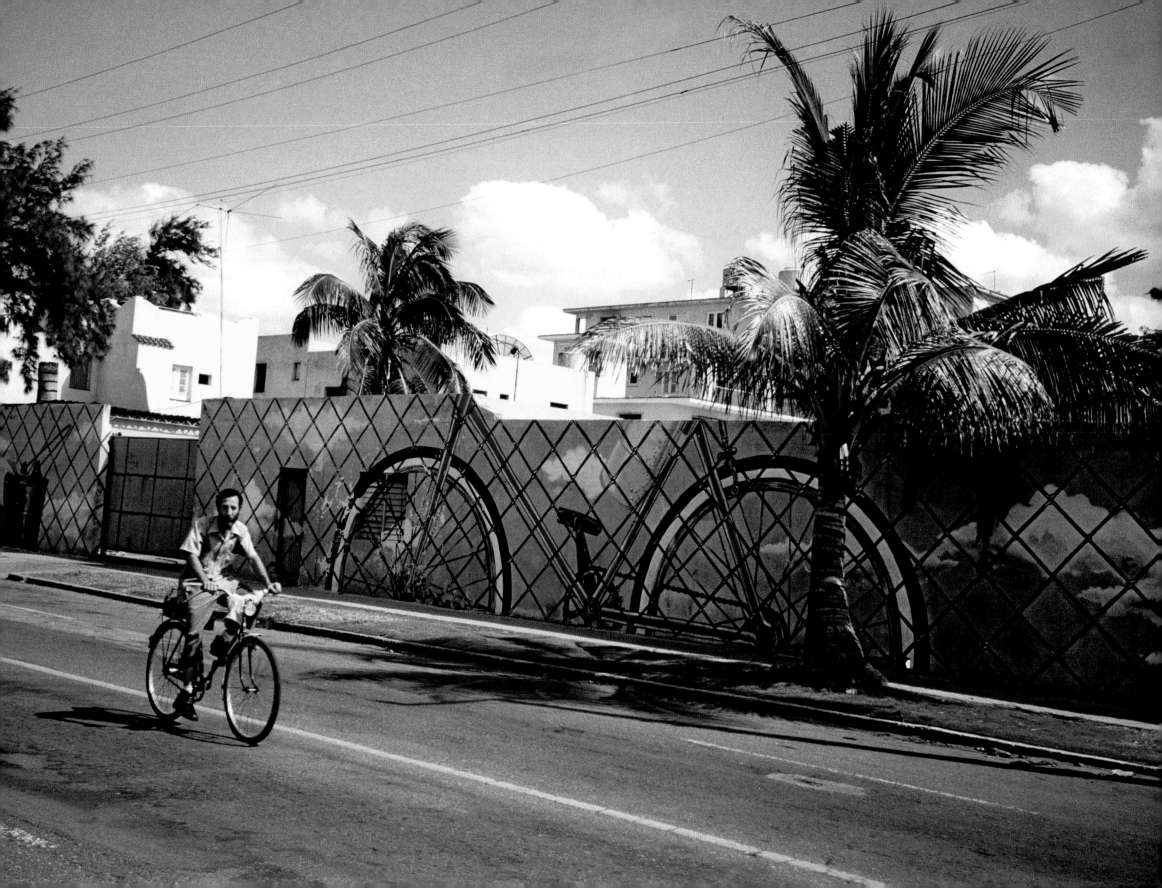

UNESCO funding financed many facade renovations in Havana, but the interiors of many buildings collapsed due to a lack of materials. Rubbage and debris were all that remained until the threat of a hurricane and high winds led the government to clean up the remains.

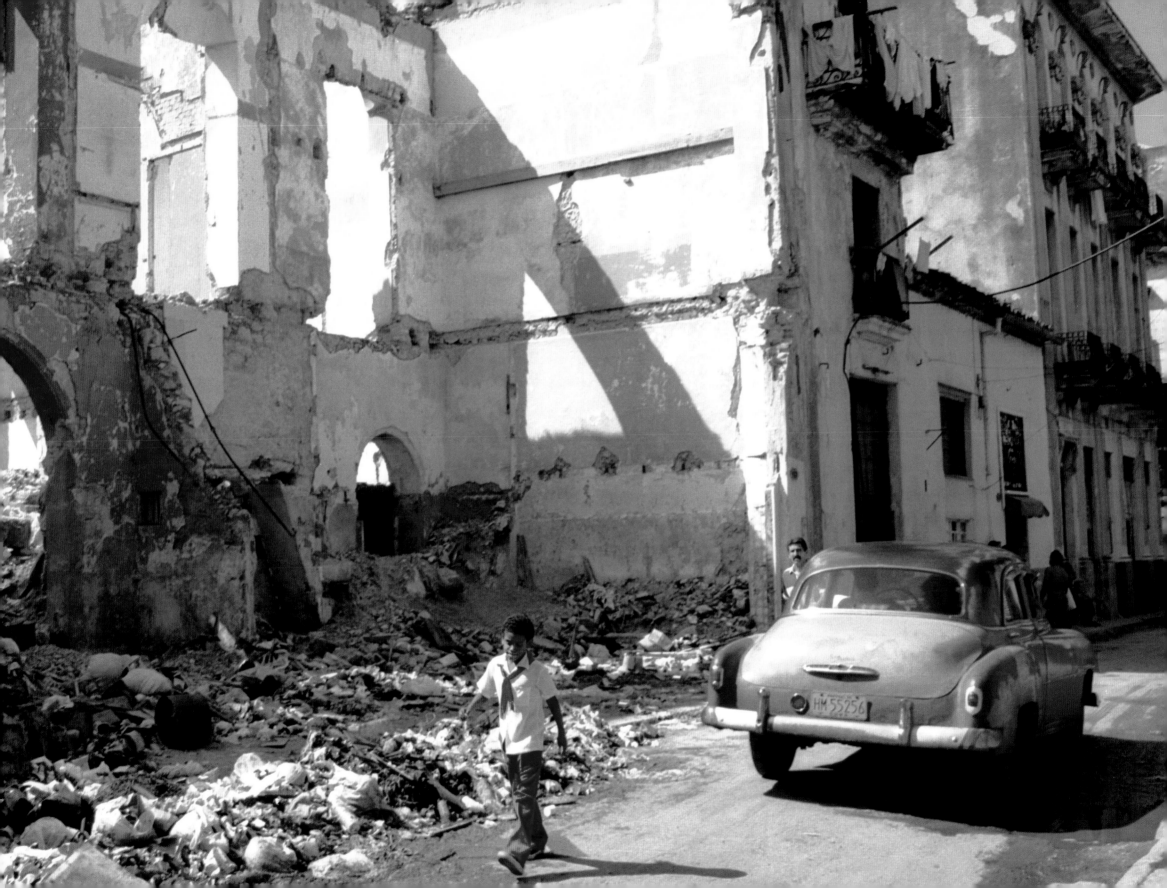

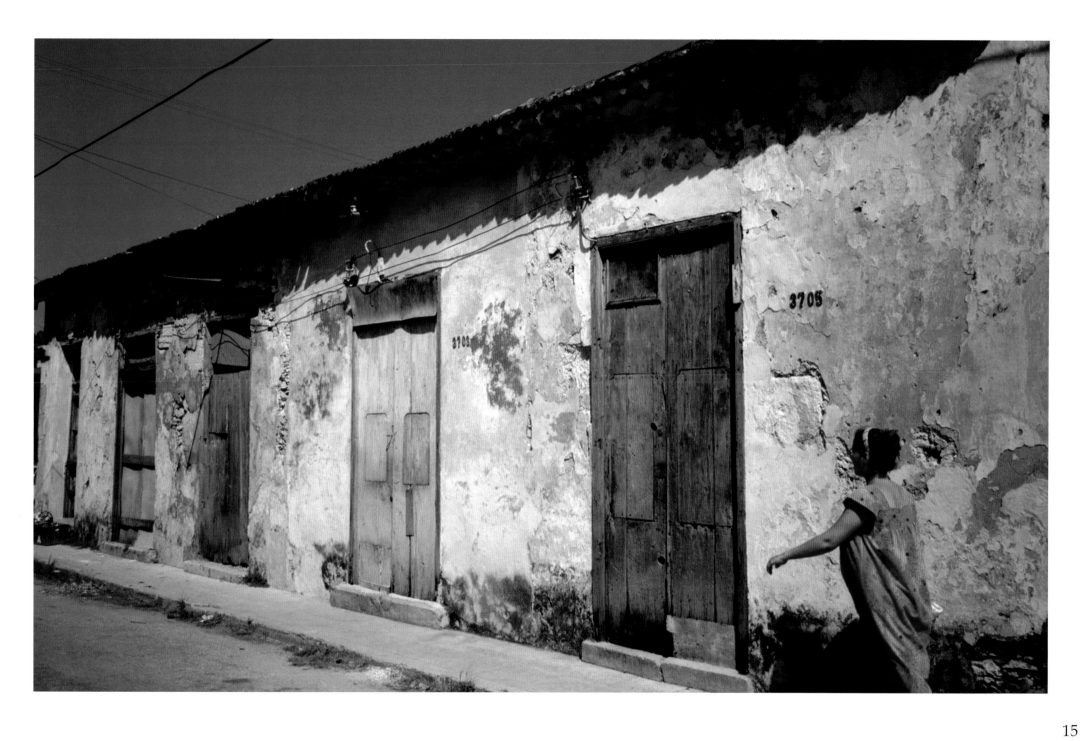

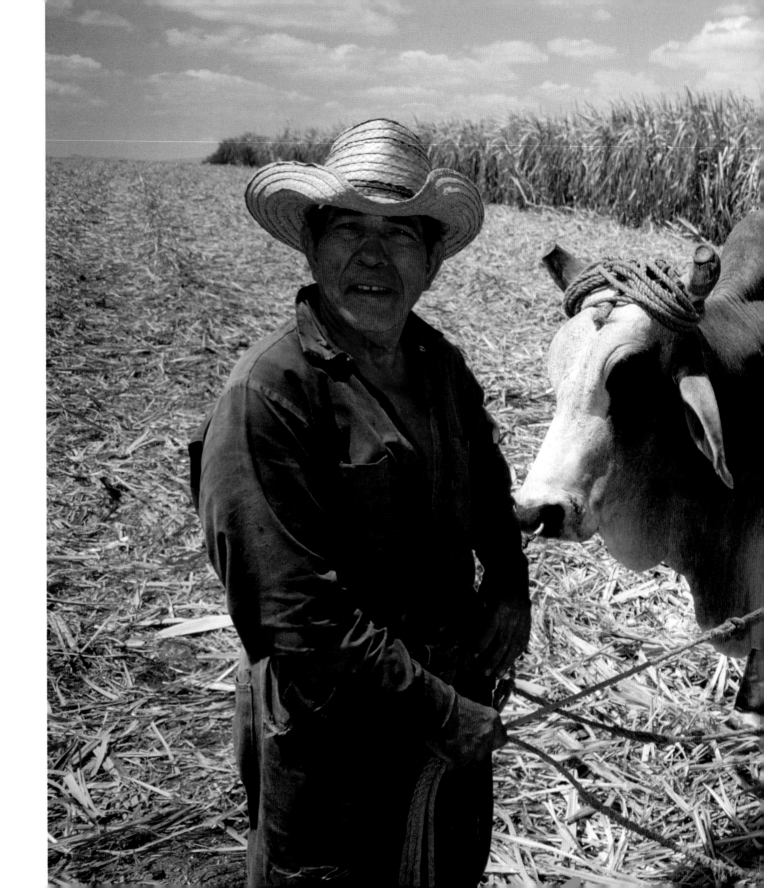

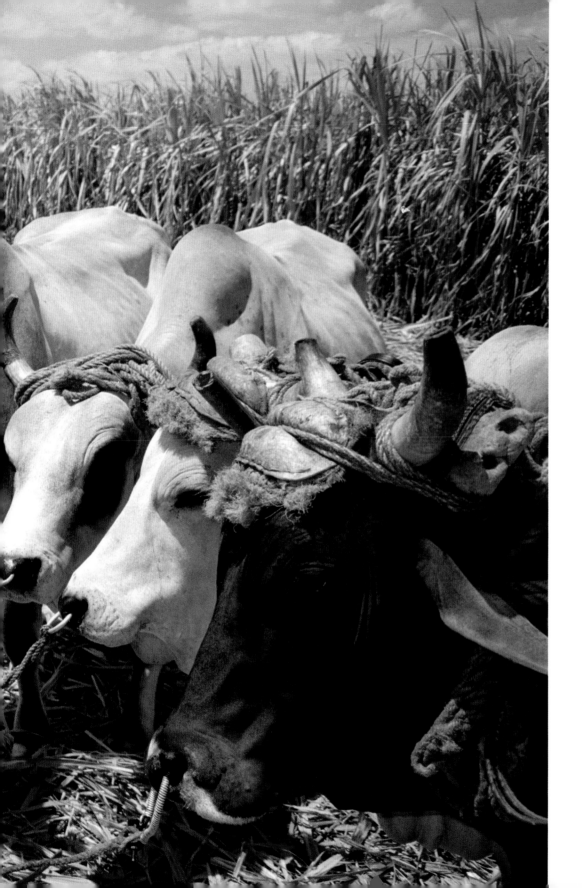

Opposite: The road from Havana to San Antonio de los Baños. Due to limited access to cars and parts as well as a lack of gas on the island, few cars travel on Cuba's highways at any one time. Luckily, this runaway cow and his herder were not at risk crossing the road as a van of tourists passed in front of them.

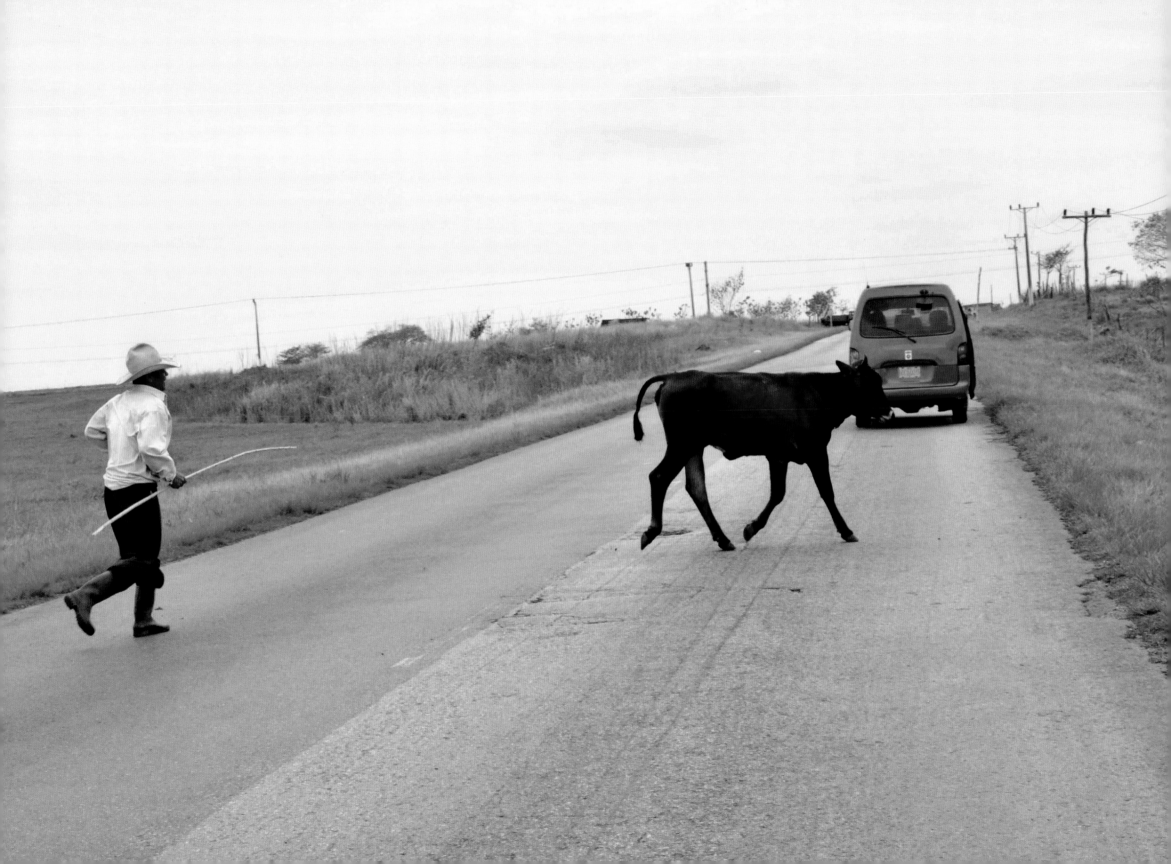

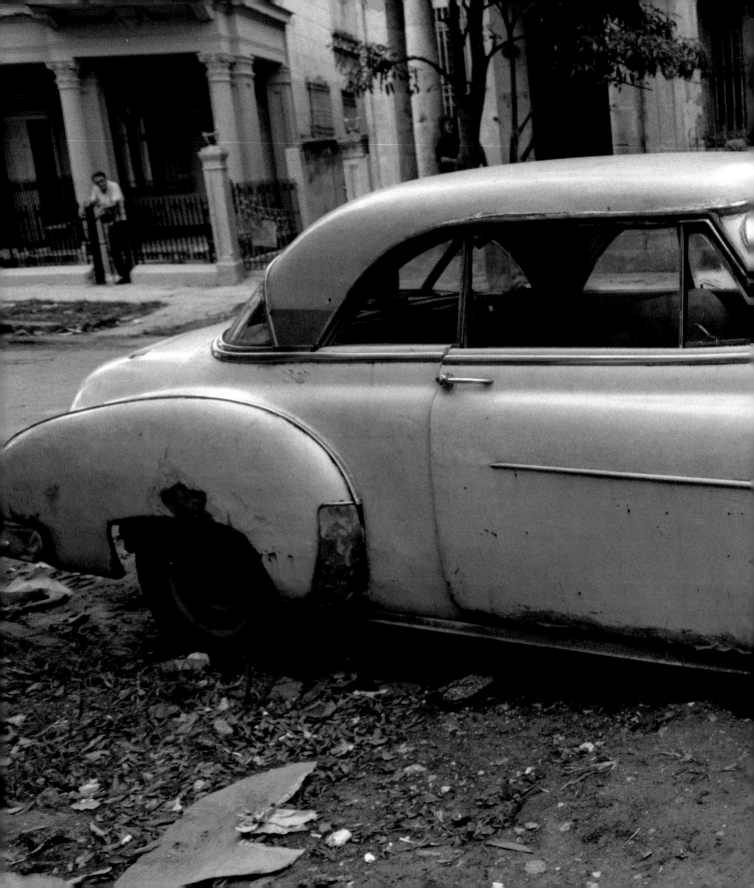

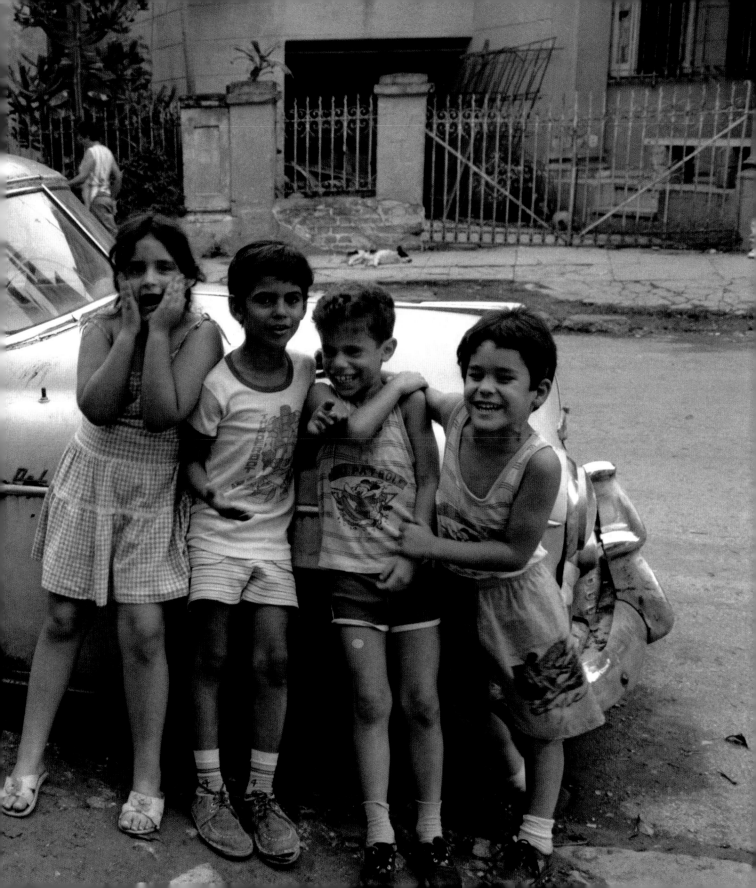

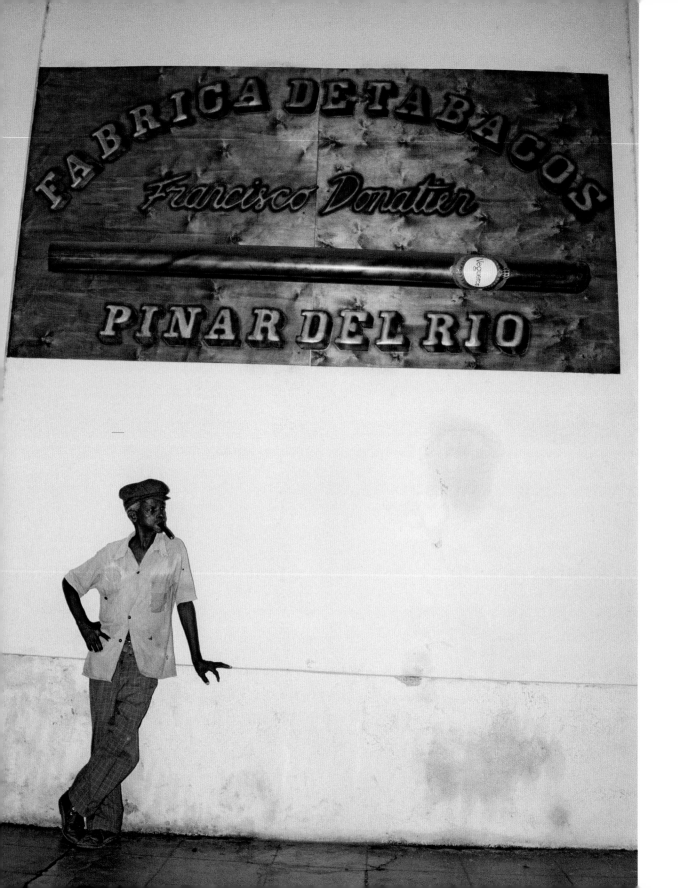

An elderly man enjoys a *puro*, Cuba's infamous cigar, outside the tobacco factory in Pinar del Río.

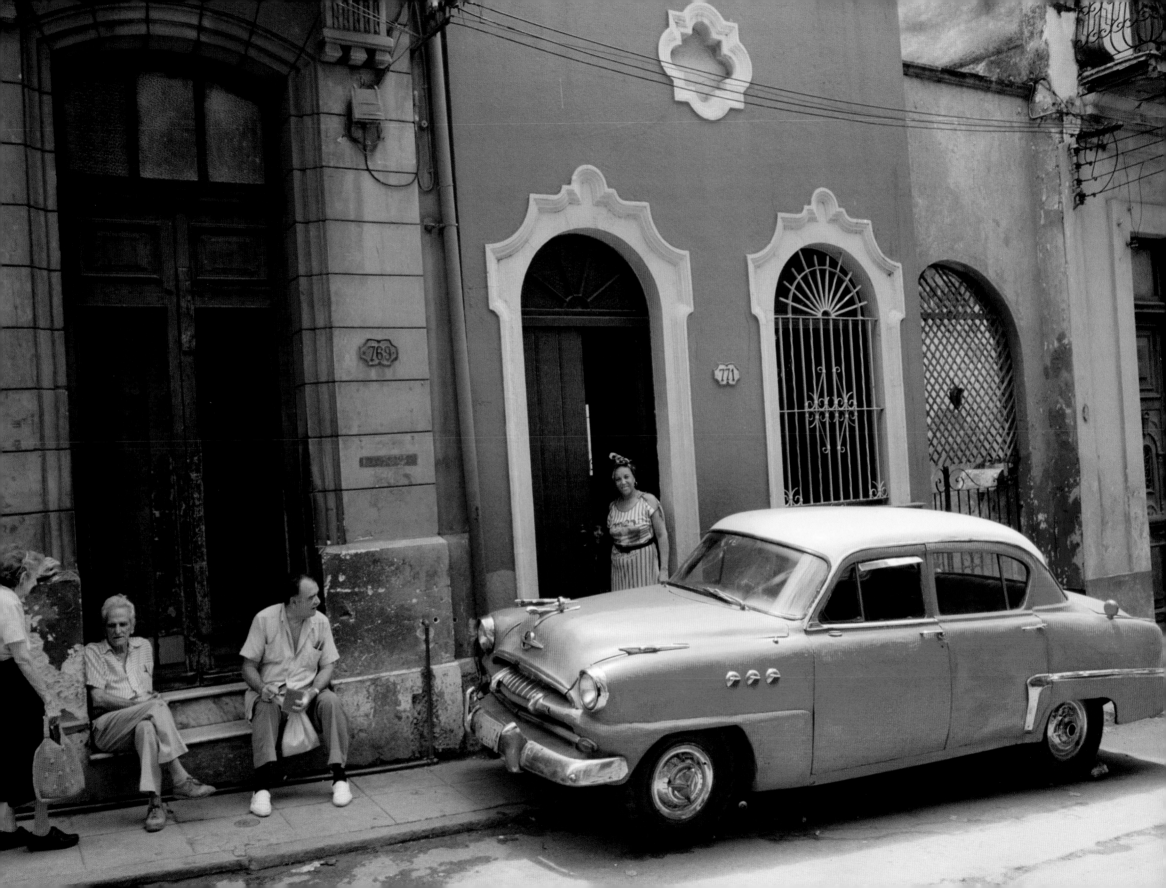

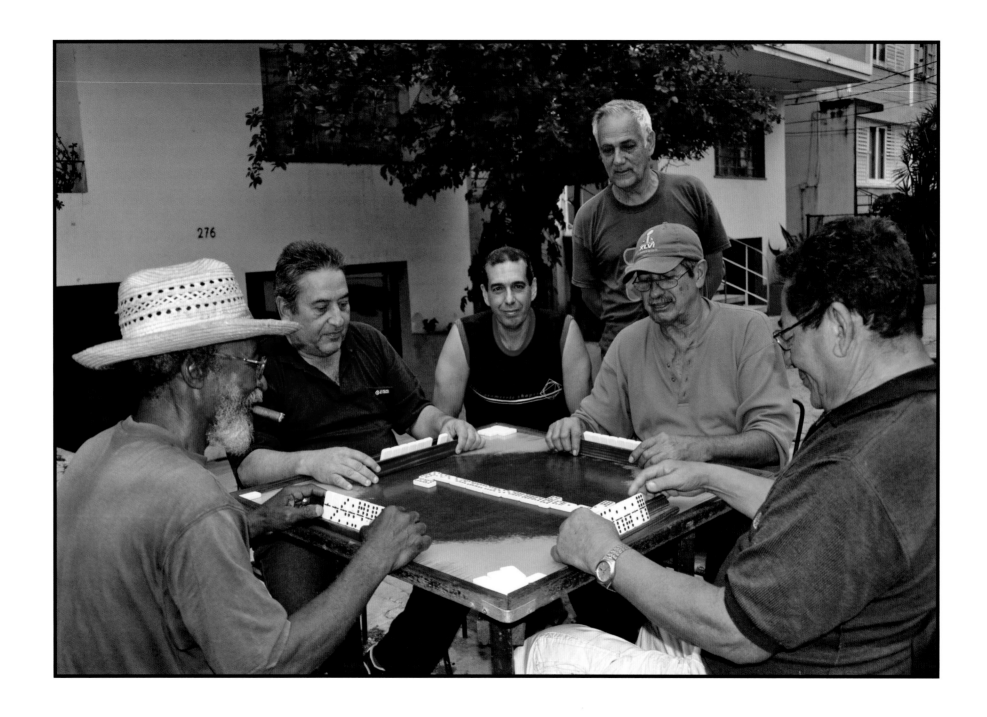

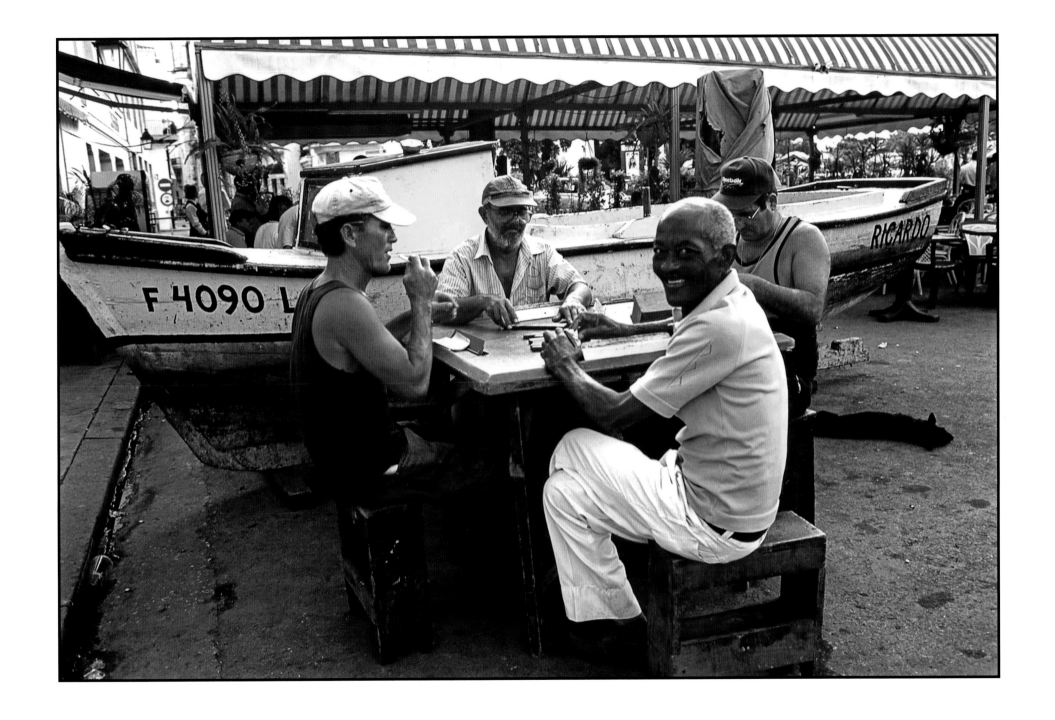

Men in San Antonio de los Baños play the Cuban version of dominoes. Talking during the game is both allowed and encouraged by the players and the people watching the game.

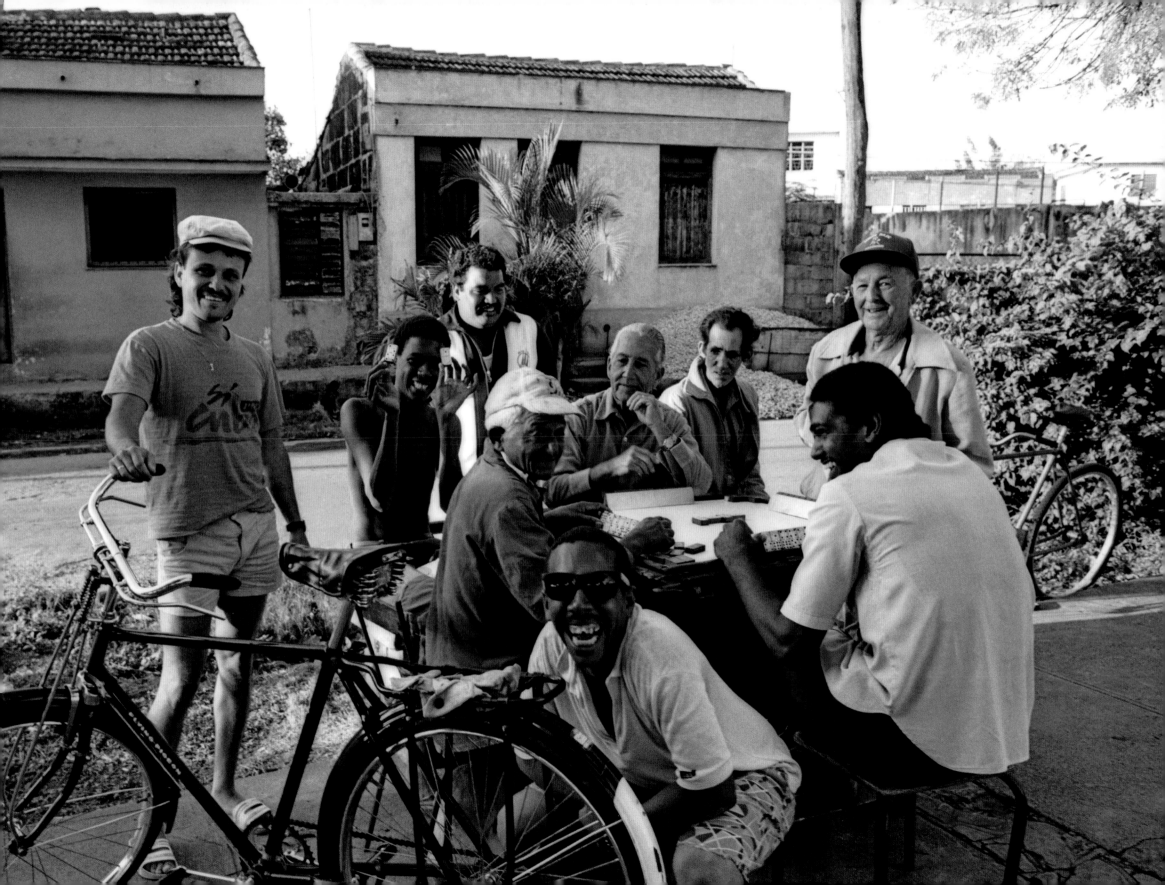

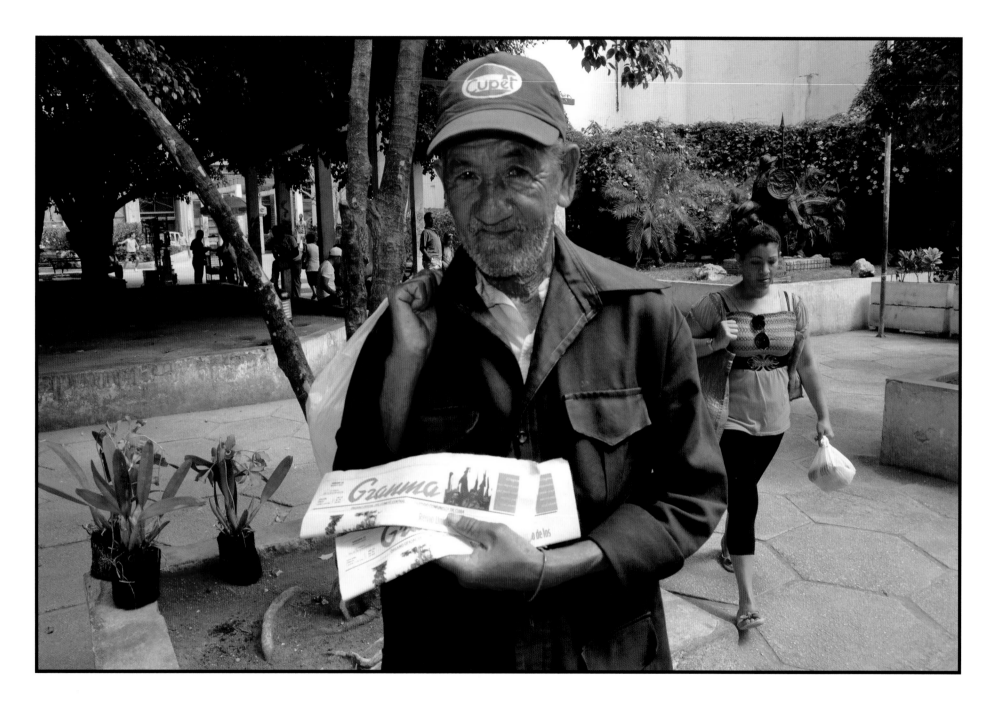

A man sells *Granma*, a newspaper named after the boat that brought Cuban revolutionaries to land from Mexico.

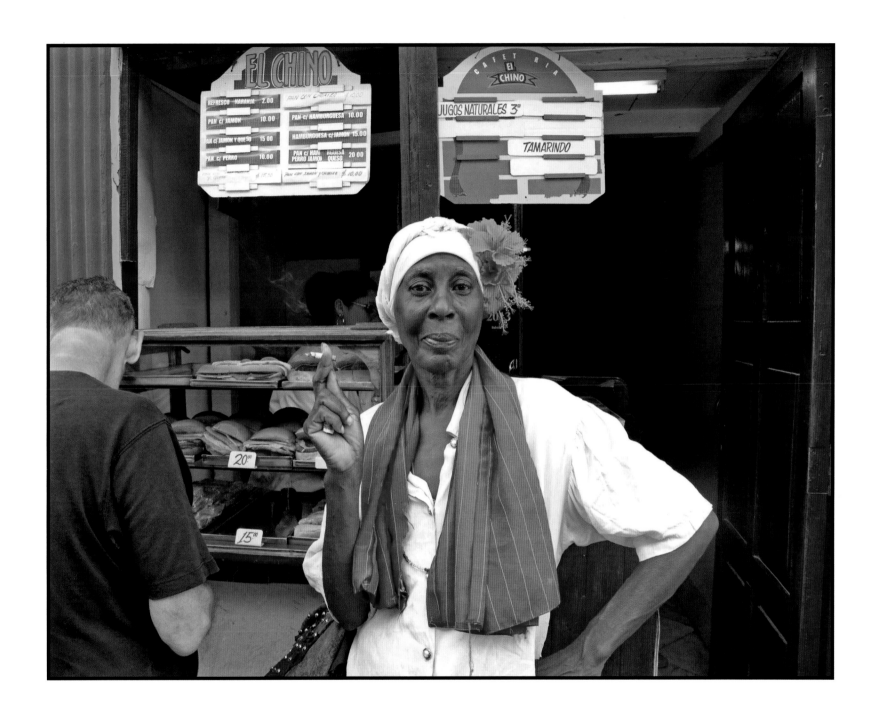

A santera, a priestess of the religion Santería, enjoys a *puro* in front of a local lunch stop in Old Havana.

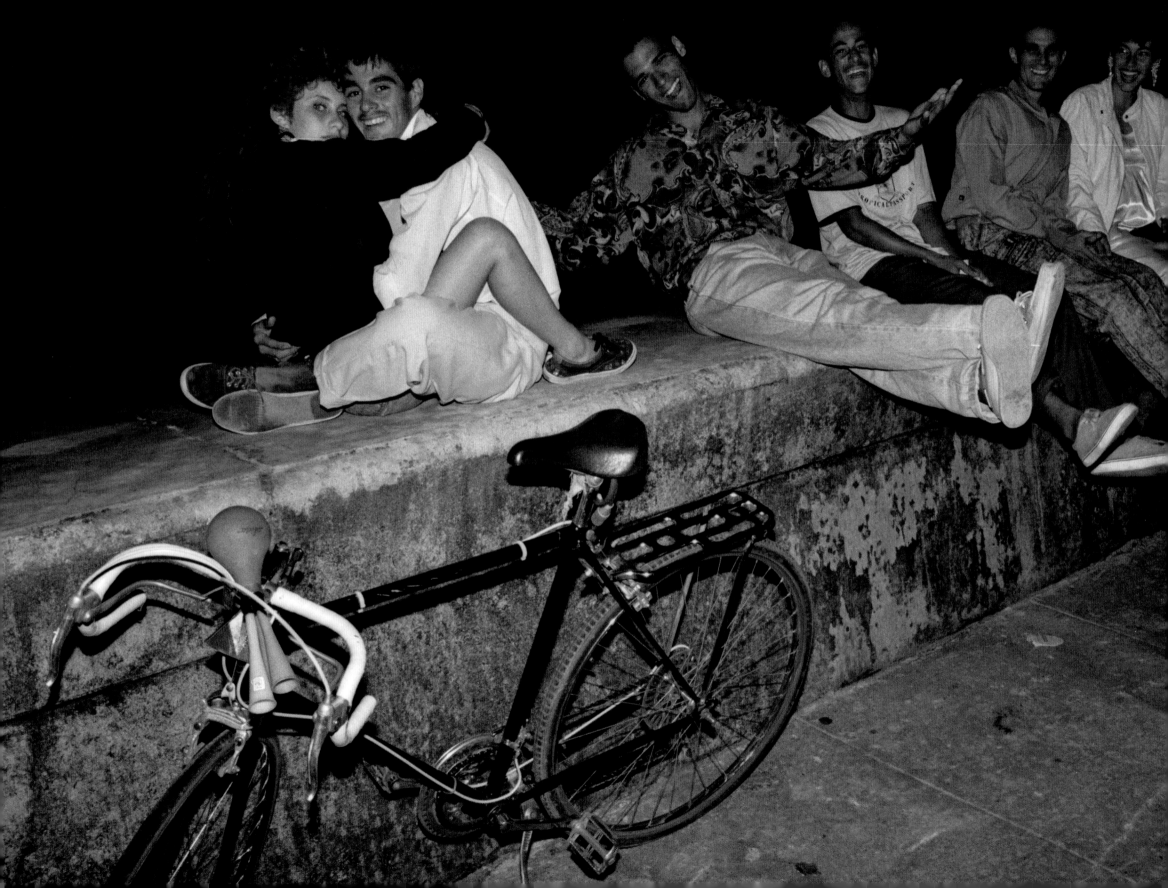

Opposite: Joyful couples enjoy El Día del Amor (Valentine's Day) along the Malecón in Havana.

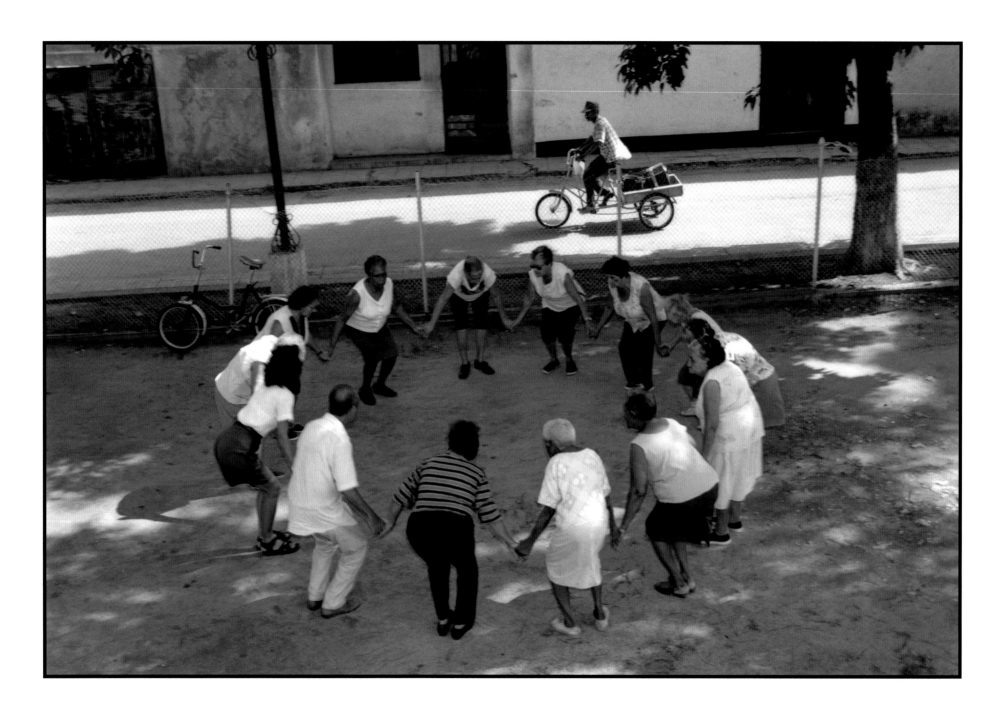

A doctor leads seniors in a morning exercise class offered daily in every neighborhood.

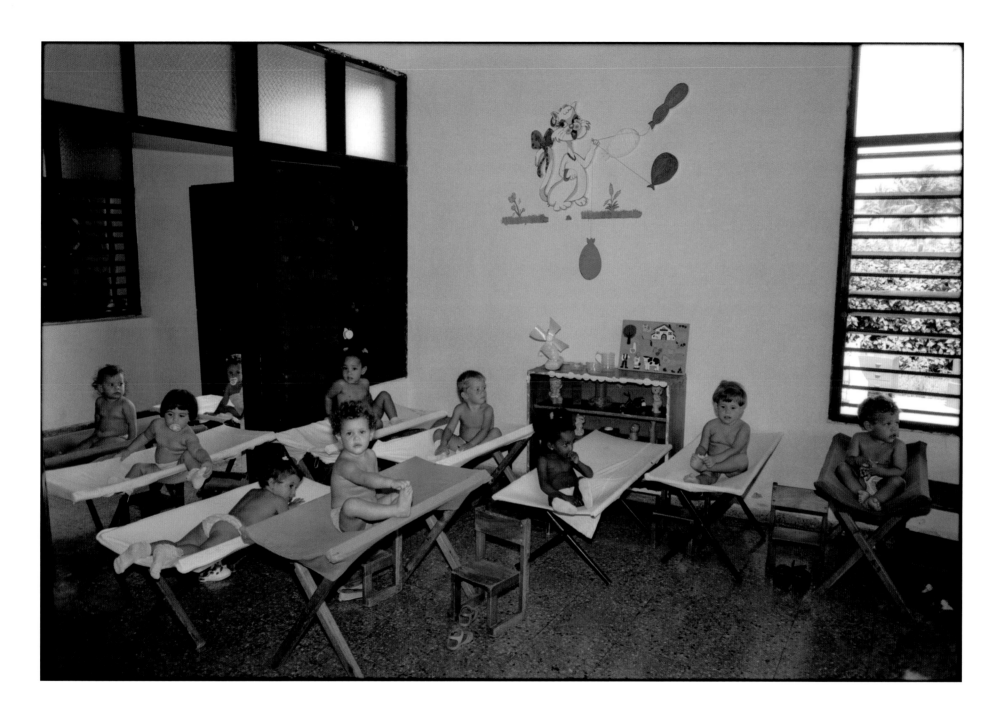

Kids during nap time in a day care center in San Antonio de los Baños.

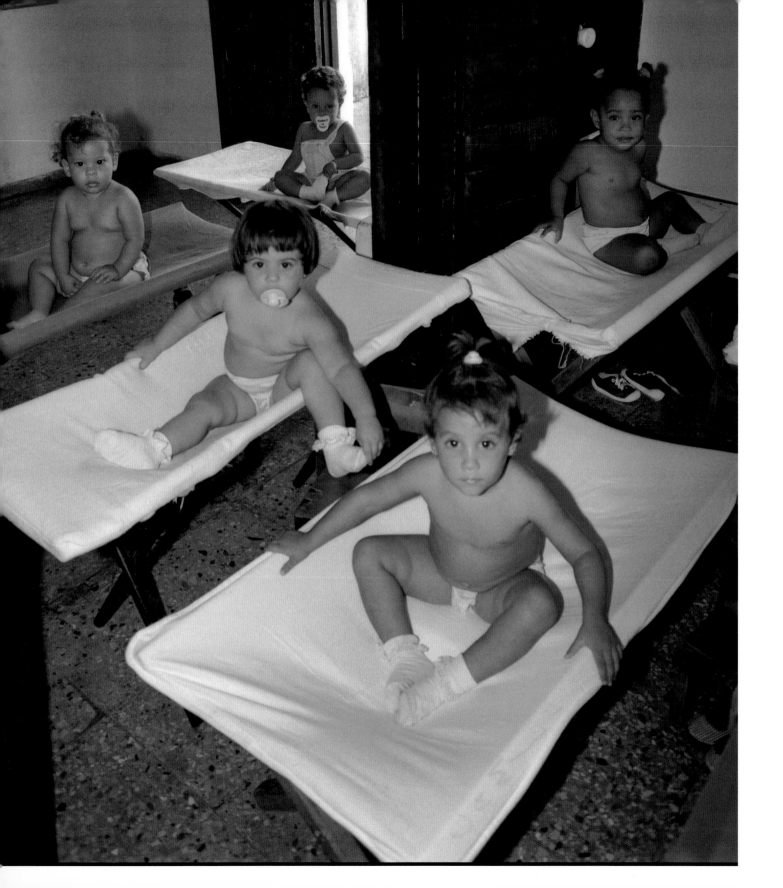

Here and opposite: Nap time at the local day care center for working mothers and fathers in San Antonio de los Baños.

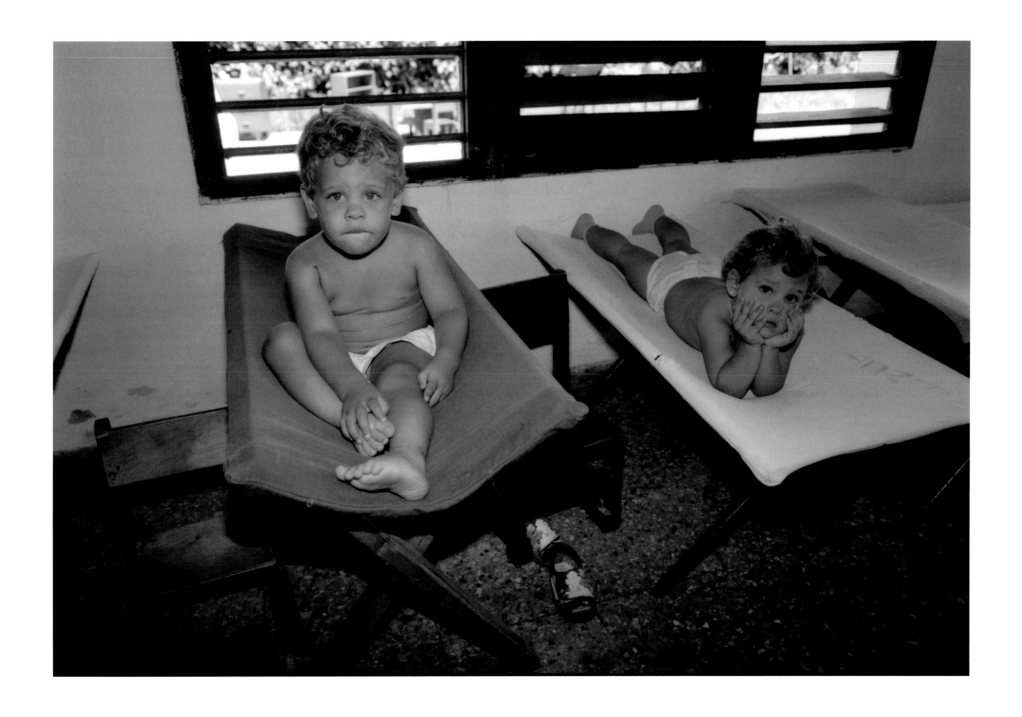

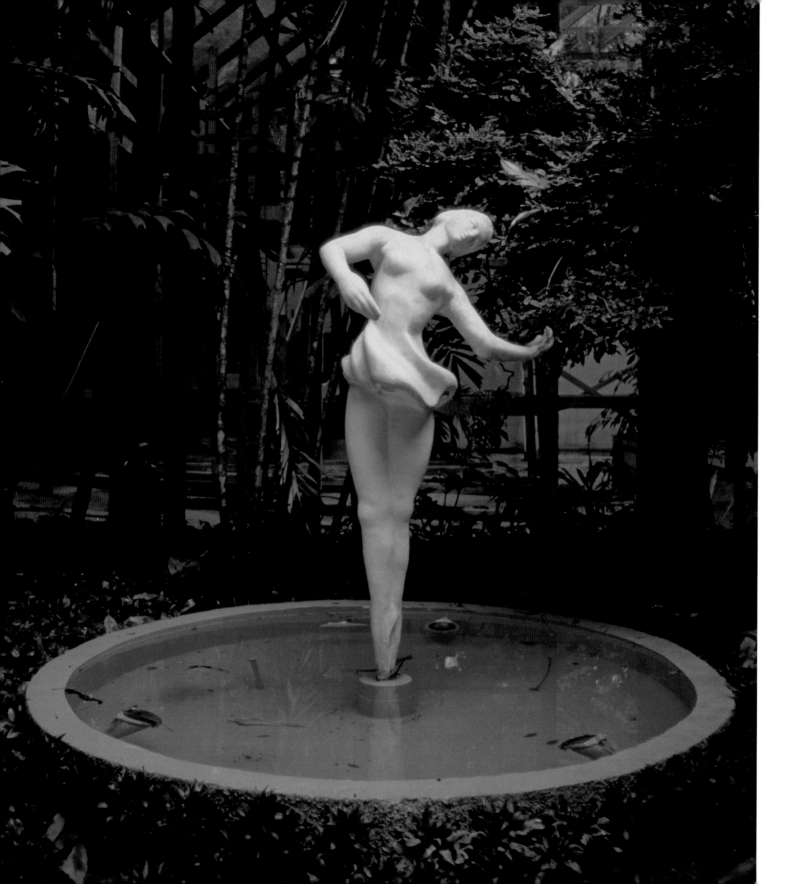

La Bailarina (The Ballerina) by Cuban artist Rita Longa, stands outside the entrance of the Tropicana nightclub in Havana.

A palm tree sways in the wind at La Playa Santa María del Mar, one of the beautiful beaches that make up Las Playas del Este, just east of Havana.

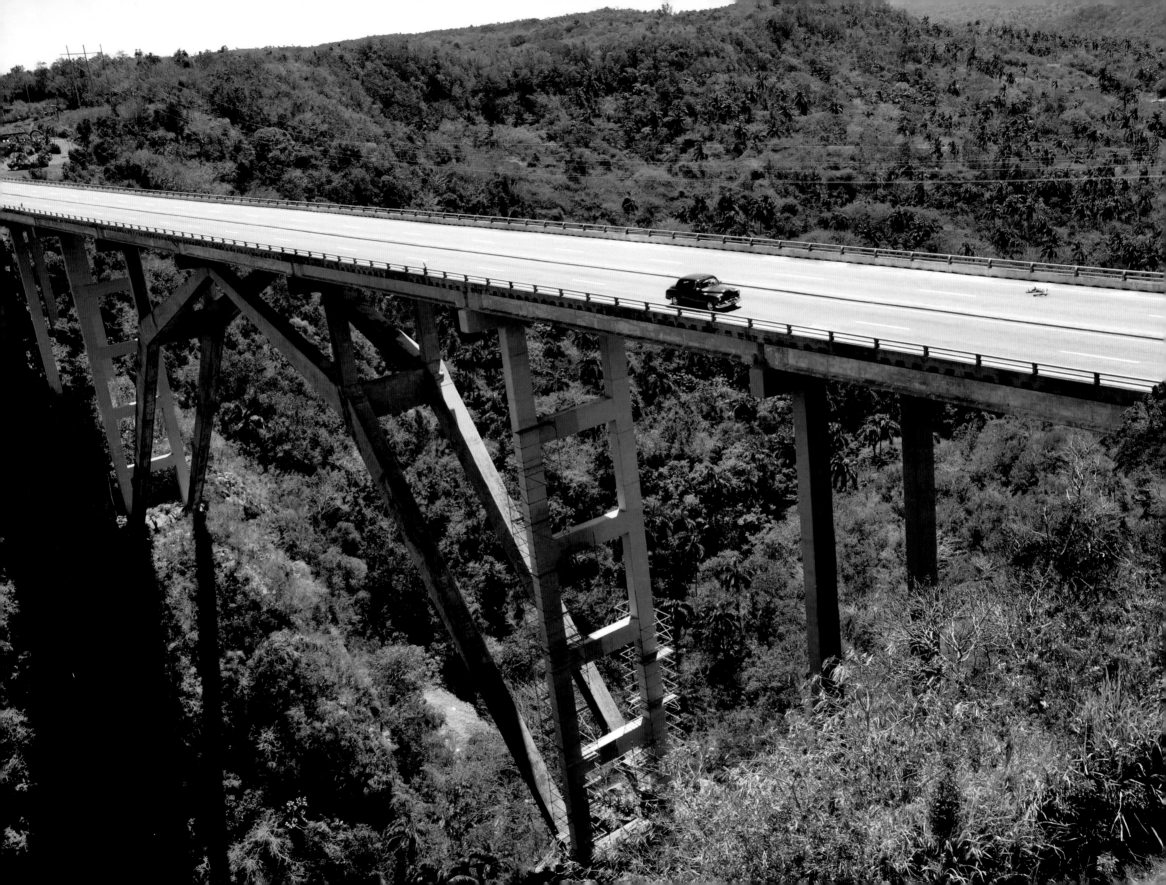

CHAPTER TWO

Views / Vistas

Page 38: Scenic view of the Yumurí Valley. Inaugurated in September 1959, this bridge, at 110 meters above the valley floor, crosses the canyon on the way from Havana to Varadero, a famous beach resort area, and is the highest bridge in Cuba. The bridge divides Matanzas Province from the new Mayabeque Province, and was designed by Cuban engineer Luis Saenz.

Viñales is a small valley town and municipality surrounded by mountains in the north-central Pinar del Río Province of Cuba. Before European settlement, the area was home to Taínos, an indigenous tribe, but in the early 1800s, tobacco growers from the Canary Islands came and developed the land. Viñales is now an agricultural area, where crops of fruit, vegetables, coffee, and especially tobacco are grown by traditional methods. Fishing is also an important part of the area's economy. In 1999, UNESCO declared the area a World Heritage site.

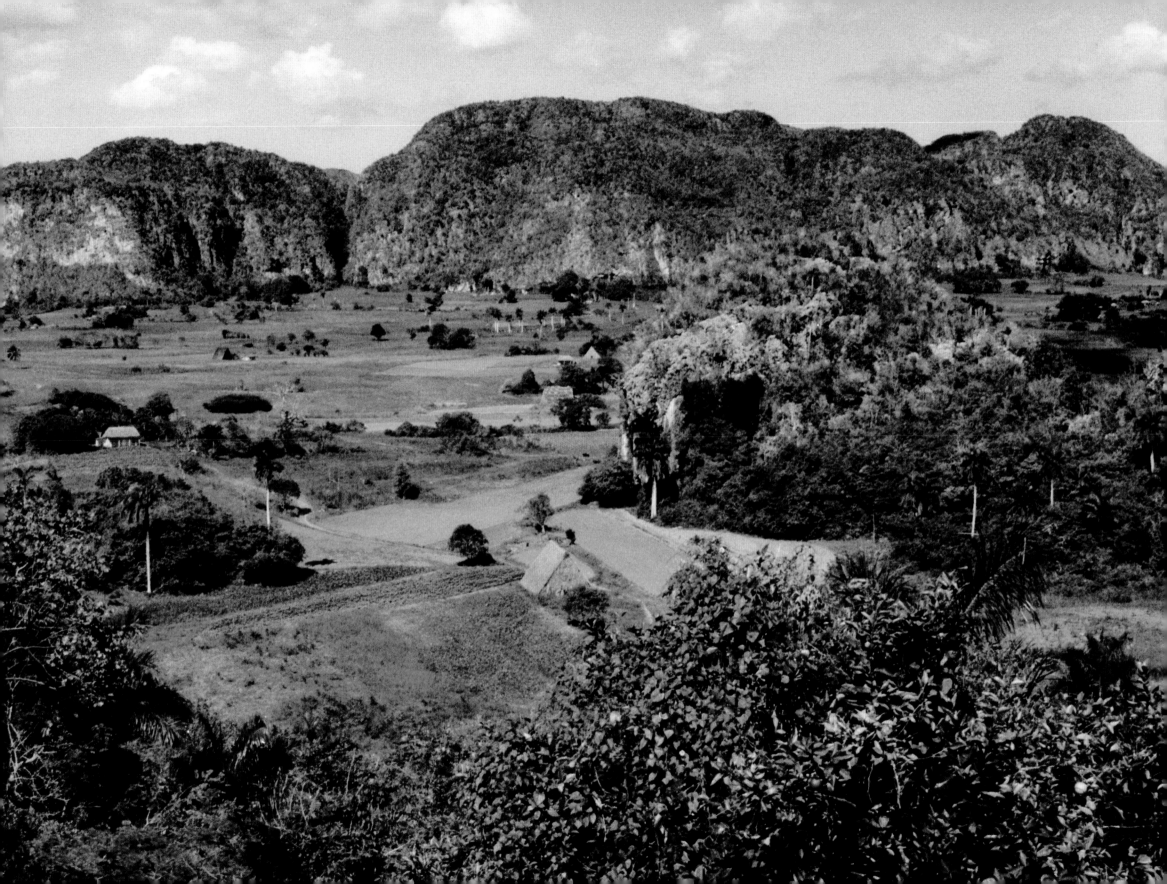

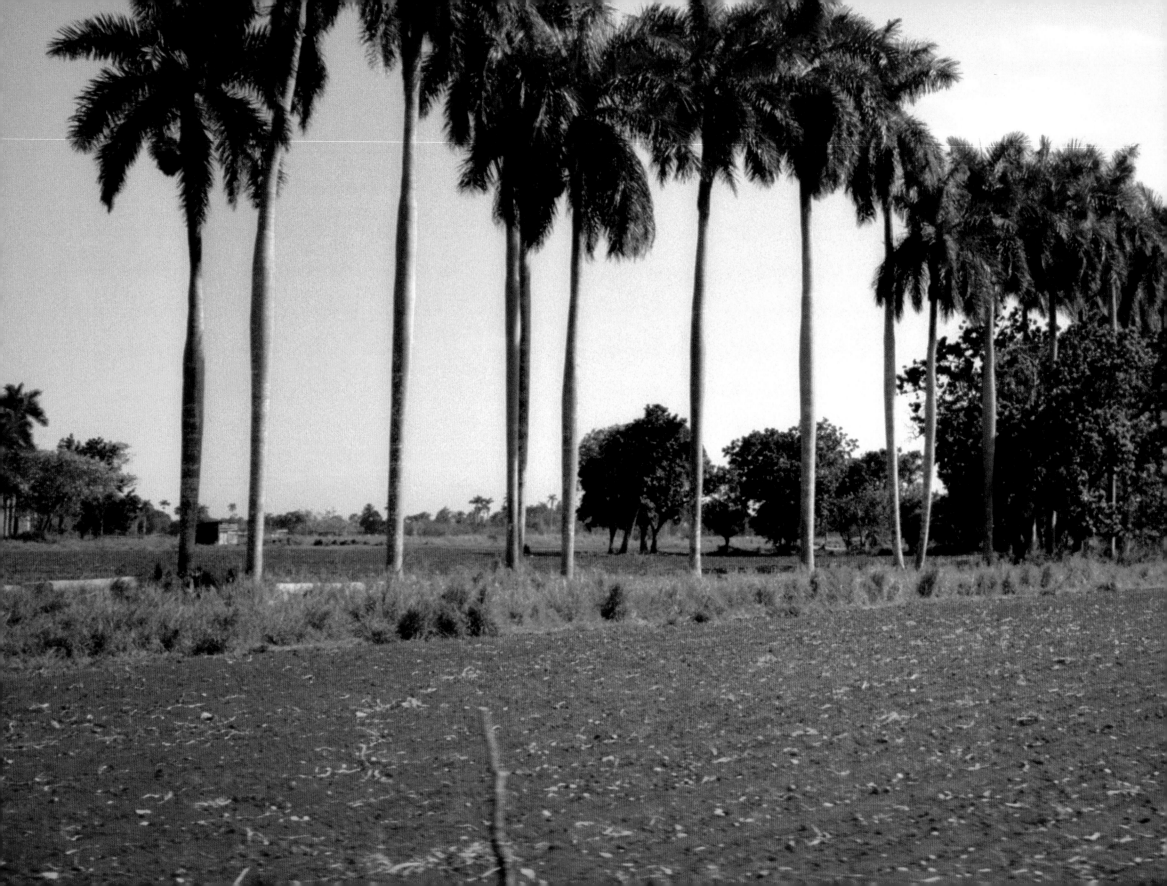

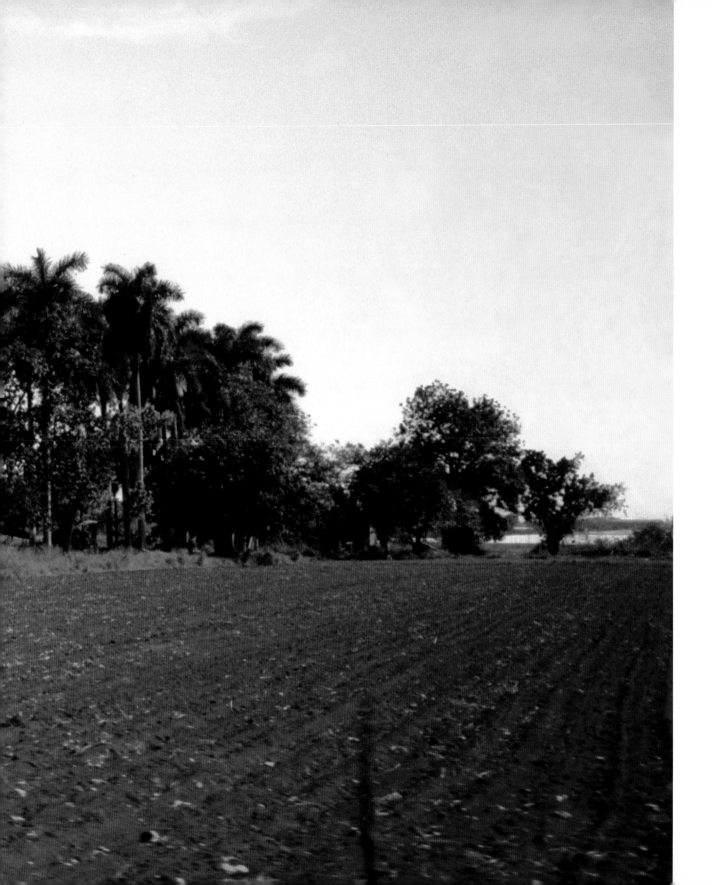

Cuba's naturally fertile soil, red in color, is rich in minerals and provides unique agricultural conditions.

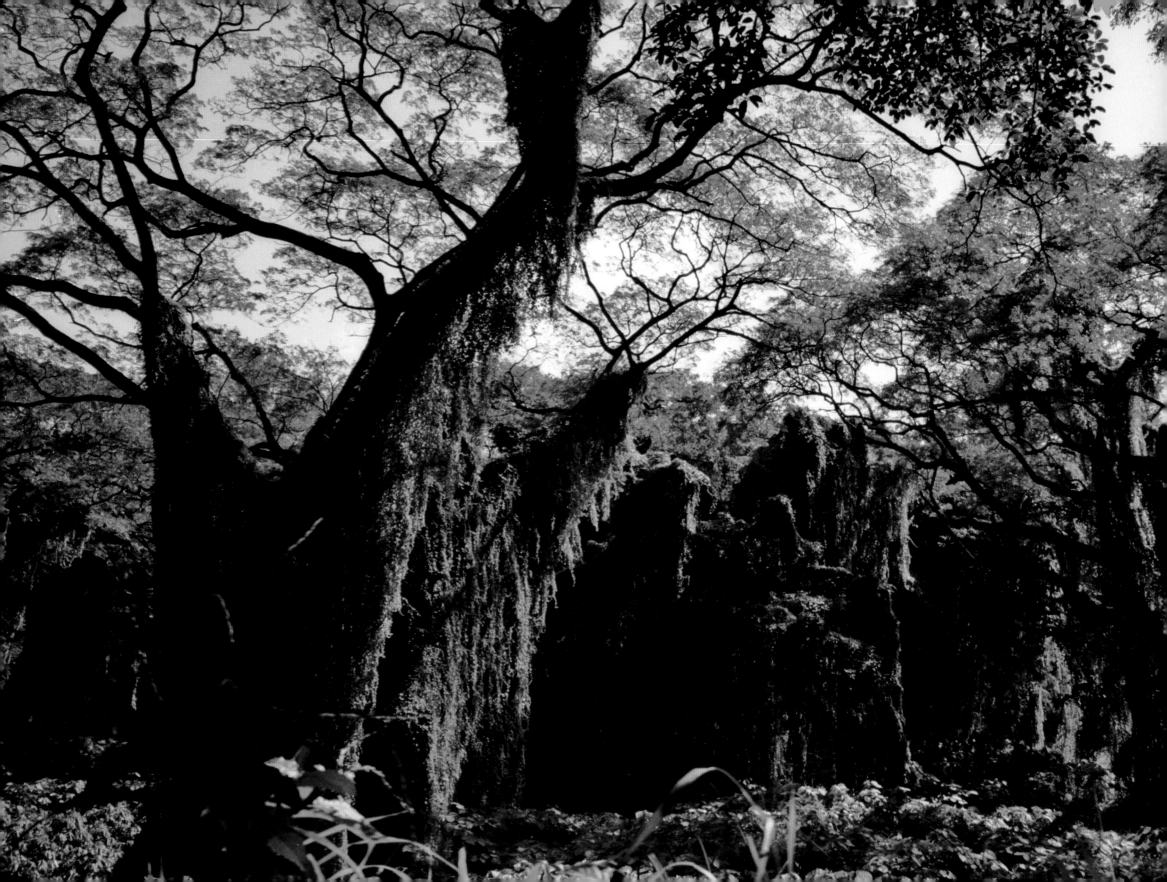

Rainforest, Havana.

The office of a Havana organization that works to develop and further the interests of Cuban companies and businesses, many of which have international operations.

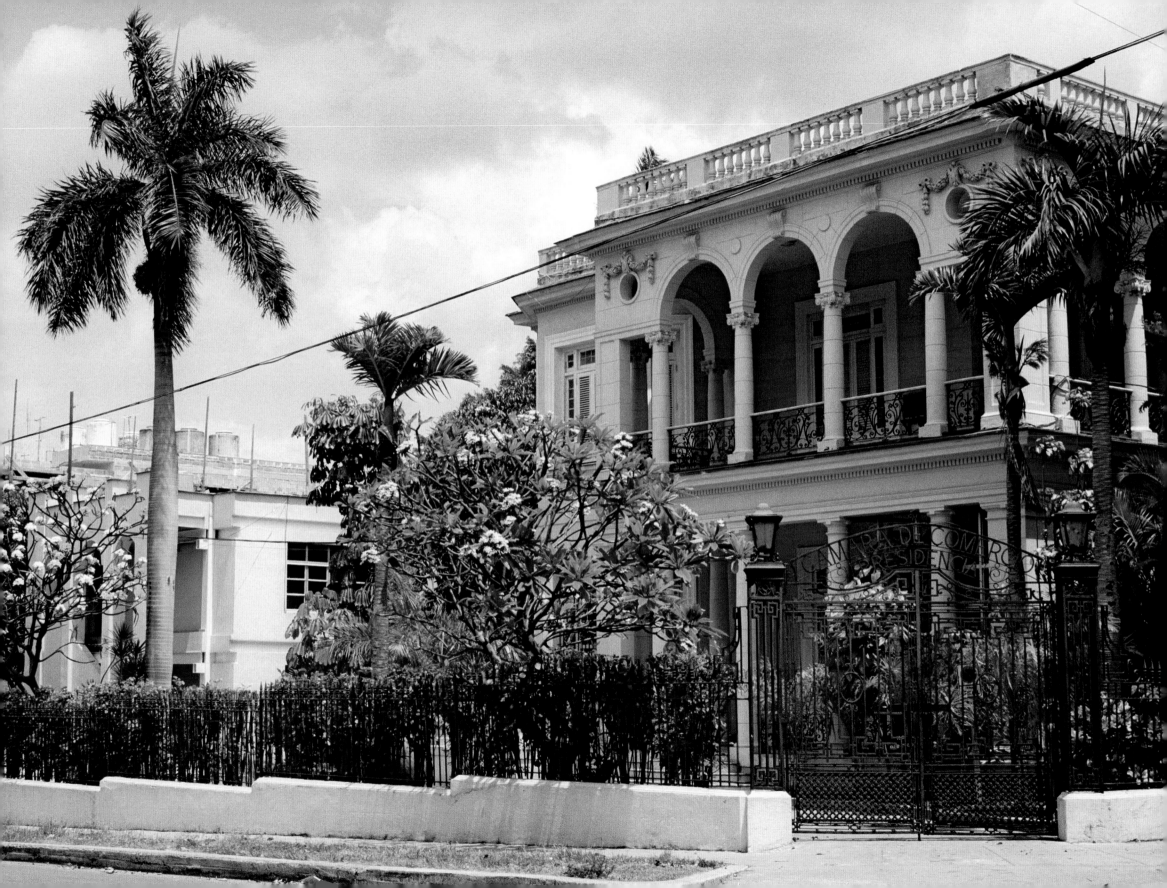

Opposite: The Hotel Nacional de Cuba was designed by a New York architectural firm and opened in 1930. It has a classic art deco style, with beautiful tiles, arches, and gardens, and a long history of hosting many known personalities from the arts, sciences, and politics, such as British Prime Minister Winston Churchill, artists Frank Sinatra and Ava Gardner, and scientist Alexander Fleming. It is located along the Malecón with views of the sea, and was declared a national monument. In 1946, the hotel was host to the infamous mob summit run by Lucky Luciano and Meyer Lansky. In 1955, Lansky persuaded then Cuban President Fulgencio Batista, to give permission for the development of a casino and luxury suites for high stake gamblers. In 1960, Fidel Castro closed the casino and the hotel became host to many visiting foreign diplomats and government officials. In 1992, the hotel was renovated, and with the increase of international tourism, it has become an important historical site in Havana.

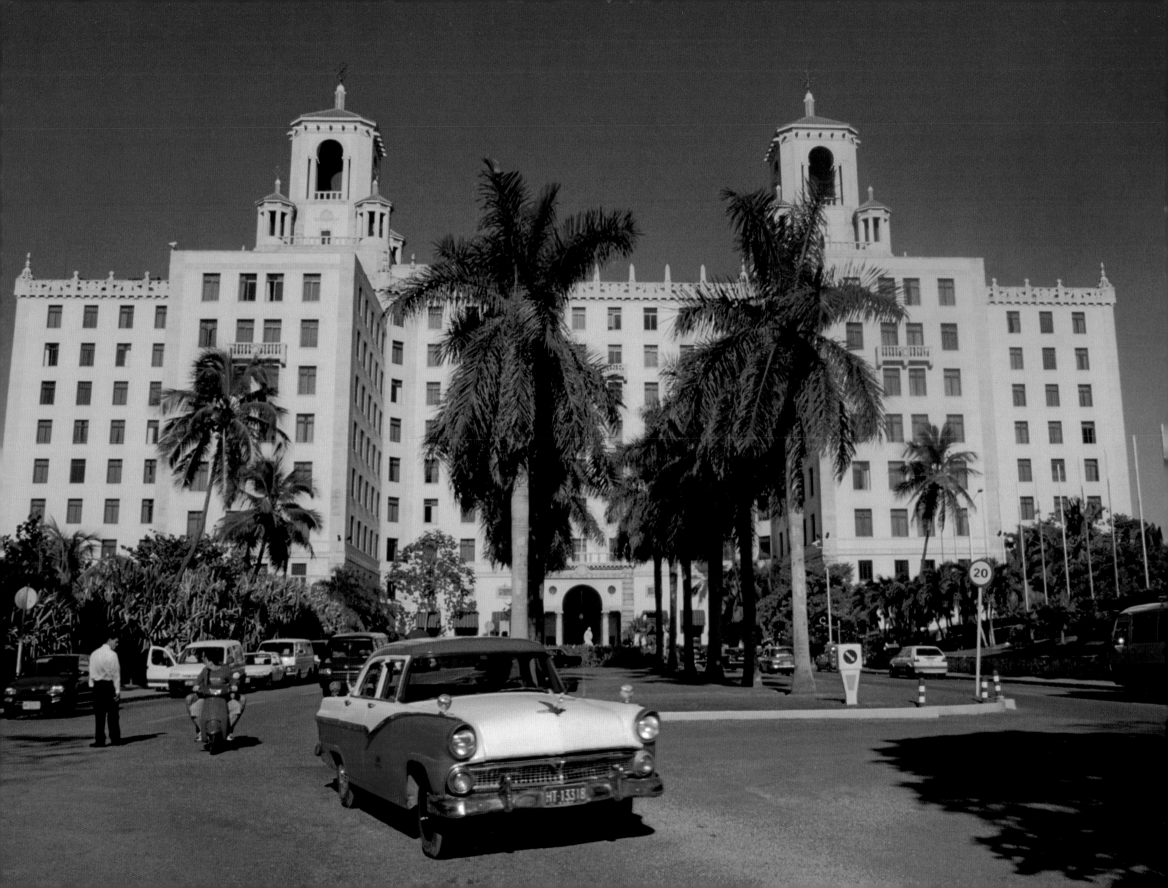

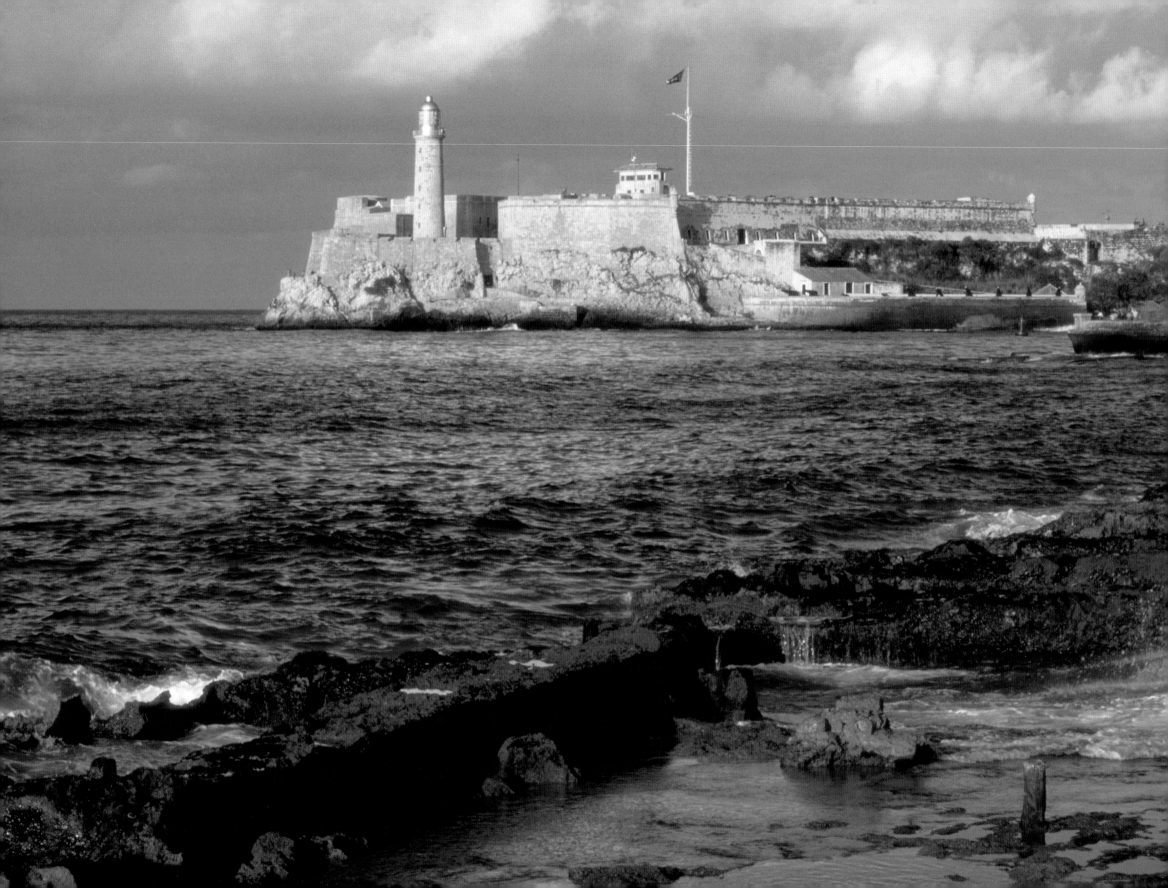

Opposite: El Morro fortress built by the Spaniards in 1589 is located along the Malecón in Havana.

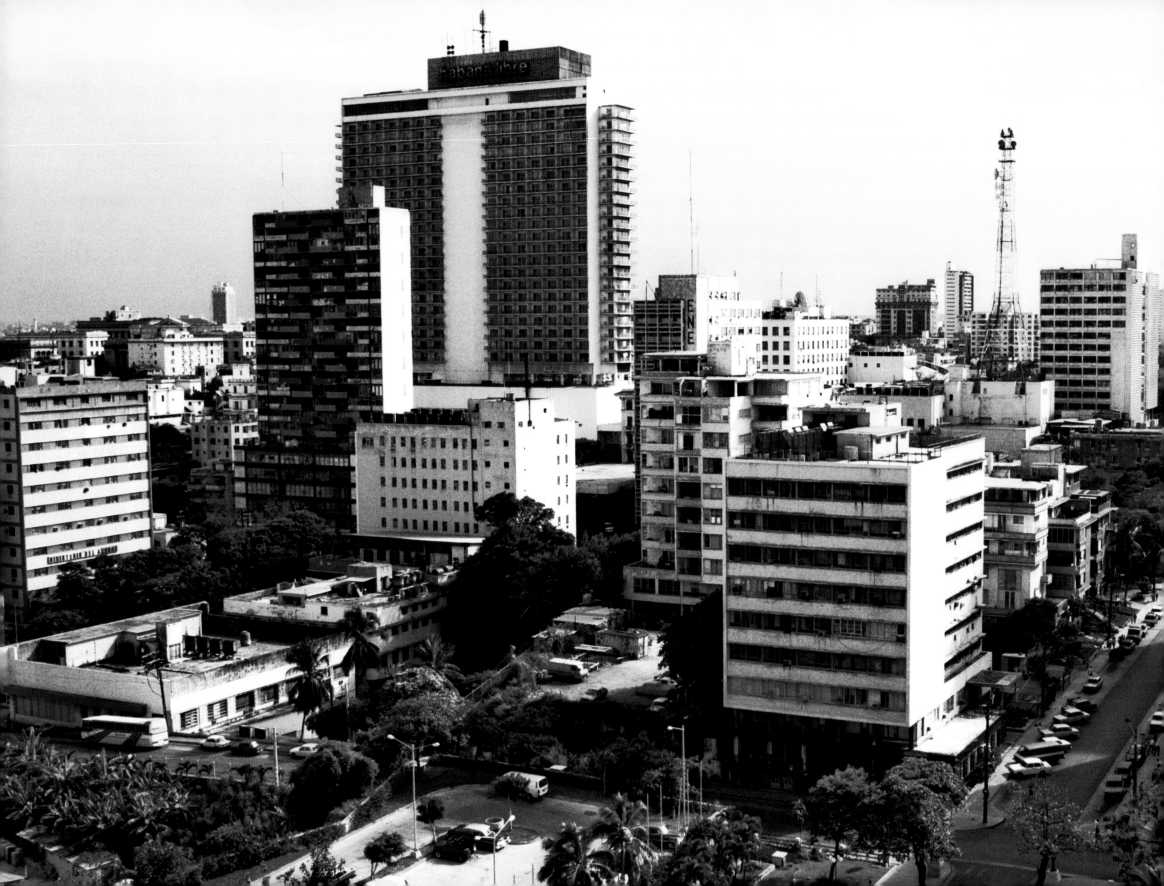

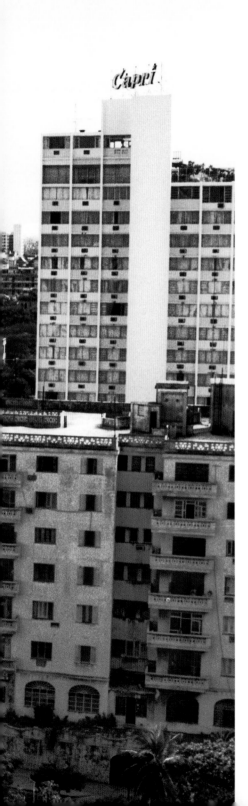

This Havana skyline view shows former casino locations popular in the late 1950s, the Habana Libre and Capri hotels. The Habana Libre hotel opened as the Habana Hilton in 1958, and was part of the American Hilton hotels chain. At the time, the hotel was known to be both the tallest and largest hotel in Latin America, with a Trader Vic's restaurant, supper club, pool, rooftop bar, and casino. Following Fidel Castro's revolutionary entry into Havana on January 8, 1959, the hotel became Castro's headquarters for three months while he also lived in one of the rooms. In 1960, after relations between Cuba and the US worsened, all American hotels became operated by the Cuban government, and Fidel Castro re-named the hotel Habana Libre (Free Havana). Today the hotels are operated by Spanish companies and are open to tourists.

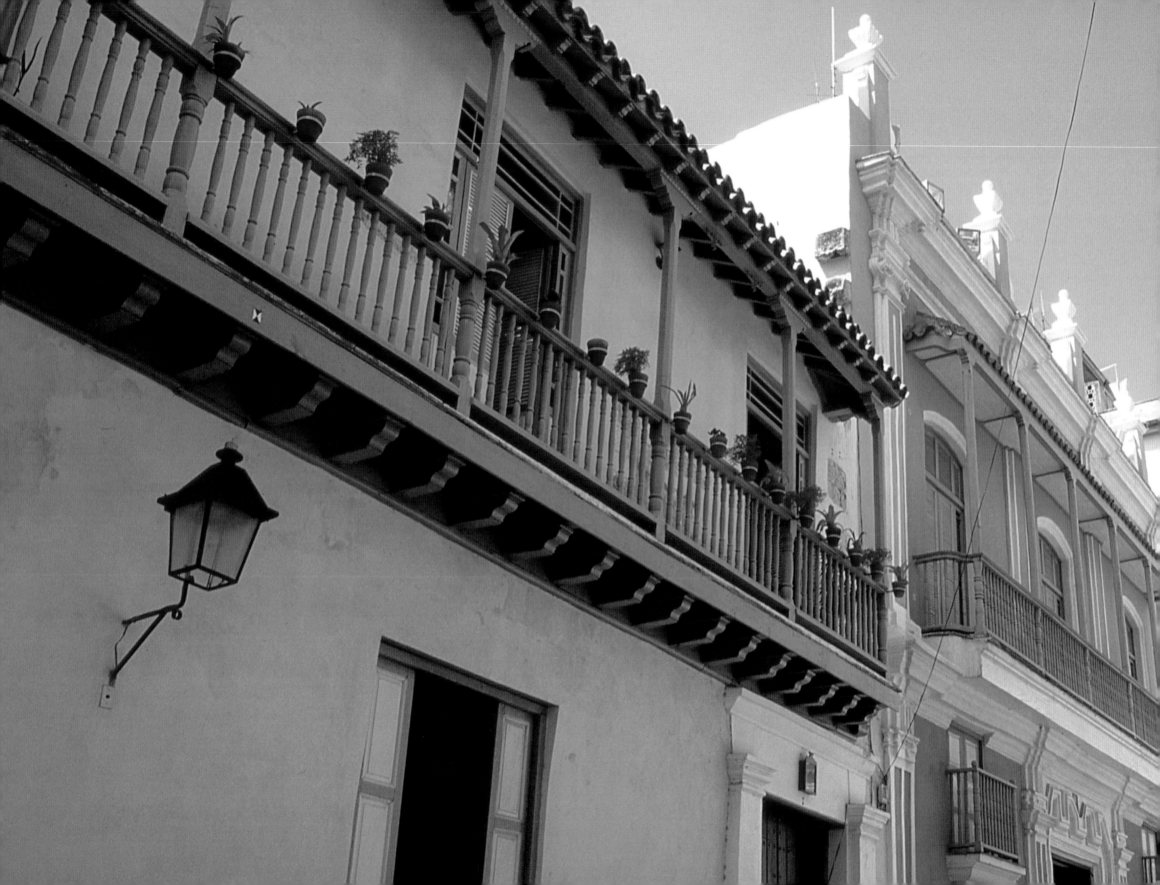

Founded in 1519 by the Spanish, Old Havana maintains a mix of Baroque and neoclassical monuments, and a homogeneous ensemble of private houses with arcades, balconies, wrought-iron gates, and internal courtyards. Designated a UNESCO World Heritage Site in 1982, subsequent funding has brought new energy, architectural rehabilitation, and increased tourism to the formerly decaying buildings of Havana's historic district and port.

Opposite: Old Havana view, with El Capitolio (the National Capitol Building), top right, under renovation.

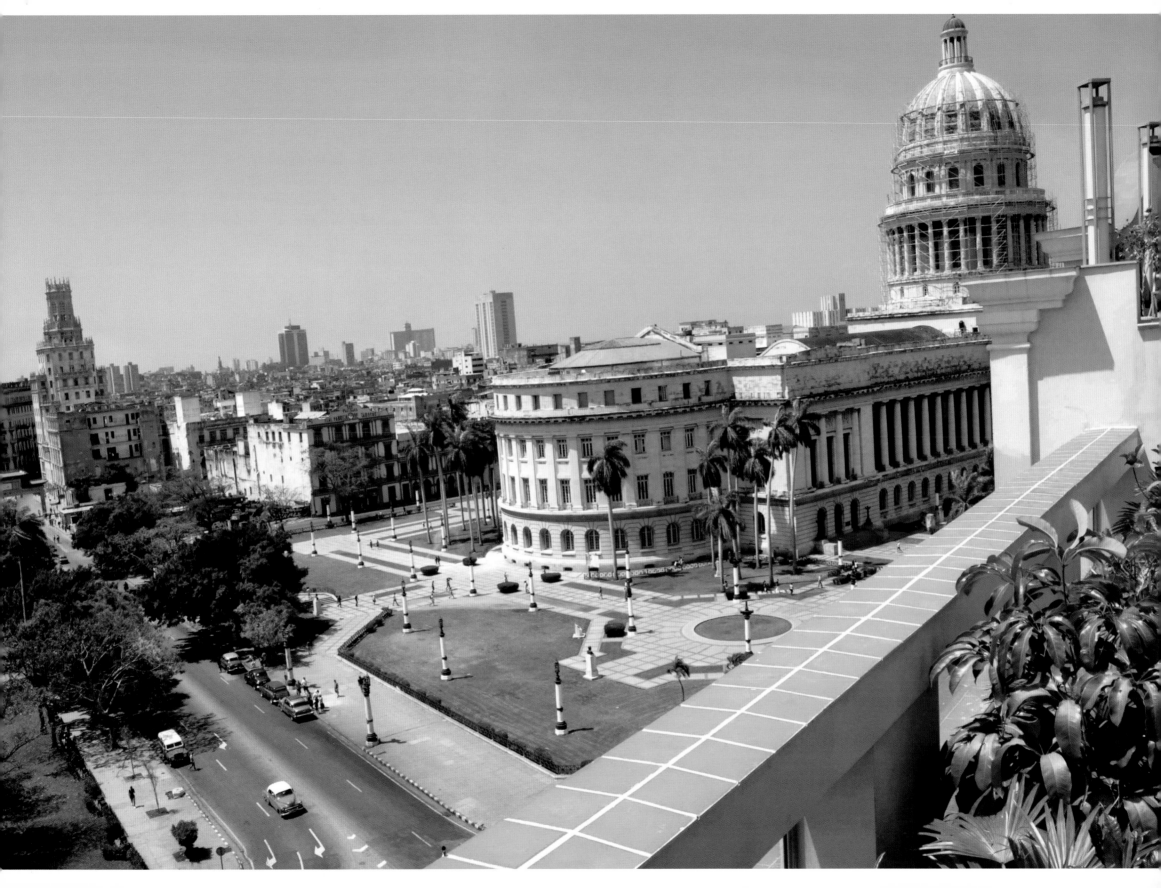

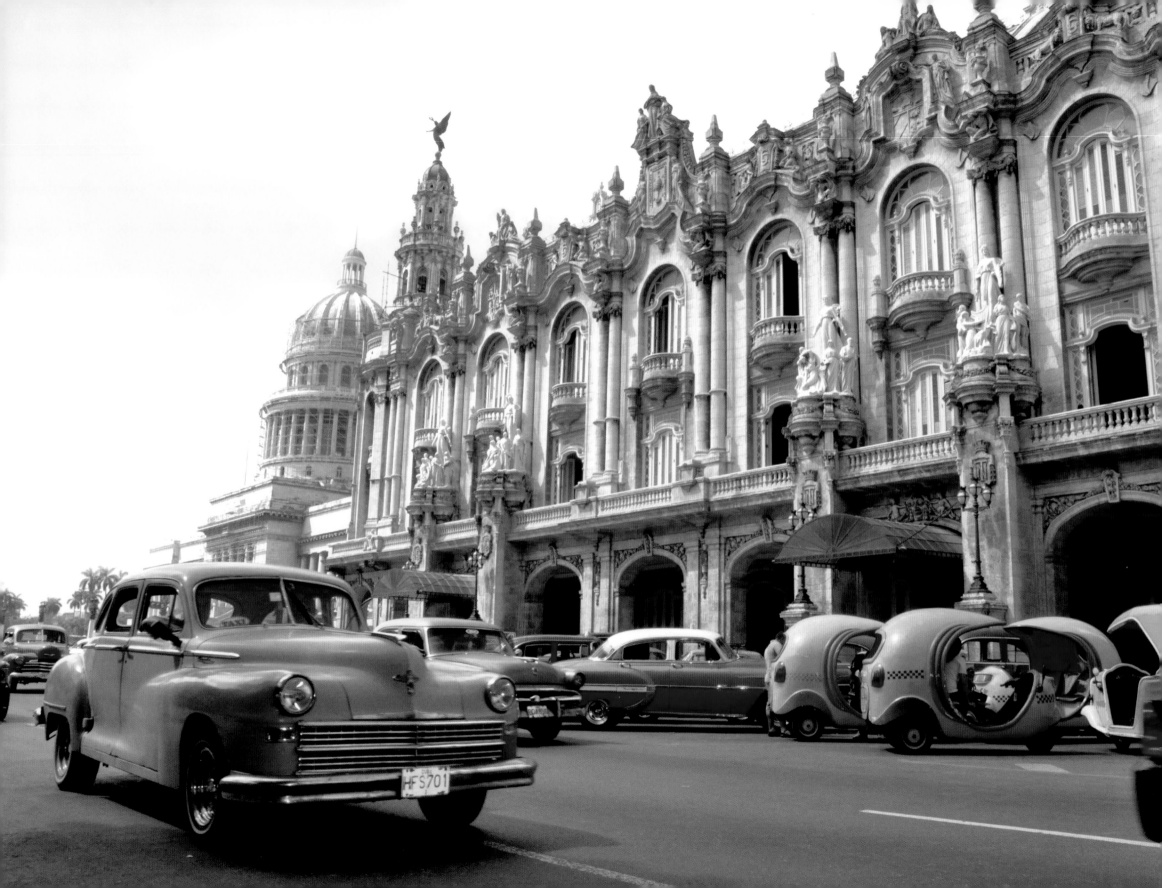

Opposite: Old American cars pass the Capitol building, under renovation, and the Grand Theater of Havana; others are parked next to modern yellow coco taxis.

El Gran Teatro de la Habana (The Great Theatre of Havana) was built as a social hall for immigrants from the Galicia region of Spain and opened in 1915 as the Palace of the Galician Centre. The theater is adorned with stone and marble sculptures by Giuseppe Moretti, representing allegories depicting benevolence, education, music, and theater. In 1985, Cuba's prima ballerina, Alicia Alonso, suggested that the government change the building's name to El Gran Teatro de la Habana. Its García Lorca Auditorium is the home location of many dance and opera performances.

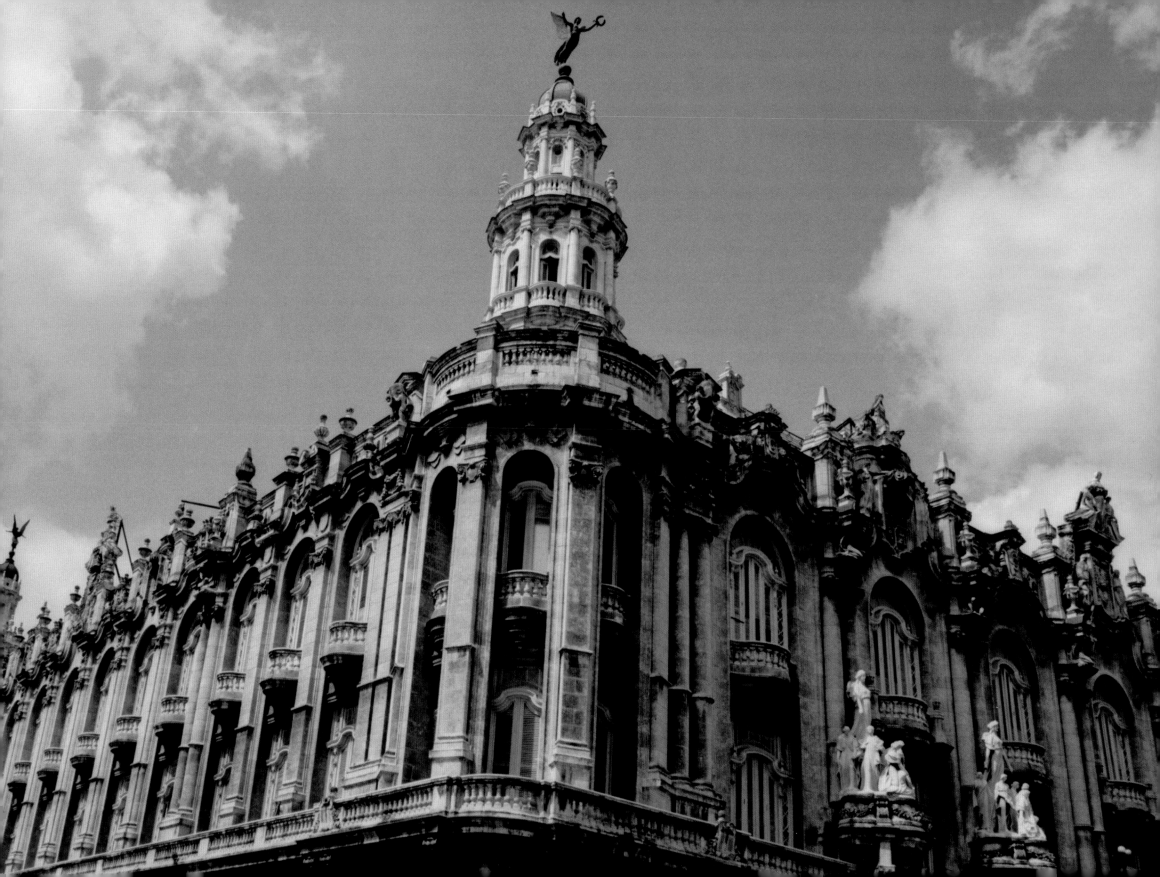

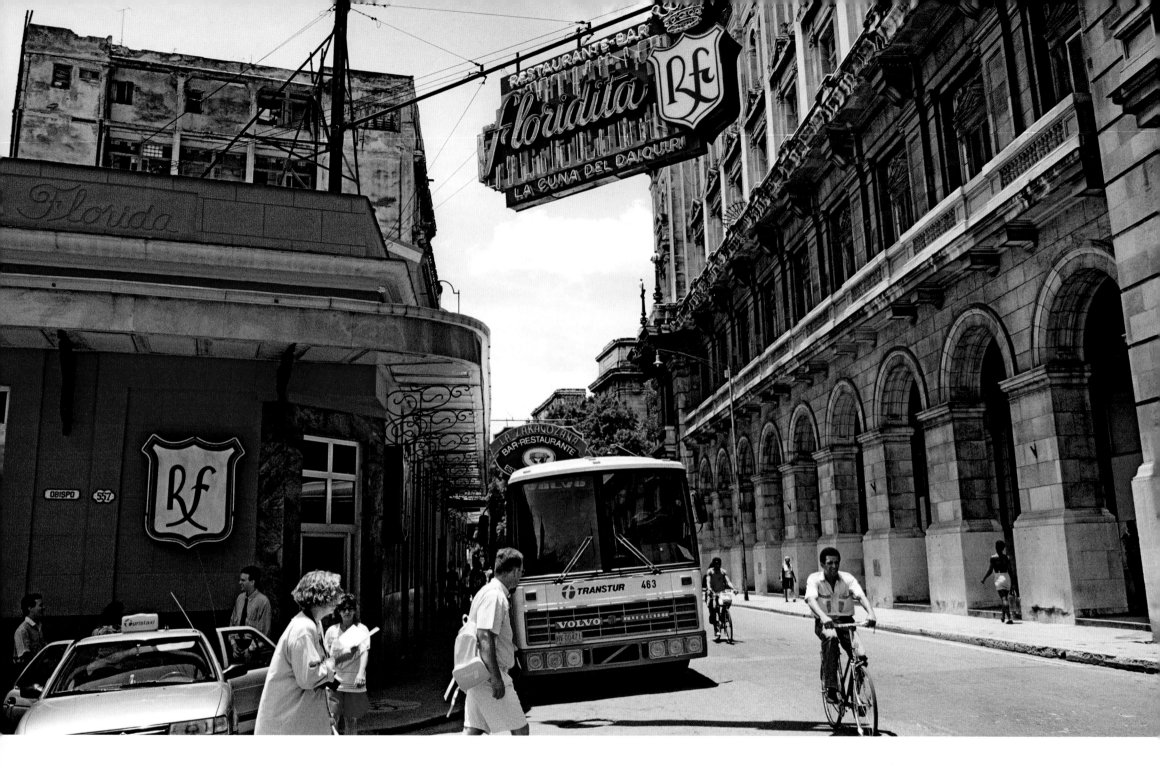

Havana's La Floridita was Ernest Hemingway's favorite bar for daiquiris and is now visited by tourists from around the world.
Opposite: La Floridita after renovation.

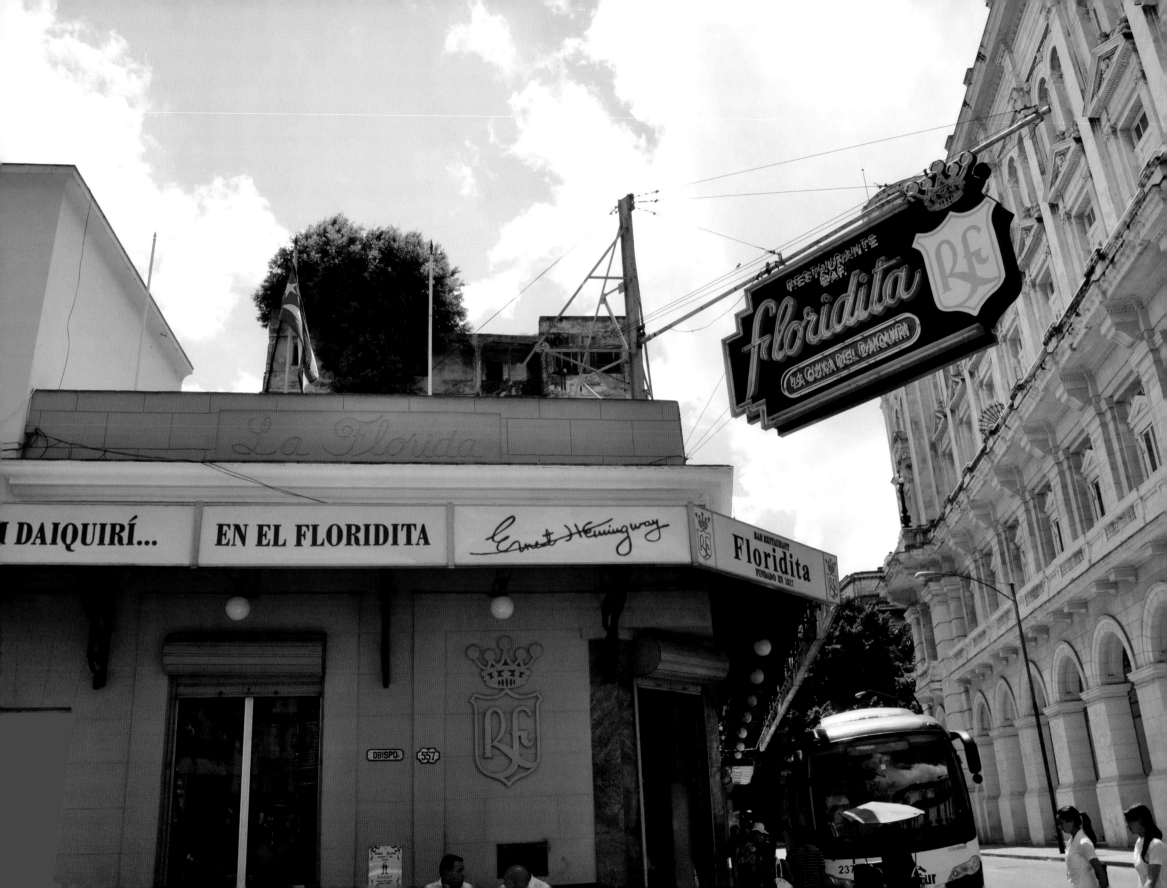

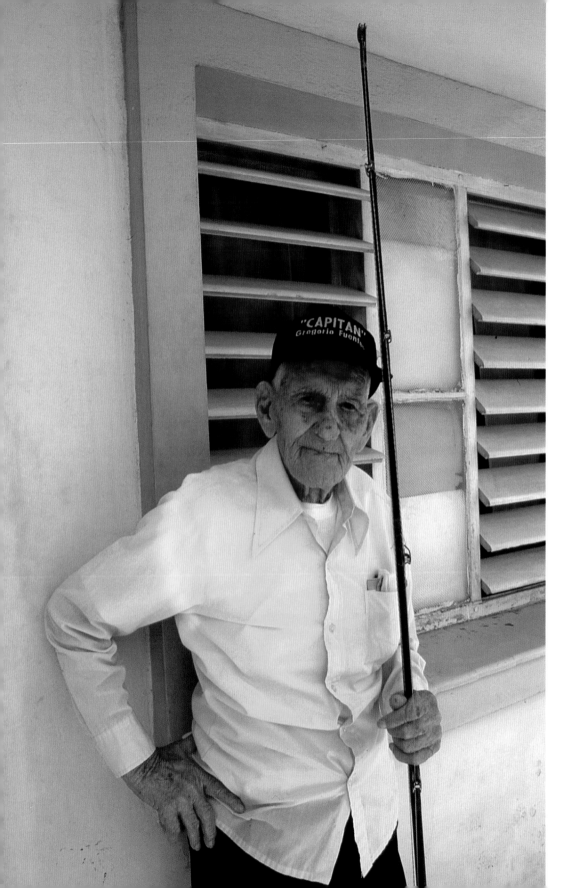

Gregorio Fuentes, the longtime captain of Hemingway's fishing boat, *Pilar*, and supposedly the inspiration for his novel *The Old Man and the Sea*.

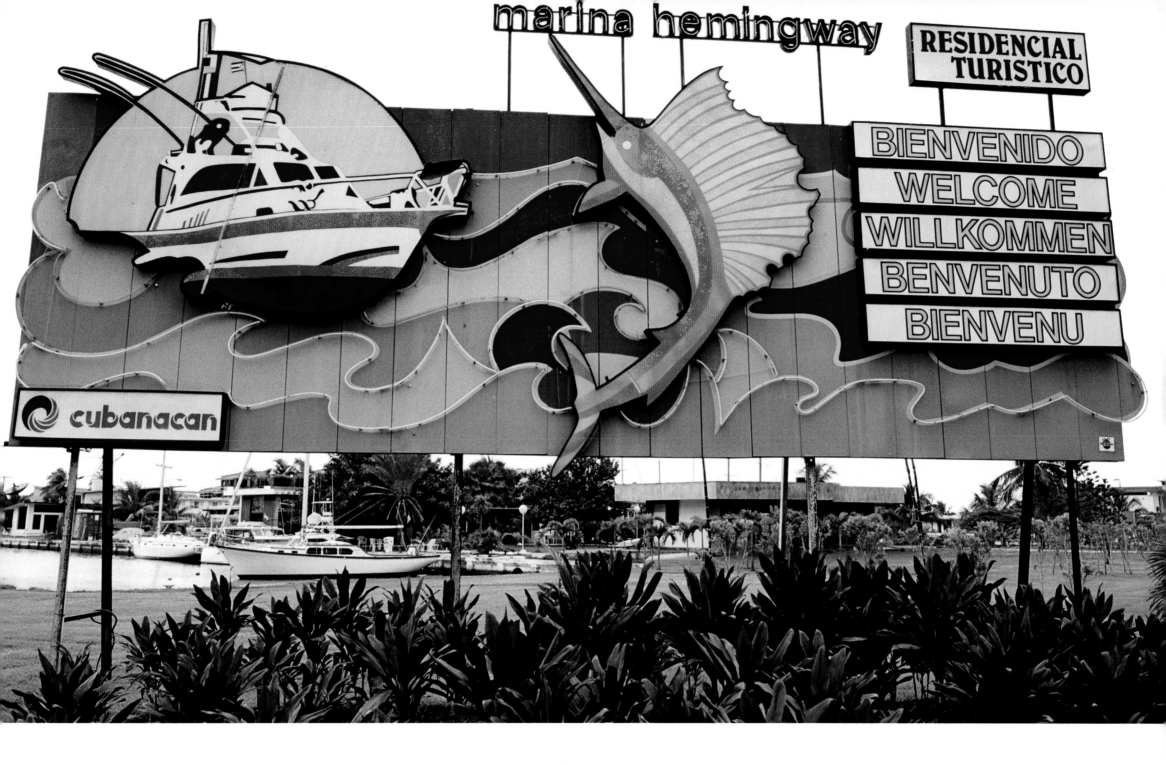

Formerly called the Marina Barlovento Complex, this Marina was built in 1953 as part of Havana's urban development plan of the time. After the revolution in 1959, the marina was nationalized and renamed the "Hemingway Marina," in honor of Ernest Hemingway who spent a lot of time in Cuba writing novels, including *The Old Man and the Sea*.

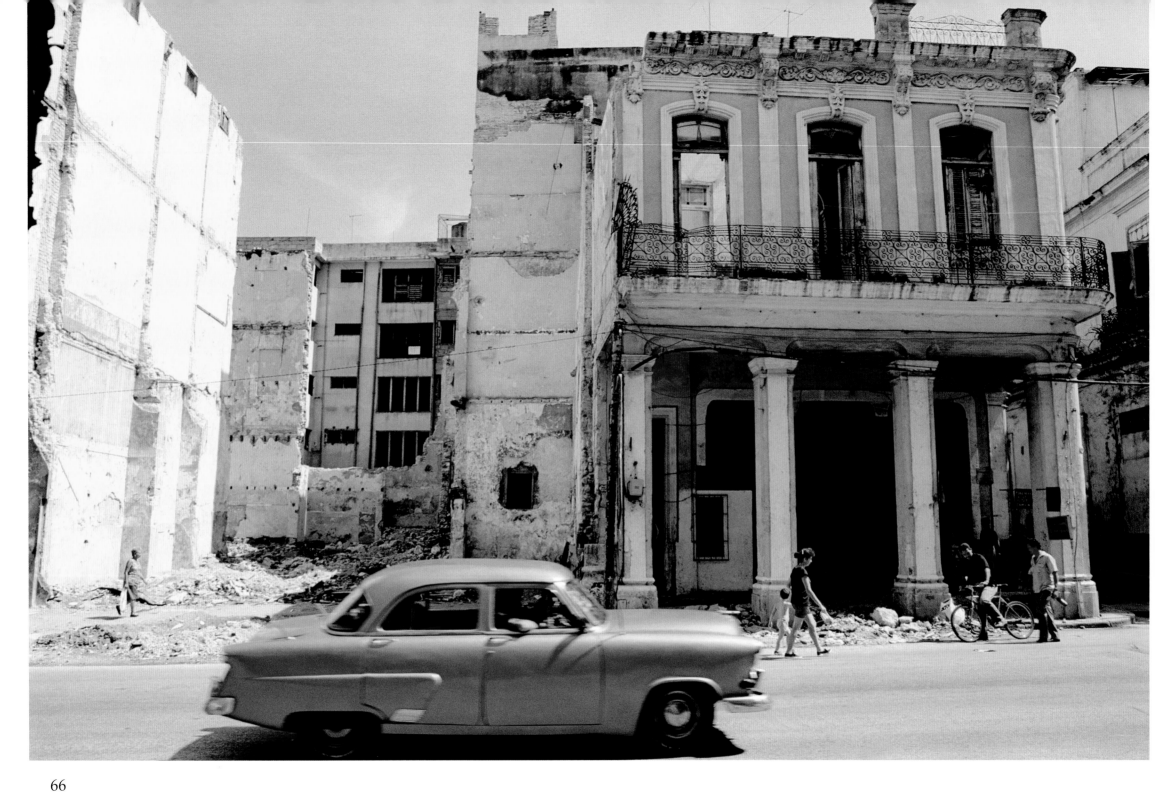

Many buildings collapse due to a lack of renovations or repairs, Havana.

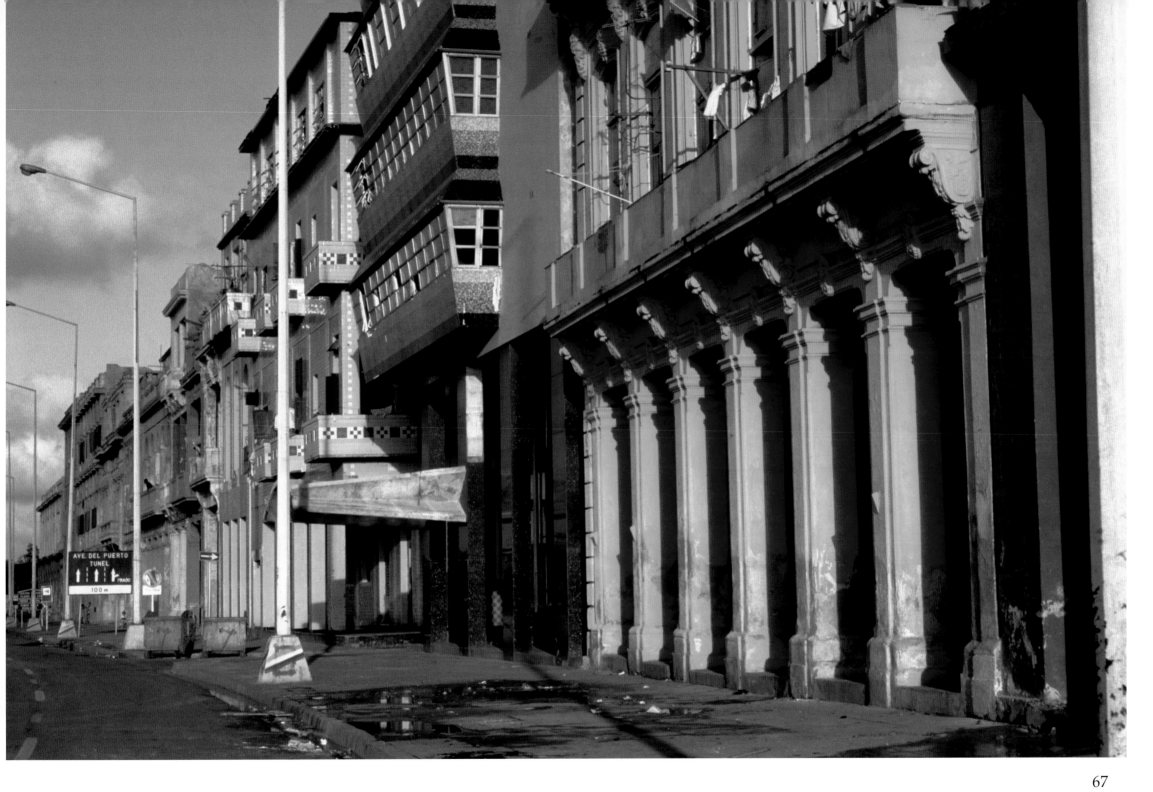

Pastel-colored houses at sunset along Havana's Malecón.

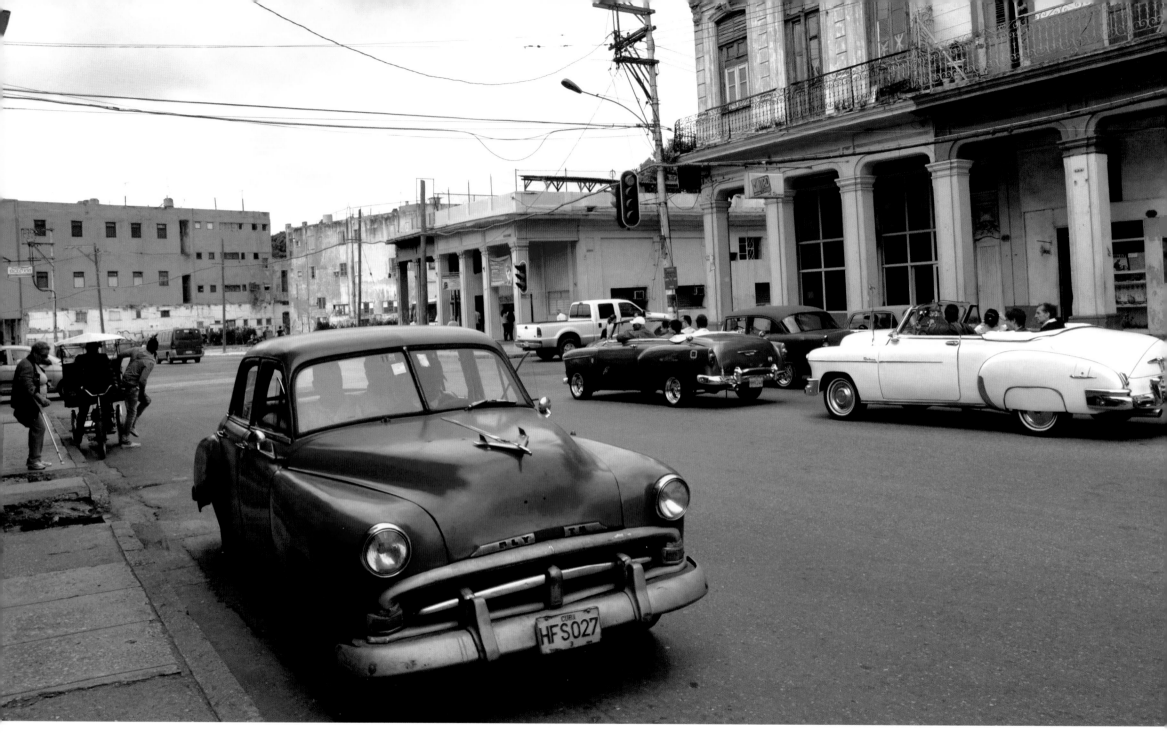

Calle Galiano, Havana.

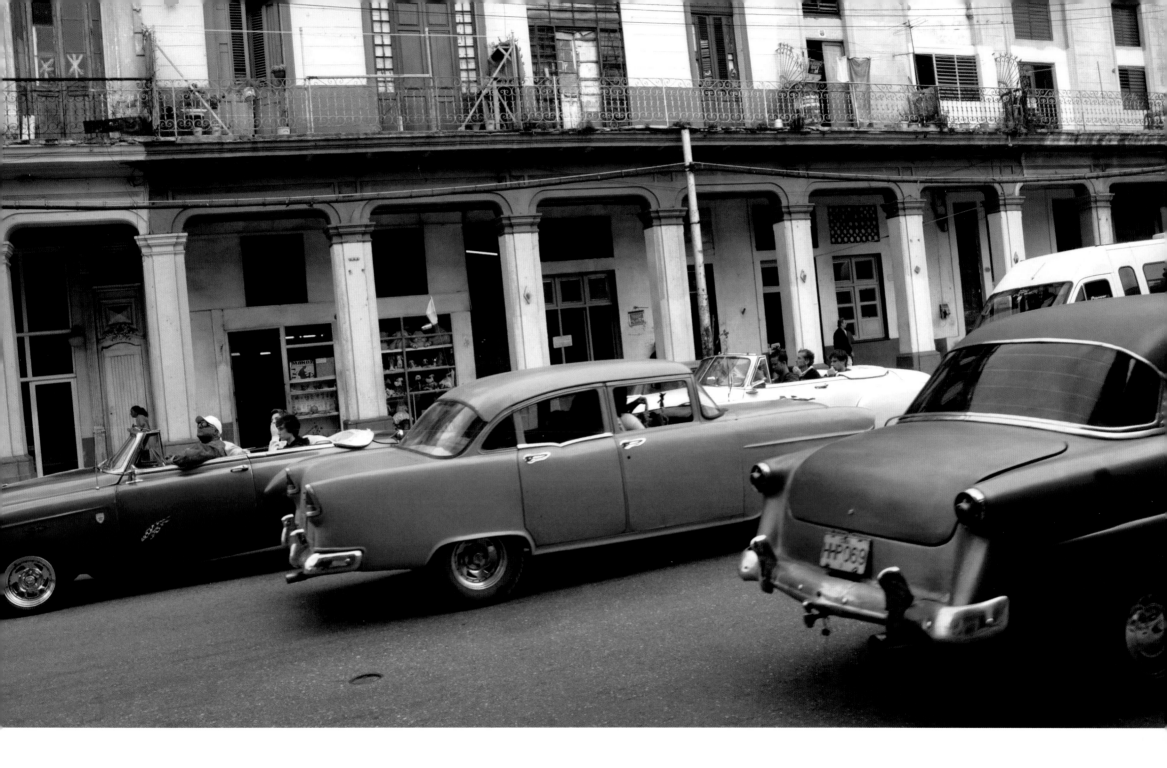

Newly renovated cars pass newly painted buildings in Havana.

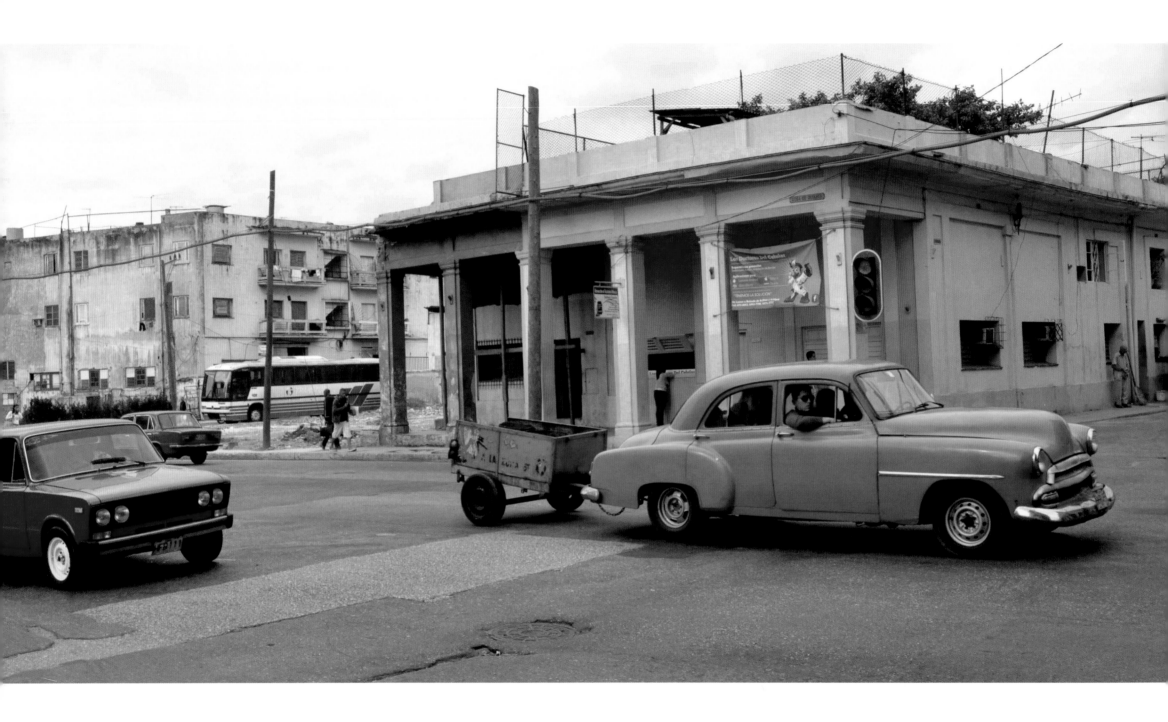

An old red Russian Lada car drives on the same road as an old green American car in Havana, showing the remnants of both the Russian and American influences in Cuban history. In the distance, a tour bus can be seen. Tourism has become the country's leading sources of revenue.

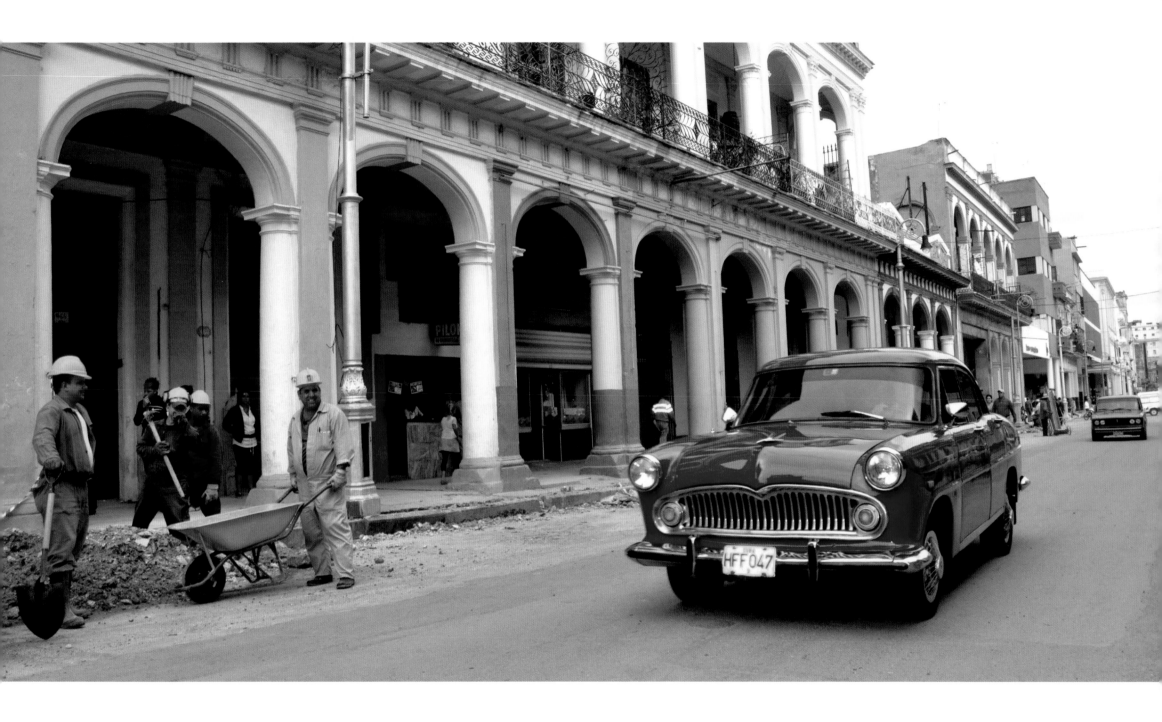

Maintaining the classic architecture and style while renovating the infrastructure of sewage on Calle Galiano in Havana.

The Caribbean Sea's shades of blue sparkle on the shores of Cuba's Varadero beach.

Opposite: Xanadú Mansion is now Club House of the Varadero Golf Club and has been refurbished, but its original design was maintained. The original owner of this exclusive estate was French-American millionaire Irénée du Pont, who had the mansion built in 1929 as his retirement home. The four-story mansion, with eleven bedrooms and adjoining baths, three large terraces, seven balconies, and a private dock, was named Xanadú after the exotic palace built by the legendary Chinese warrior and conqueror Kubla Khan, as described by the English poet Samuel Taylor.

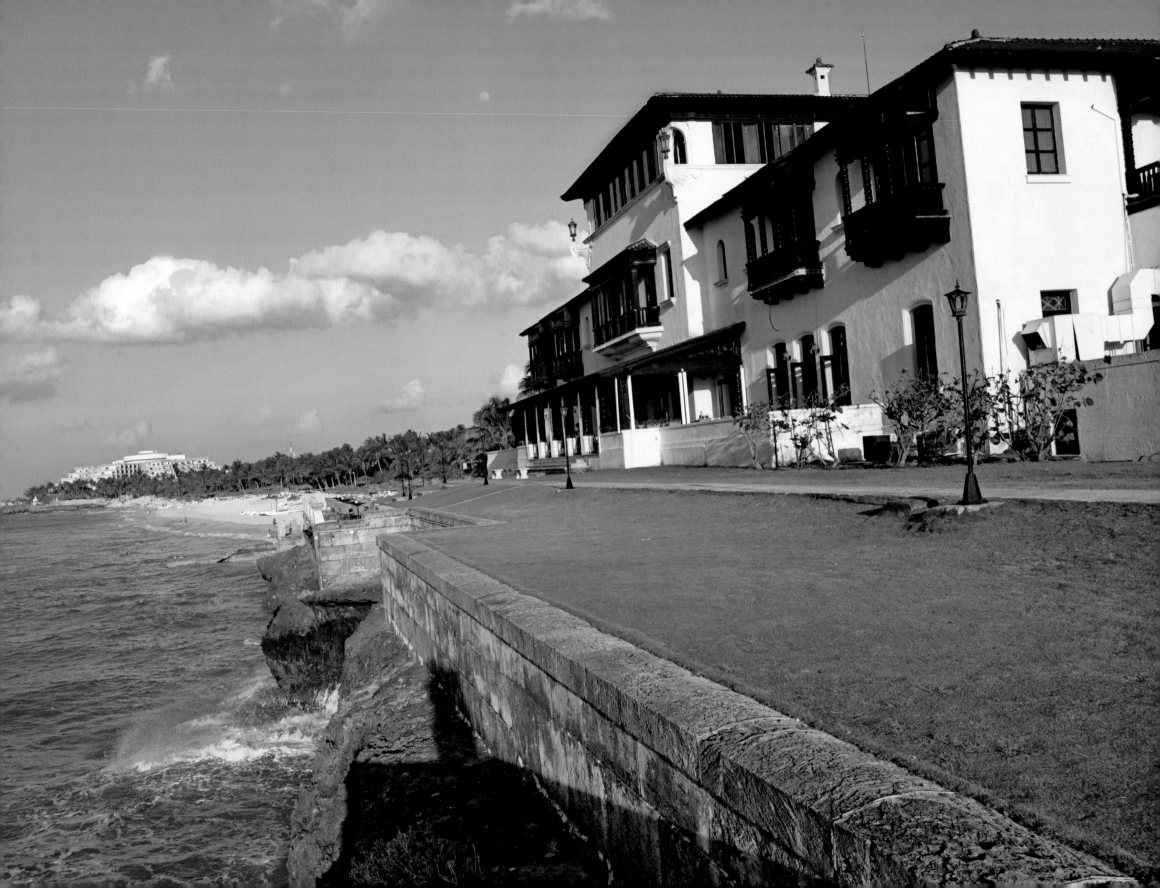

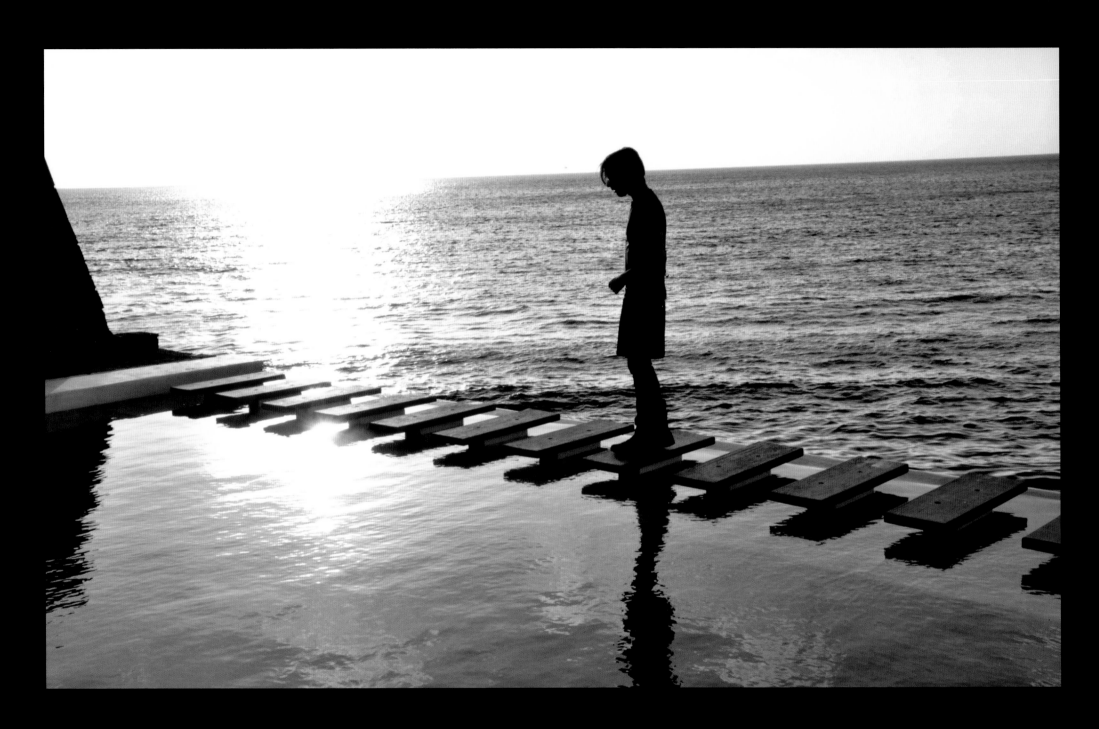

Paladar Vistamar, located in the Miramar neighborhood of Havana, on the sea.

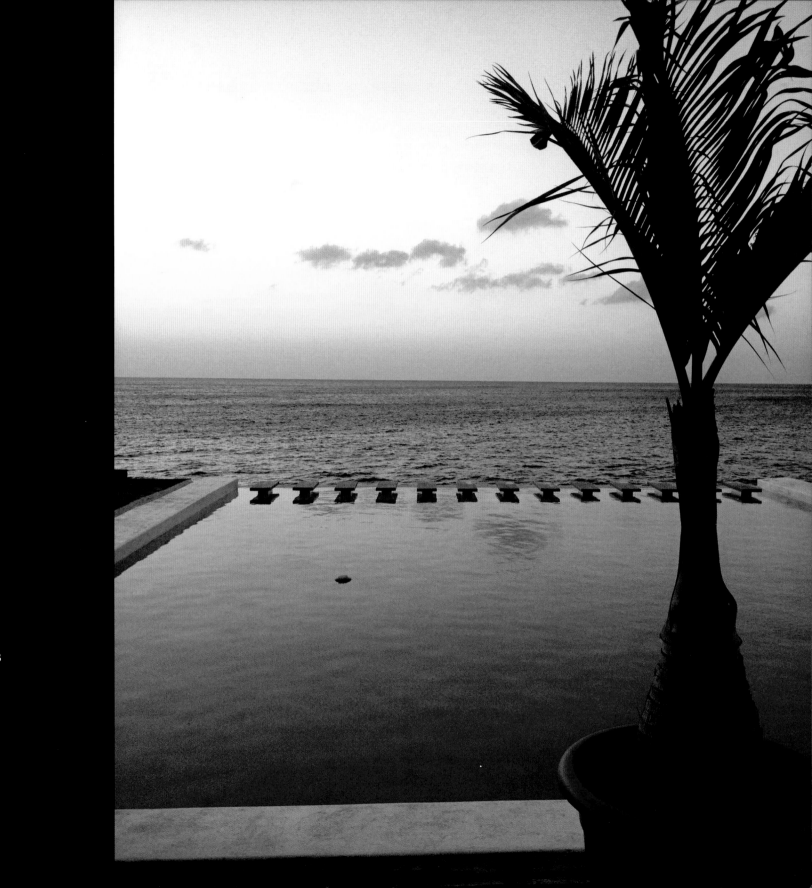

One of Havana's special *paladar* restaurants
in Miramar. These are usually family-run,
not state-run, businesses.

Pages 79–81: José Rodríguez Fuster, a Cuban painter of international renown, has been called the "Gaudi of Cuba," and the "Caribbean Picasso." In 1994, Fuster transformed his own house, in Jaimanitas, just outside Havana, with strategically placed mosaic tiles. Neighbors continually asked when he was going to tile their homes, and the project grew to include the entire neighborhood, which now attracts tourists from around the world who come to experience this colossal, colorful environment.

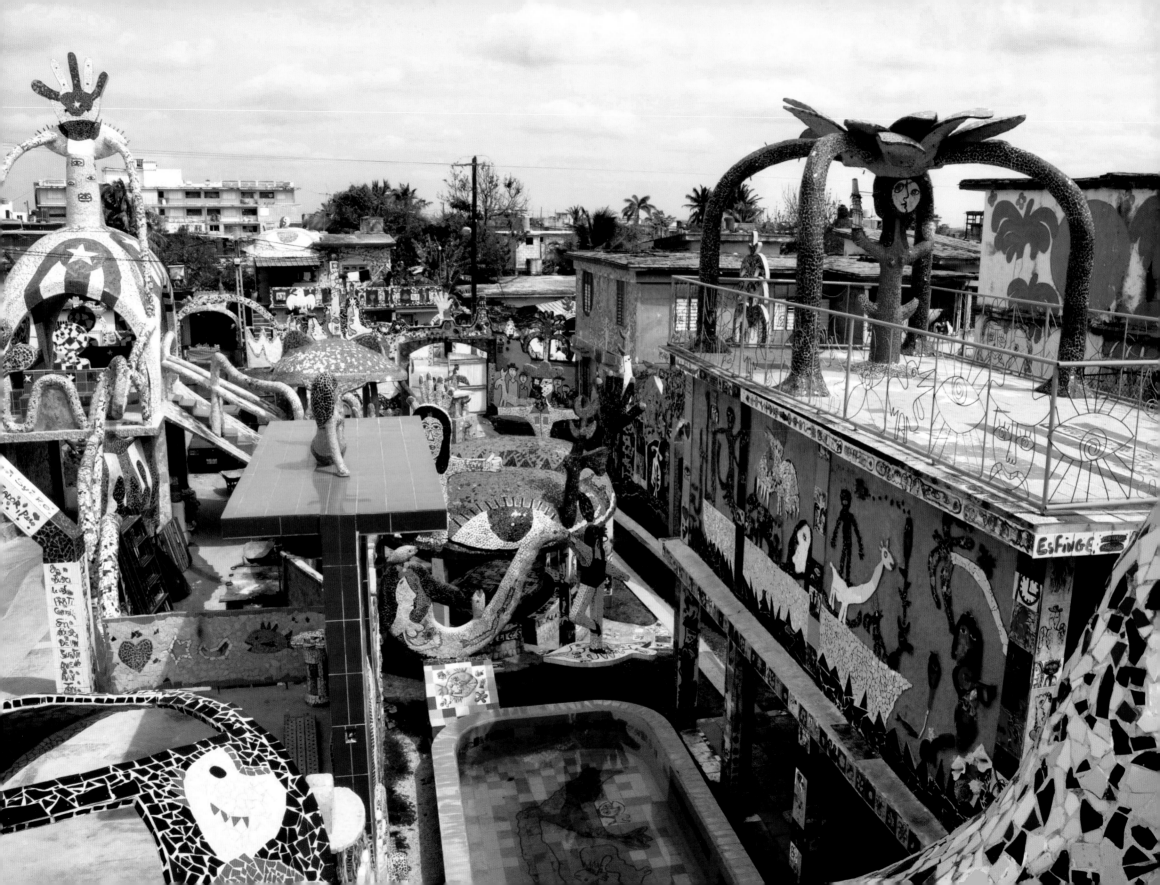

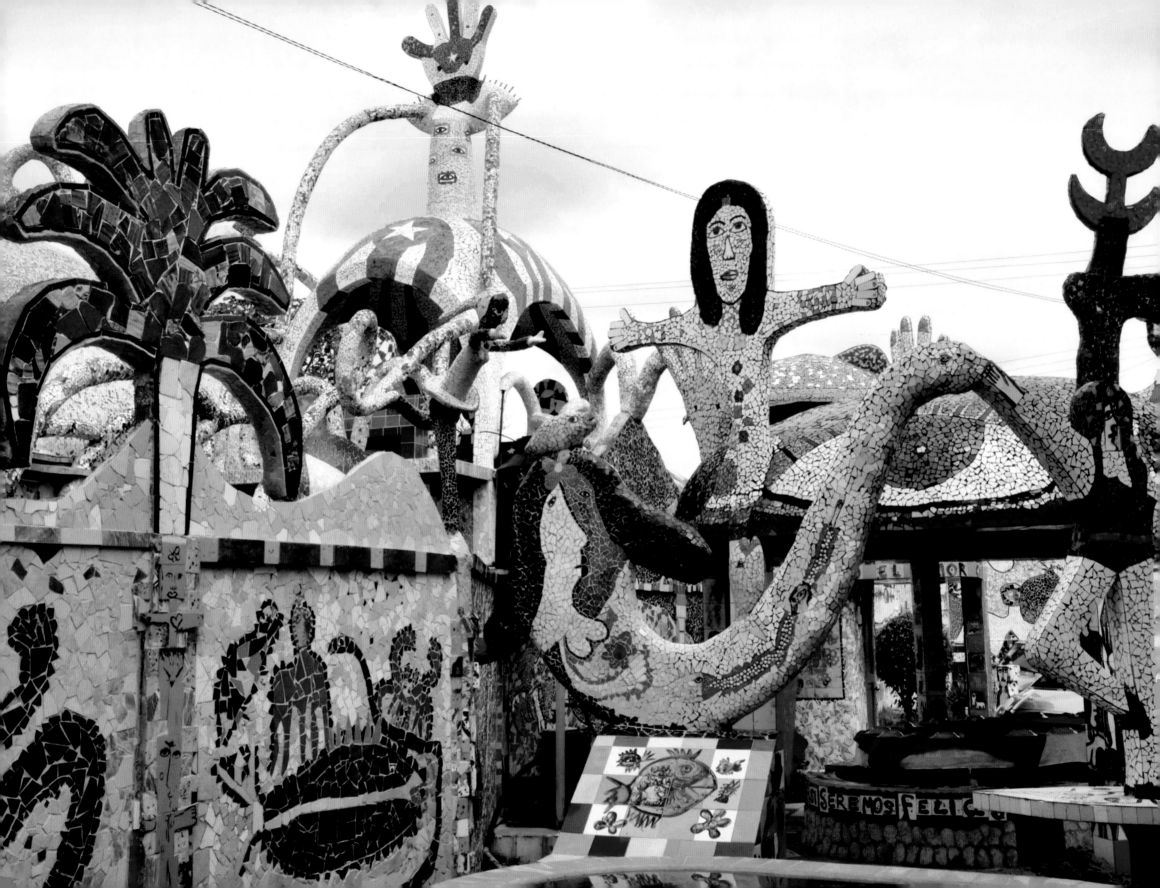

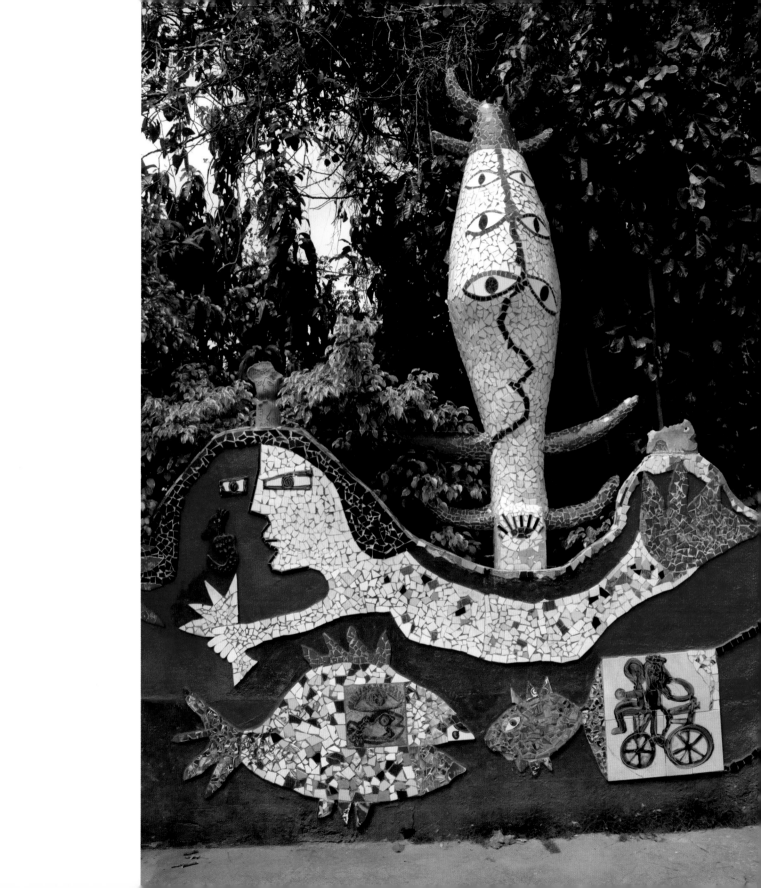

Opposite: Callejón de Hamel (Hamel's Alley) is in the Cayo Hueso neighborhood of Havana, where Cuban painter and muralist Salvador Gonzáles Escalona lives and continues his community project: an ever-changing and growing artistic celebration and expression of the Afro-Cuban culture. Salvador, as everyone calls him, began this socio-cultural project in 1990. His inspiration comes from his African heritage with a style that is a mix of cubism, surrealism, and abstraction. Salvador welcomes his neighbors to collaborate with him as they expand their remarkable and vibrant displays of sculptures, paintings, and murals to represent the symbols and stories of the African religions Santería and Palo Monte, and the Afro-Cuban men's group, the Abakuá society. On Saturday afternoons, the alley hosts a rumba party with traditional folkloric dancers performing, sharing, and teaching the dances of Cuba's orishas (the gods and goddesses of the Santería traditions originally from Yoruba in Africa and now practiced throughout Cuba). It is open to the public and always full of curious tourists from around the world who are welcomed by smiling local families and talented artists. Salvador's project has created a place where the local community can socialize, perform their Afro-Cuban music, and dance with foreigners who come to experience Cuba's unique spirit, music, talent, and traditions.

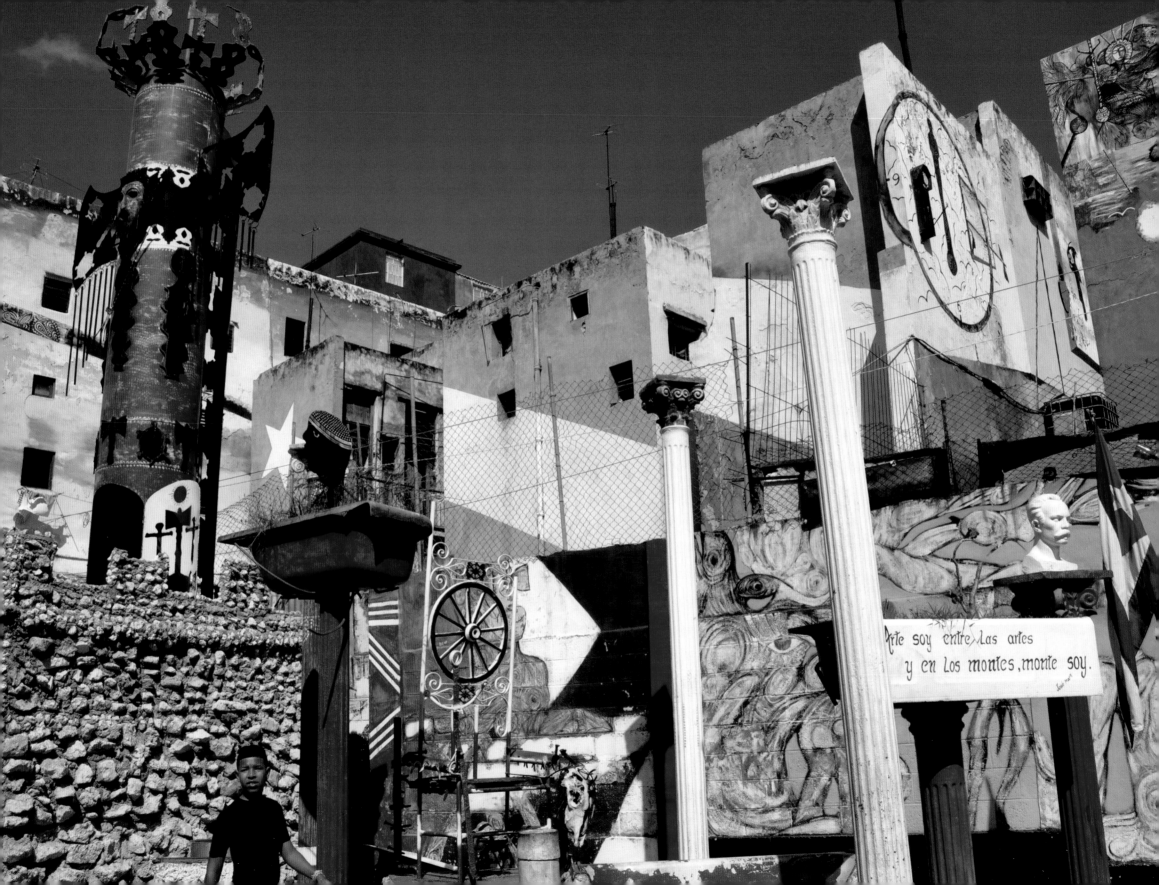

Arte soy entre las artes
y en los montes, monte soy.

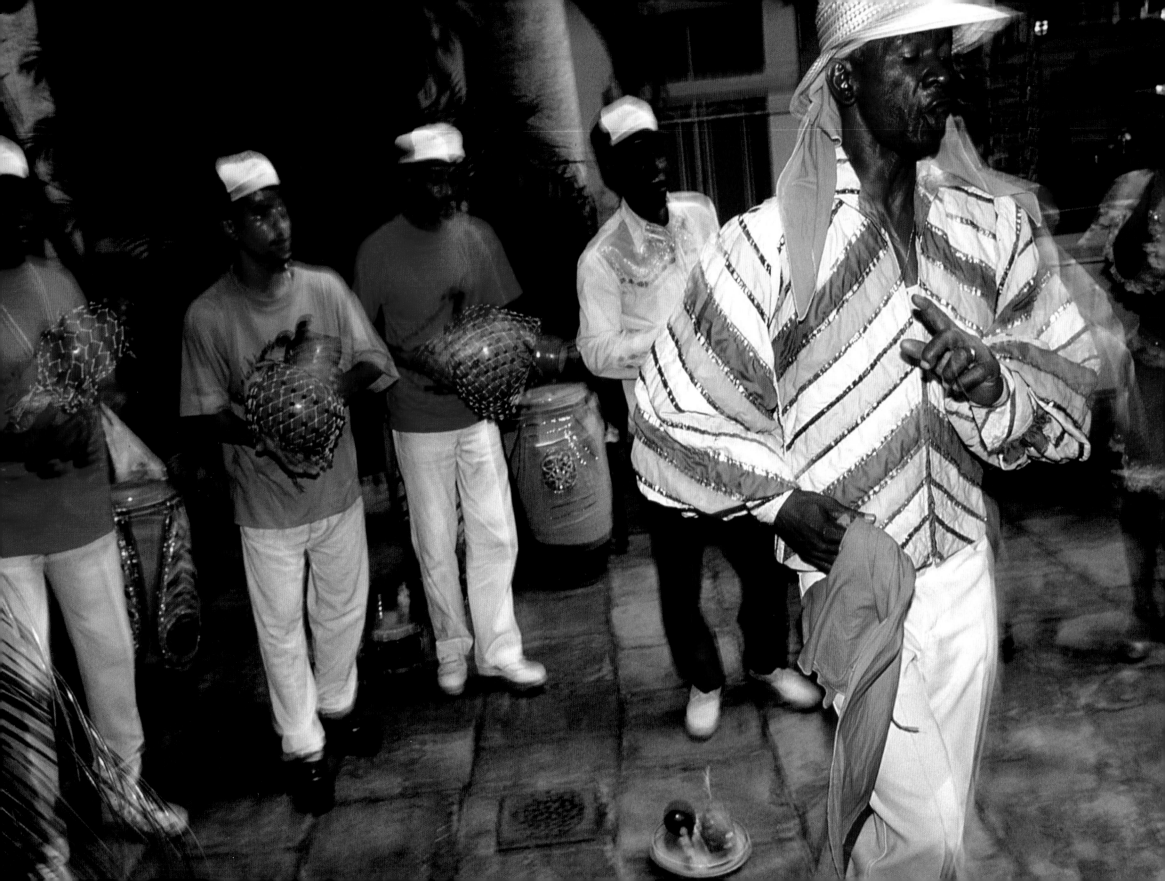

CHAPTER THREE

Stories in Motion / Cuentos en Movimiento

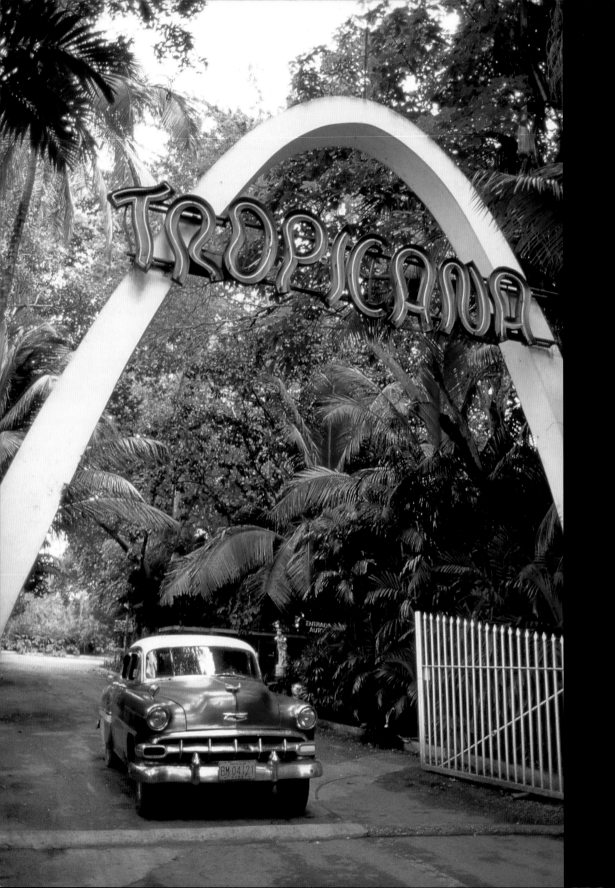

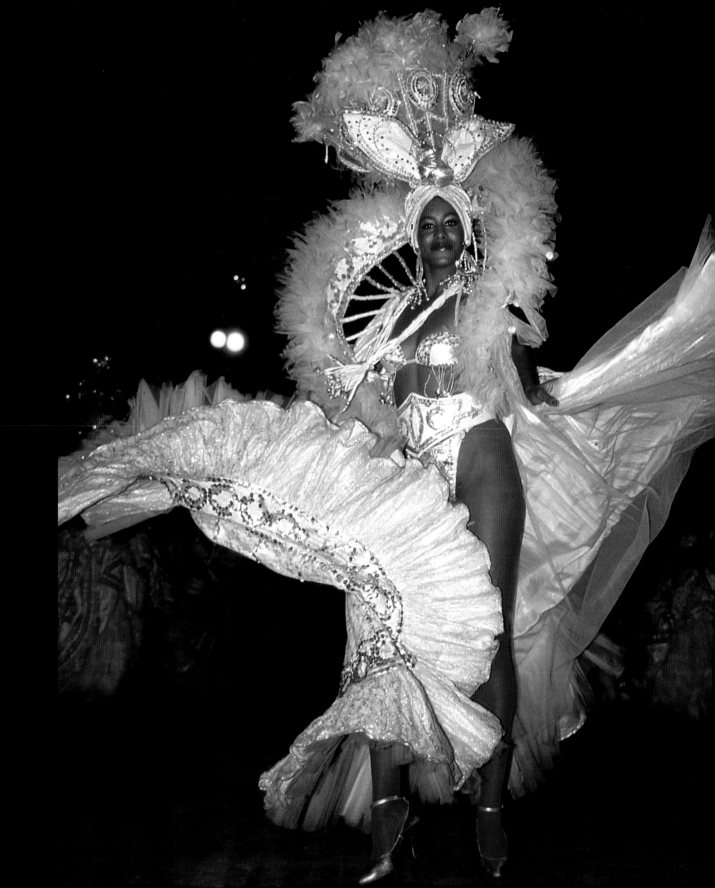

Entrance to the world renowned Tropicana Club, in Havana, which has been entertaining audiences since it opened in 1939. The club features musical theater, a large orchestra, and voluptuous showgirls wearing sensational sequined and feathered costumes, which were copied in cities such as Paris, Las Vegas, and New York.

Page 86: Dancers perform a traditional Santería dance for tourists in Havana.

Pages 89–93: Tropicana Club dancers representing different god and goddesses of the Santería belief.

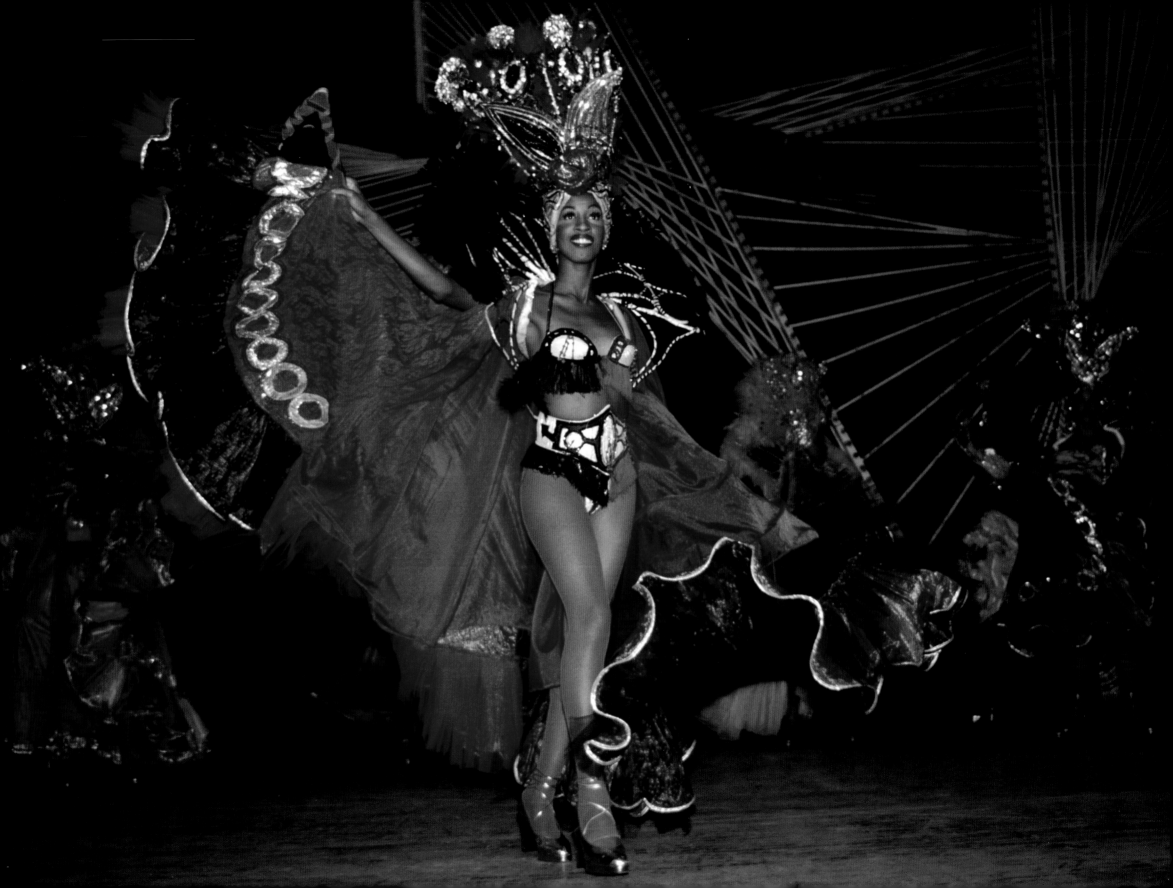

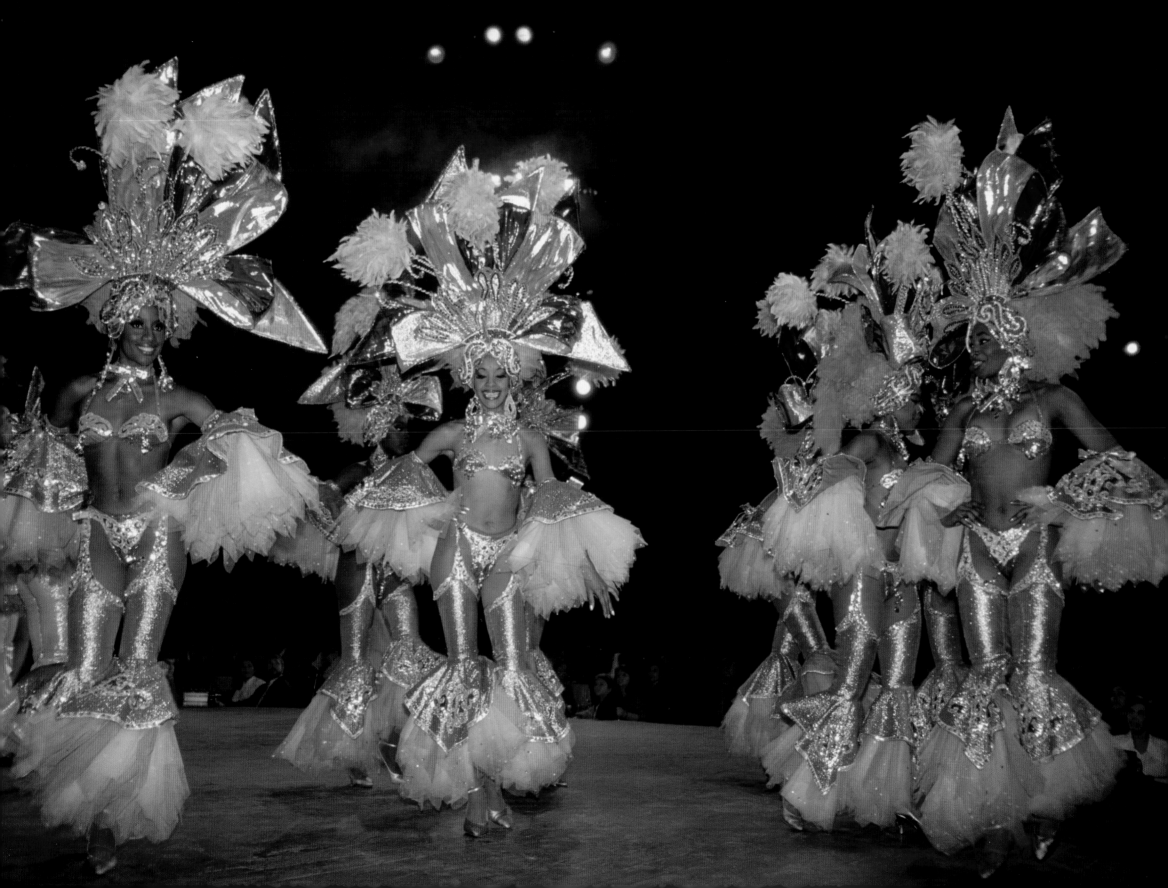

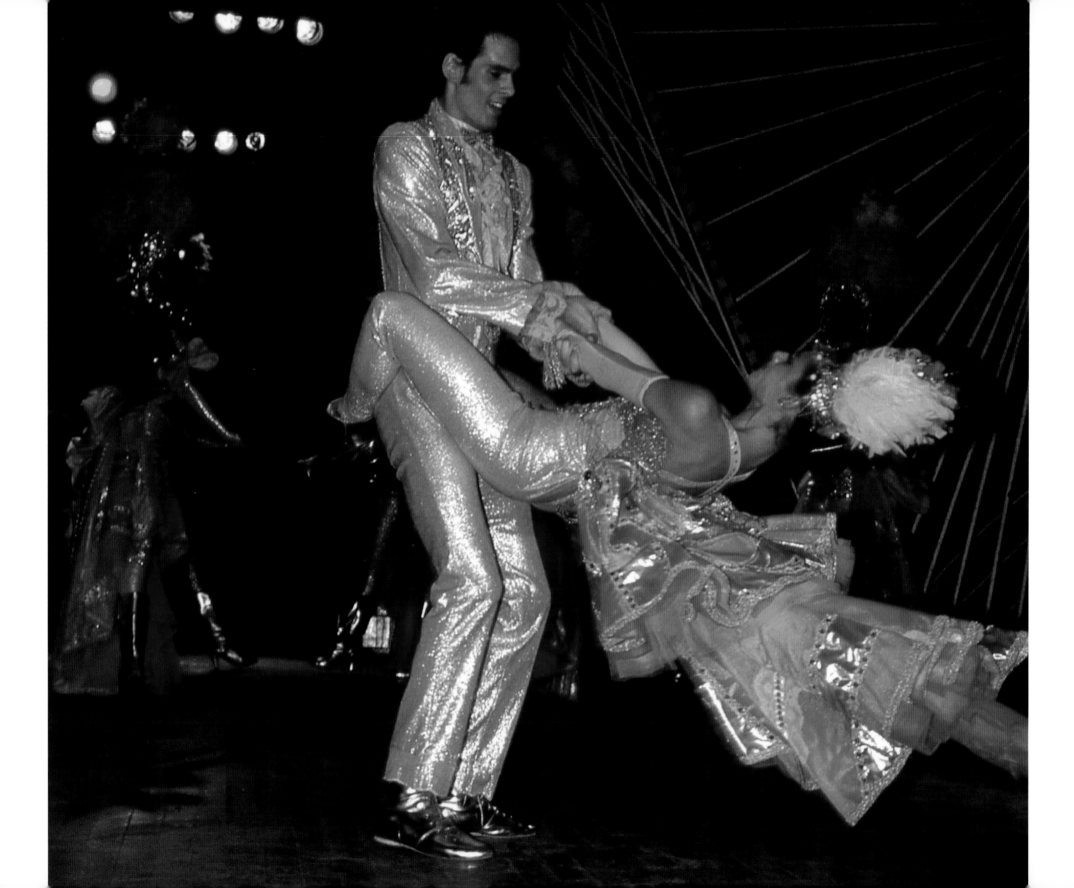

Ritmo Cubano (Cuban Rhythm), a bronze sculpture by Cuban artist Florencio Gelabert, in the lobby of the Hotel Riviera in Havana. Commissioned by the hotel's original owner, mob leader Meyer Lansky, who built the resort envisioned as the "Riviera of the Caribbean," in 1957. The artwork was planned to connote the energy and excitement of the entertainment and activity around the resort hotel.

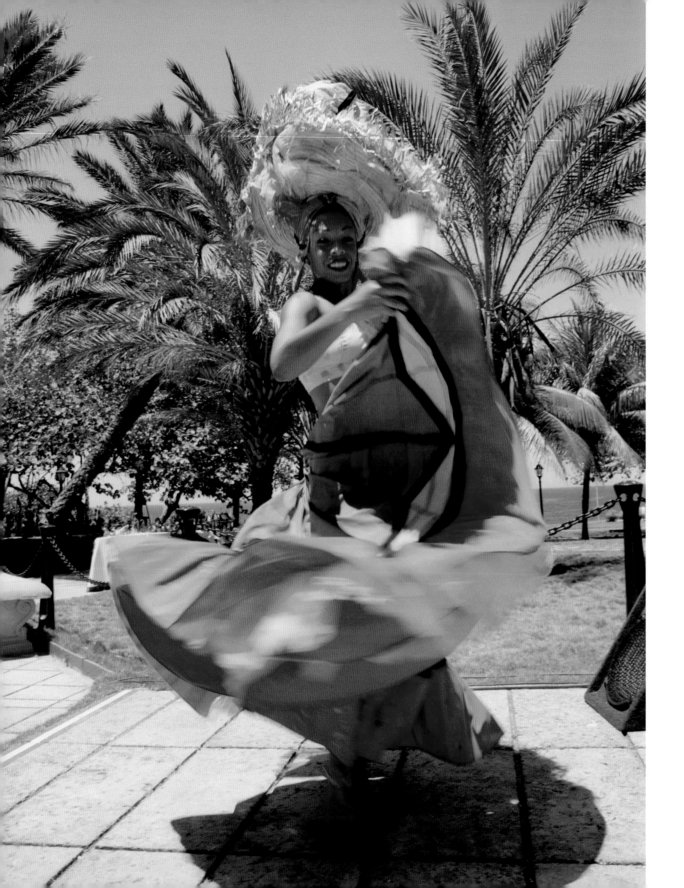

A folkloric dancer performs for tourists at the Hotel Nacional in Havana.

Ochumaré, an African word meaning "passion," is the name of this ensemble of dancers who interpret traditional Yoruban folklore in Cuba. Vibrant colors and symbols are hand-painted onto the skin of these exotic women by the Afro-Cuban artist Manuel Mendive. Each dancer represents a different god or goddess of the Santería tradition as they perform modern dances with mysterious, provocative movements to old African drum rhythms.

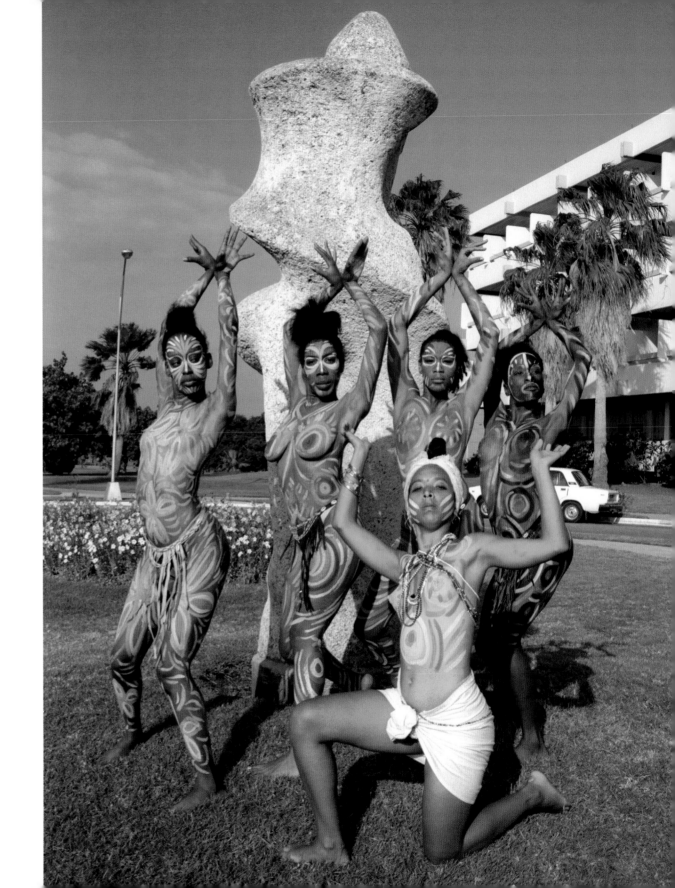

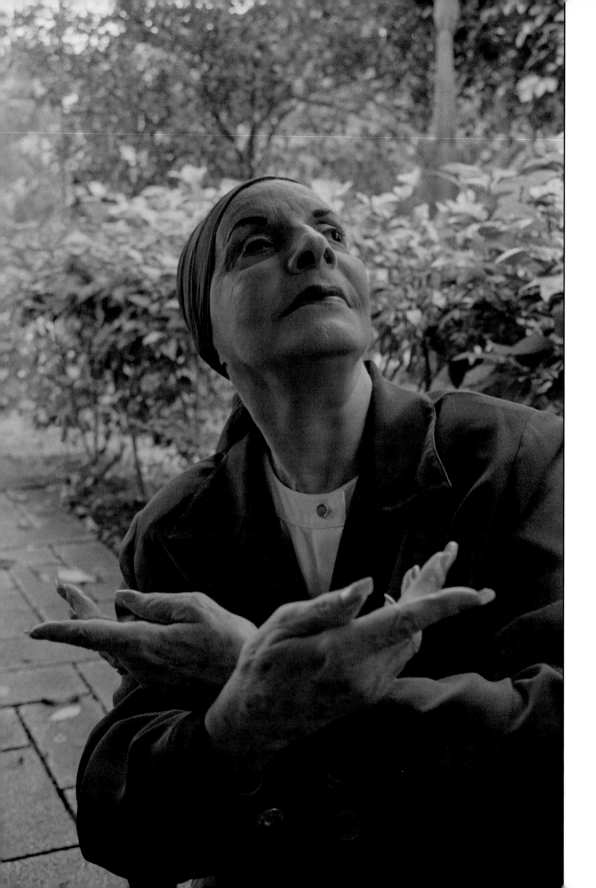

Prima ballerina, choreographer, and founder and director of Ballet Nacional de Cuba, Alicia Alonso poses at home in Havana, with her hands like a swan alluding to the famous ballet *Swan Lake*.

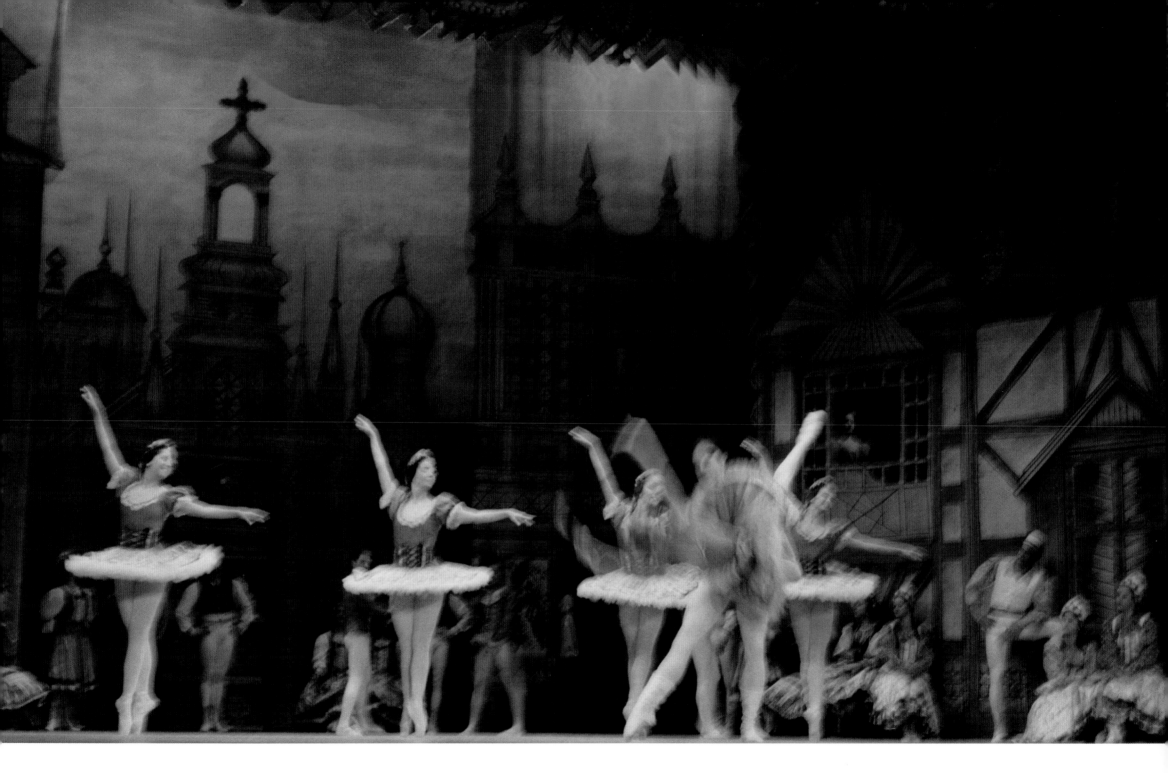

The Cuban National ballet performs *Coppélia* on its home stage in the Grand Theatre of Havana.

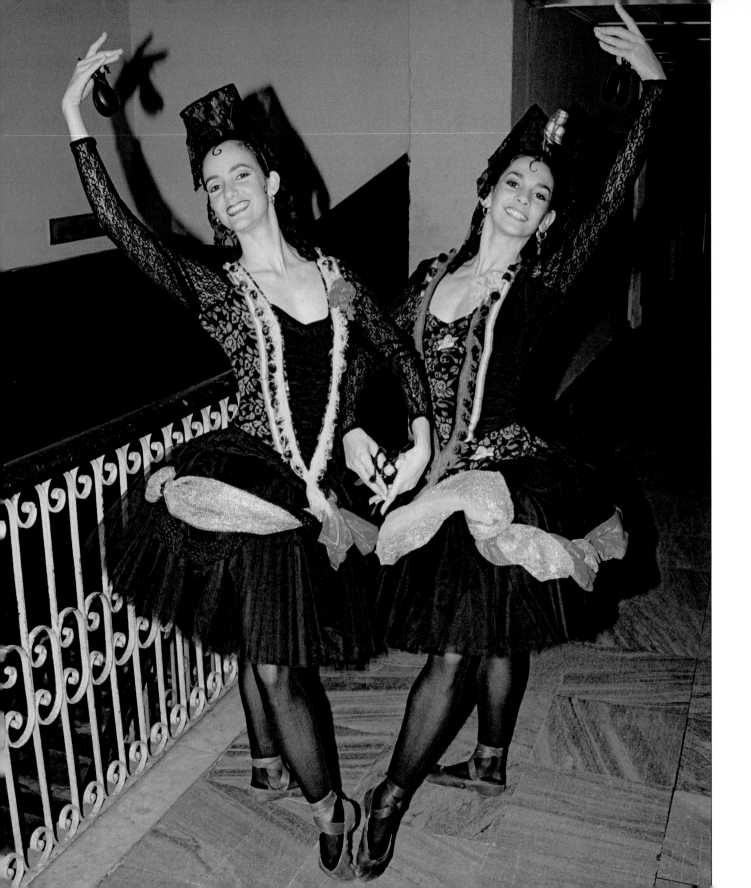

Dancers from the Cuban National Ballet pose
backstage at the Grand Theatre of Havana,
wearing their costumes from the famous
ballet *Carmen*.

Opposite: *Coppélia*.

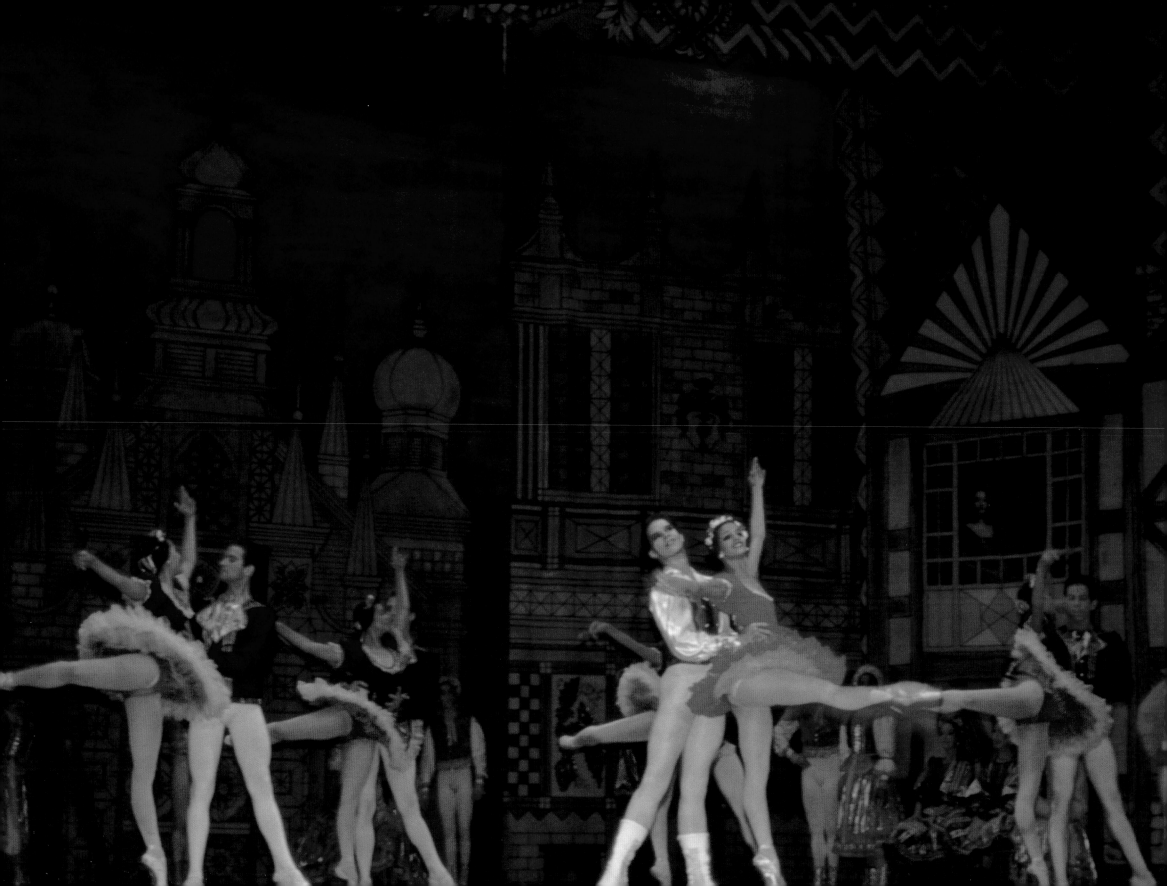

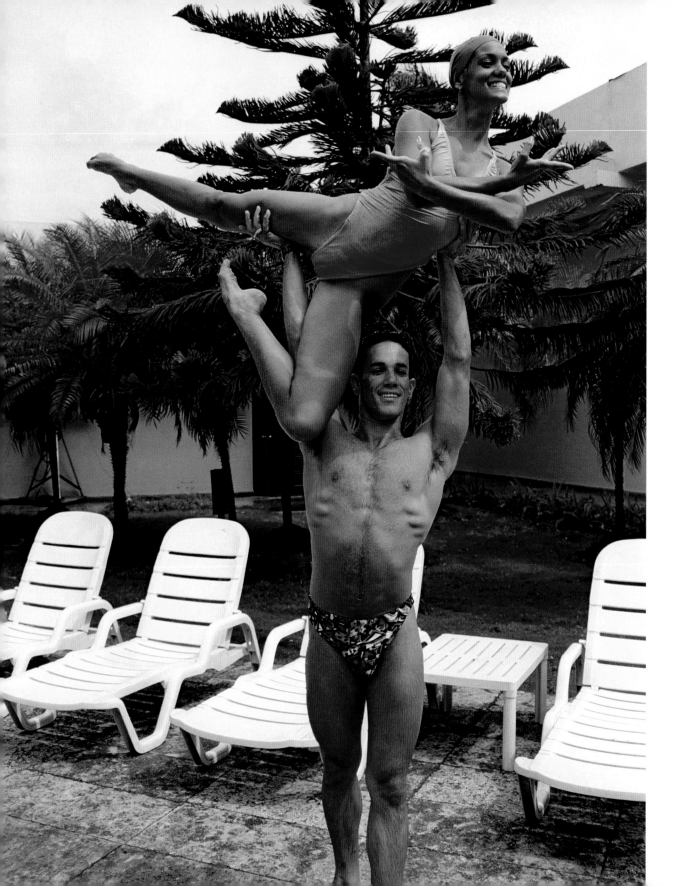

Here and opposite: Dancers from Cuba's water ballet team pose for a photo during a break from practicing their routine.

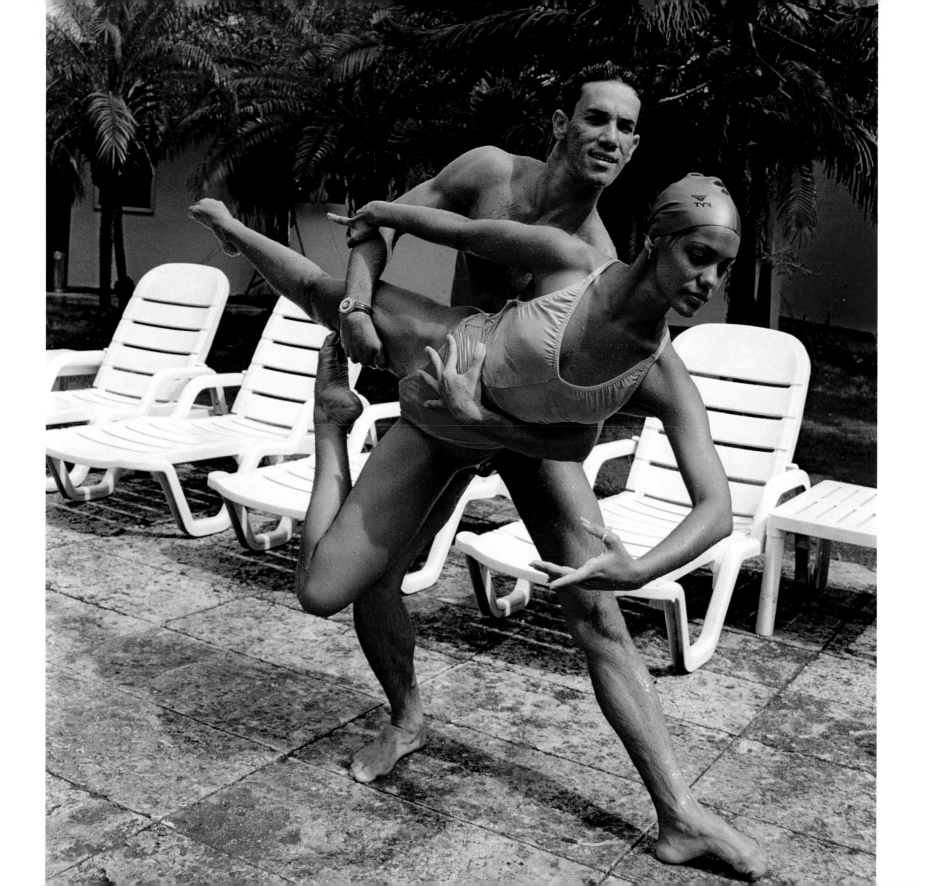

CHAPTER FOUR:

Embargo / El Bloqueo

Page 102: A government-owned clothing store, where Cubans can get clothes with their ration books or pesos, in San Antonio de los Baños.

Opposite: A logo for the technology company Apple on an old American car, now used as a taxi in Havana. Apple products cannot be purchased in Cuba due to the US economic embargo. Nonetheless, the Apple logo sticker is the new status symbol in Havana.

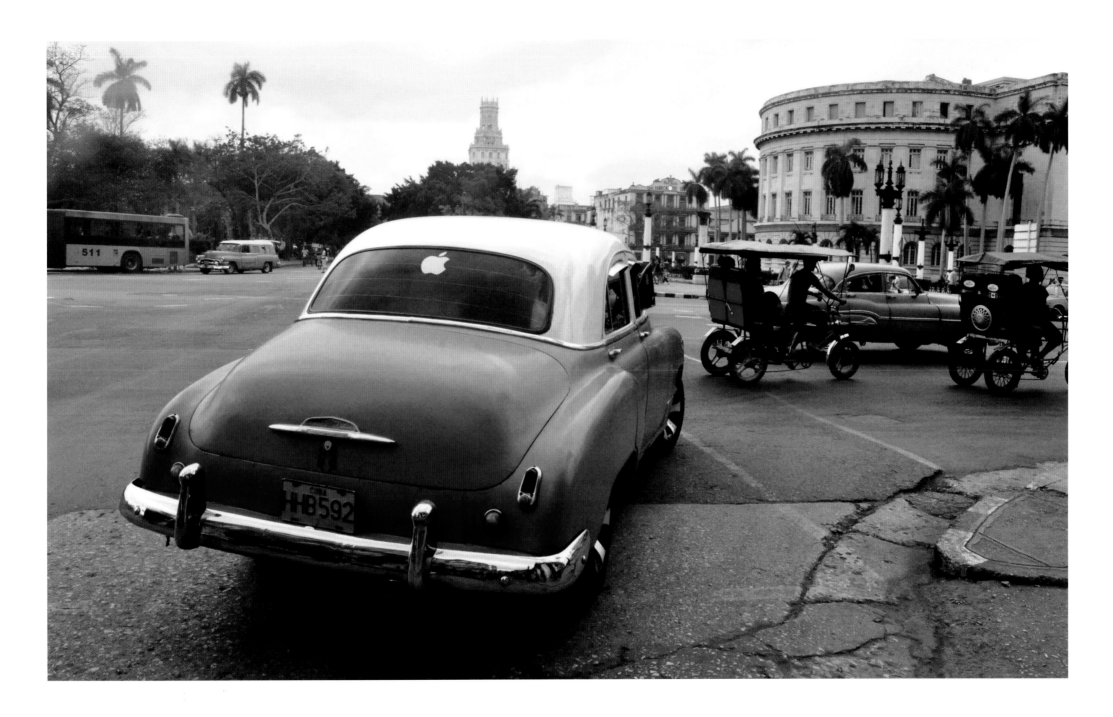

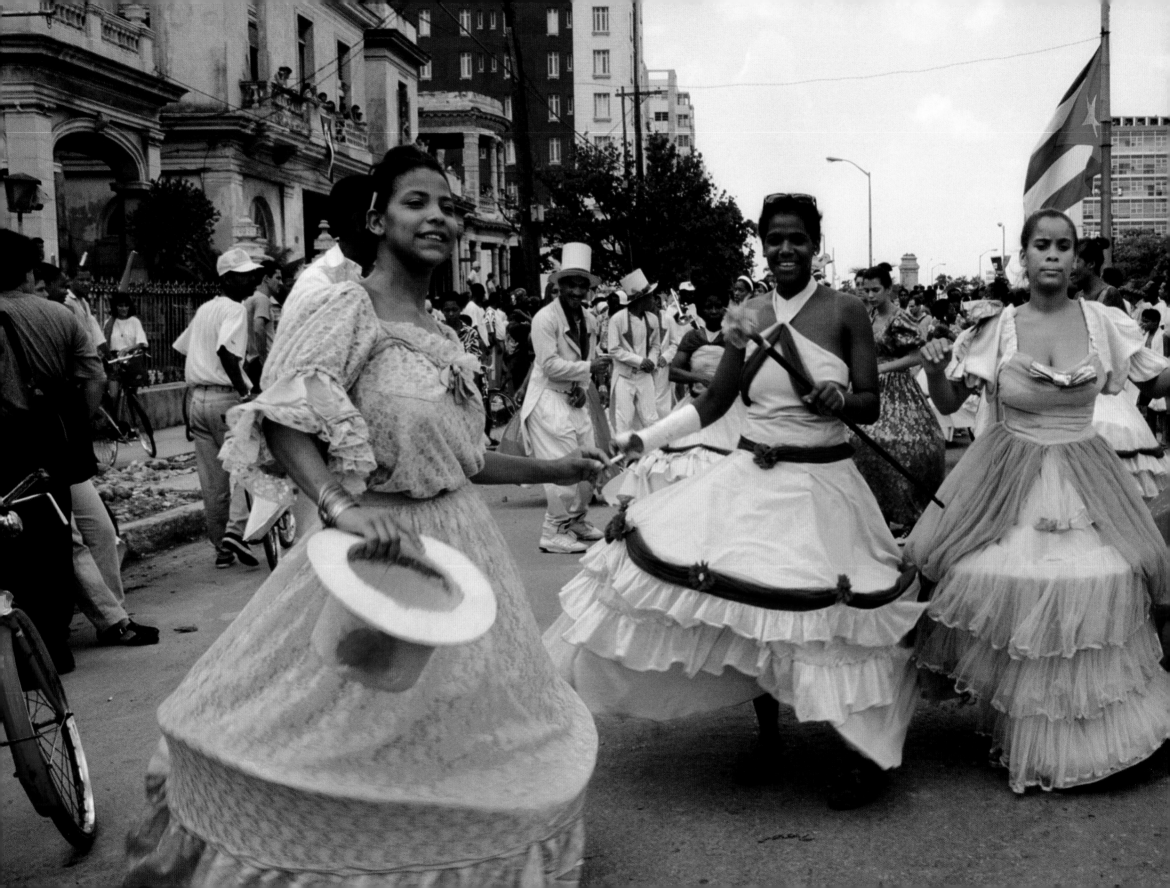

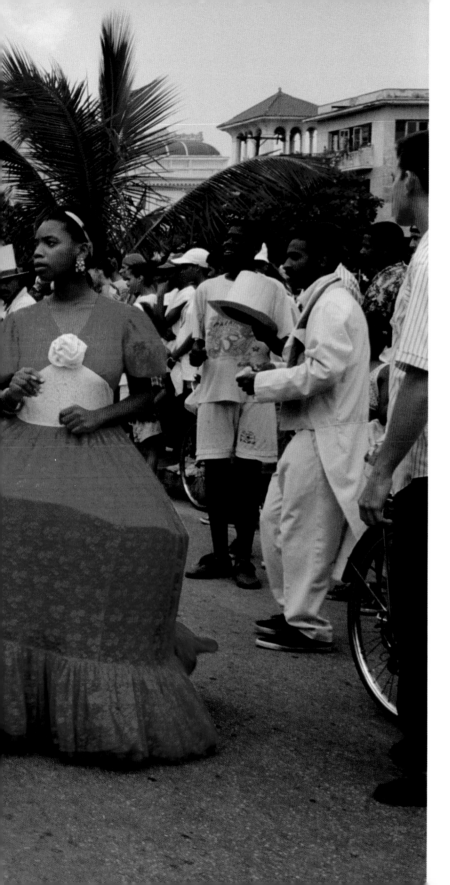

Due to a gas shortage in Cuba in 1995, Carnival celebrations were cancelled. Some women decided to wear their traditional costumes during a government organized anti-US embargo demonstration in Havana.

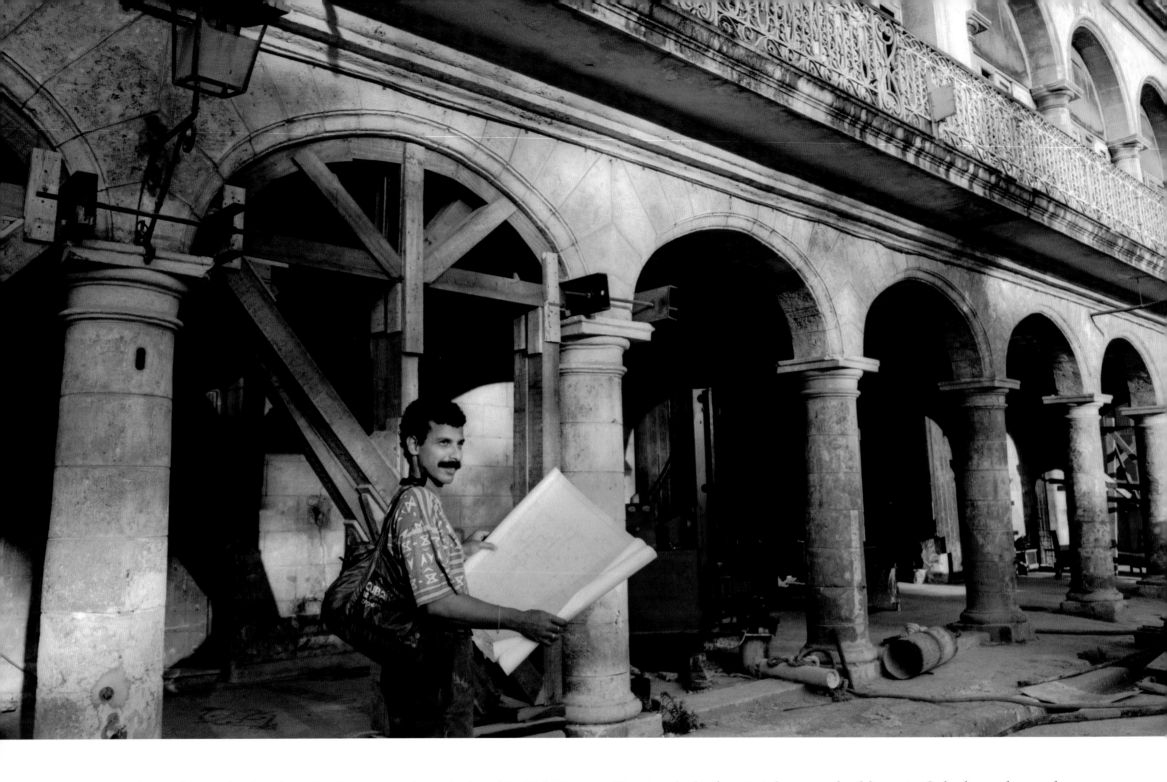

An architect checks plans for the renovation of a hotel in Old Havana. Due to a lack of materials, many buildings in Cuba have decayed.

A woman brings her ration booklet, called a *libreta de abastecimiento*, for her monthly allotment of food from the government.

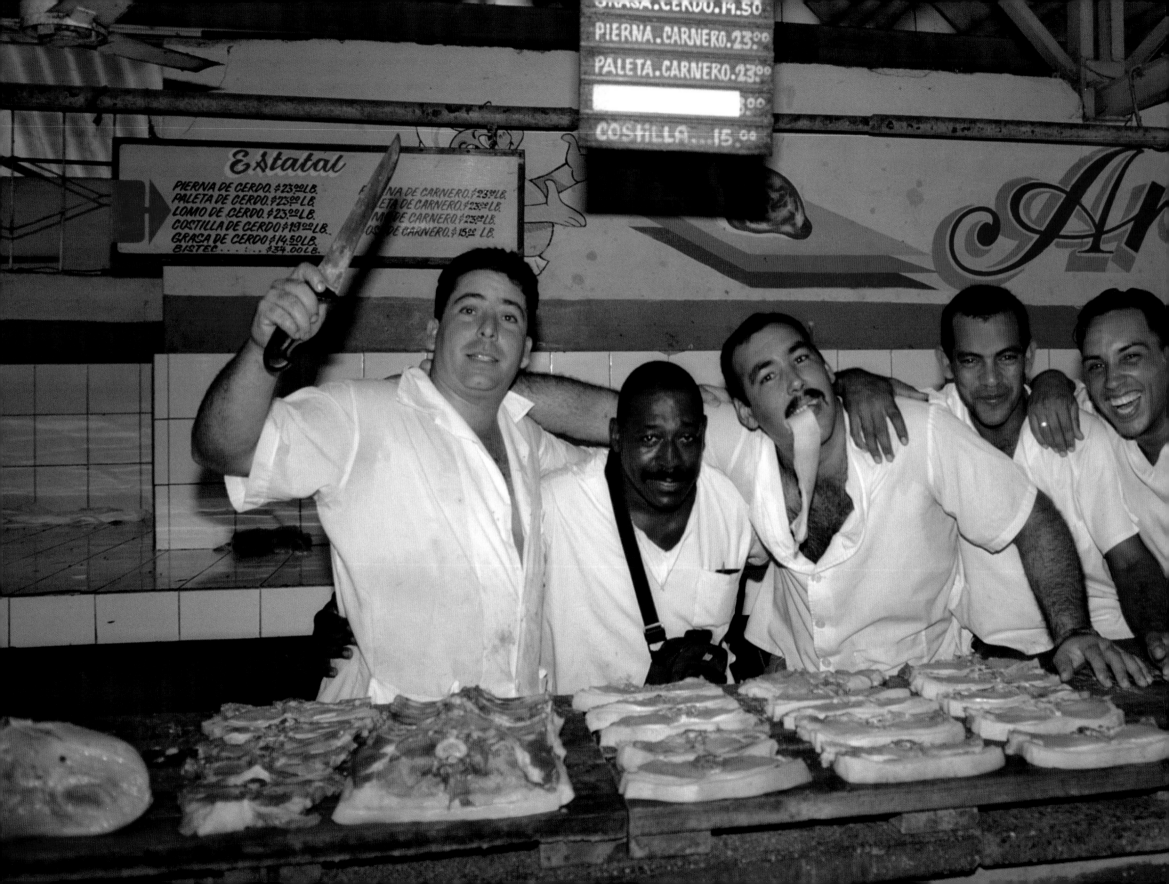

Workers prepare and sell meat, an expensive item for Cubans, at a national food market in Havana.

Opposite: Food from North Dakota arrives for distribution in Regla. After US politicians approved reforms in 2001, American farmers could sell food to Cuba for cash.

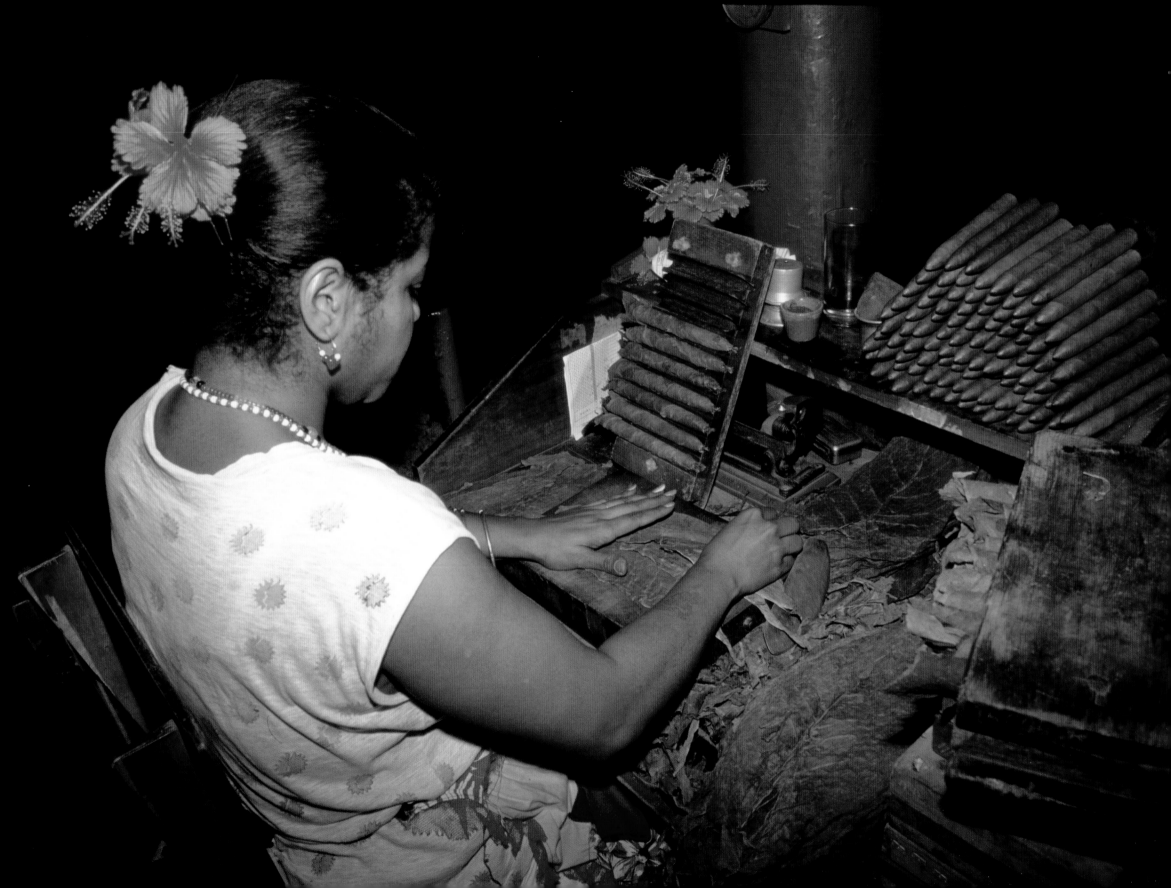

Opposite: A worker inside the Partagas Cigar Factory in Havana makes Montecristo No. 2 cigars, one of Cuba's signature brands and exports. Since their quality is highly controlled by the government, this worker had to train for ten years before being allowed to make this type of cigar. She wears a flower in her hair for adornment, and its scent is a substitute for expensive perfume.

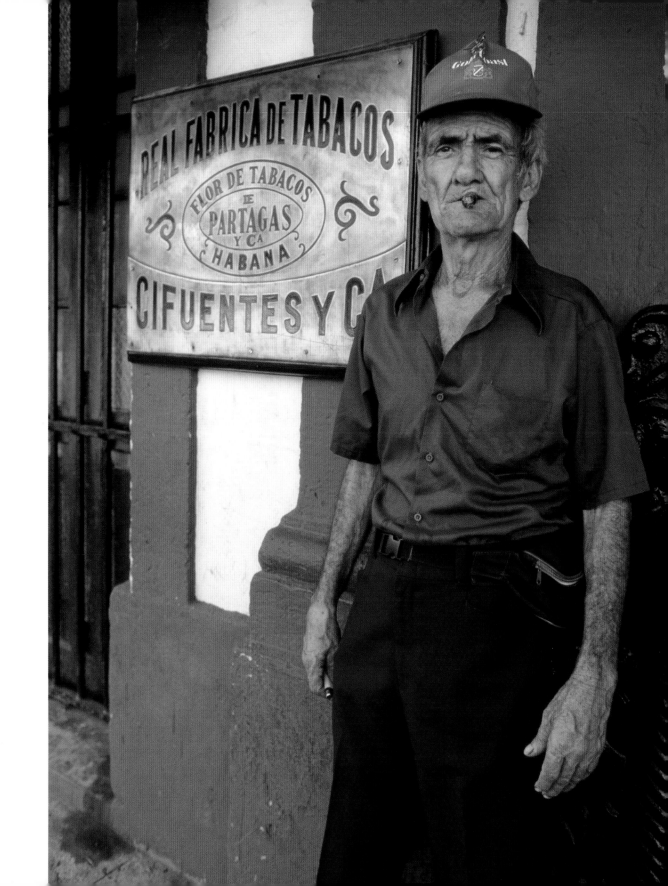

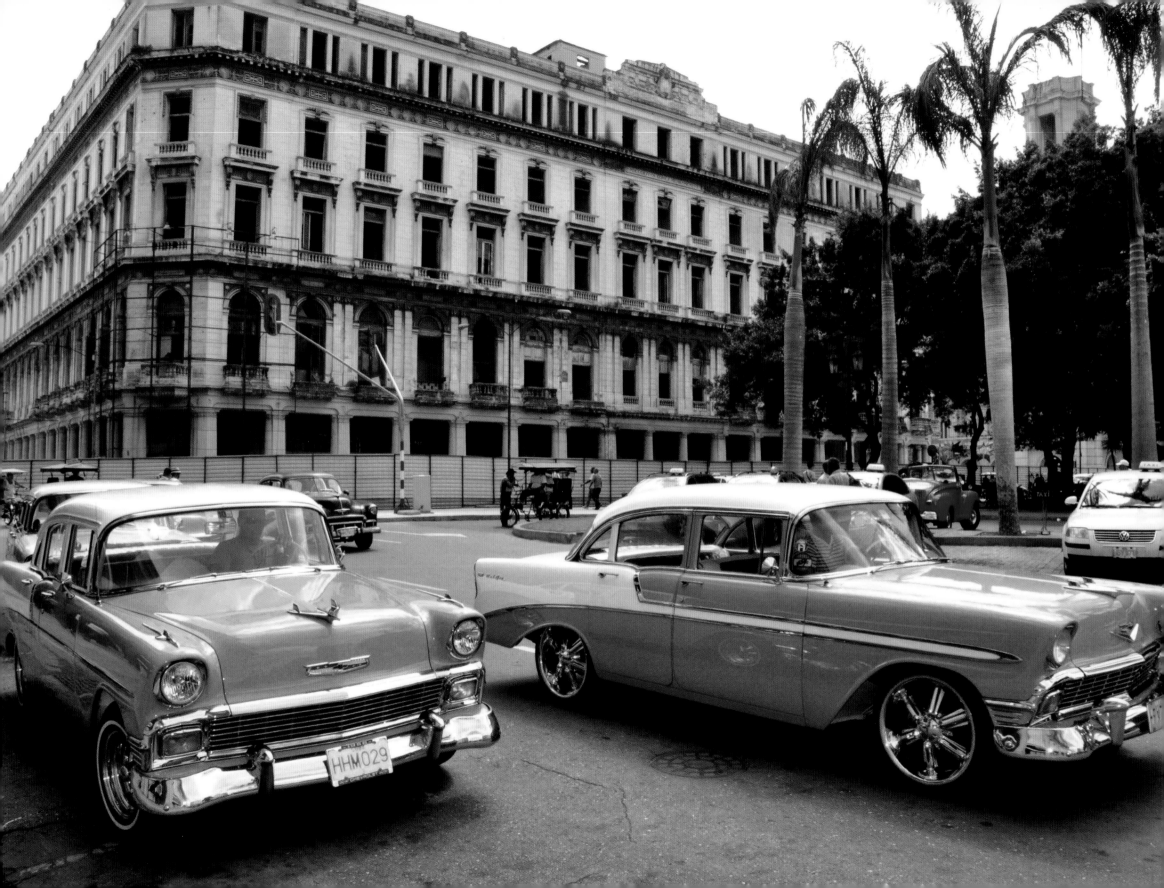

CHAPTER FIVE

Entrepreneurs / Empresarios

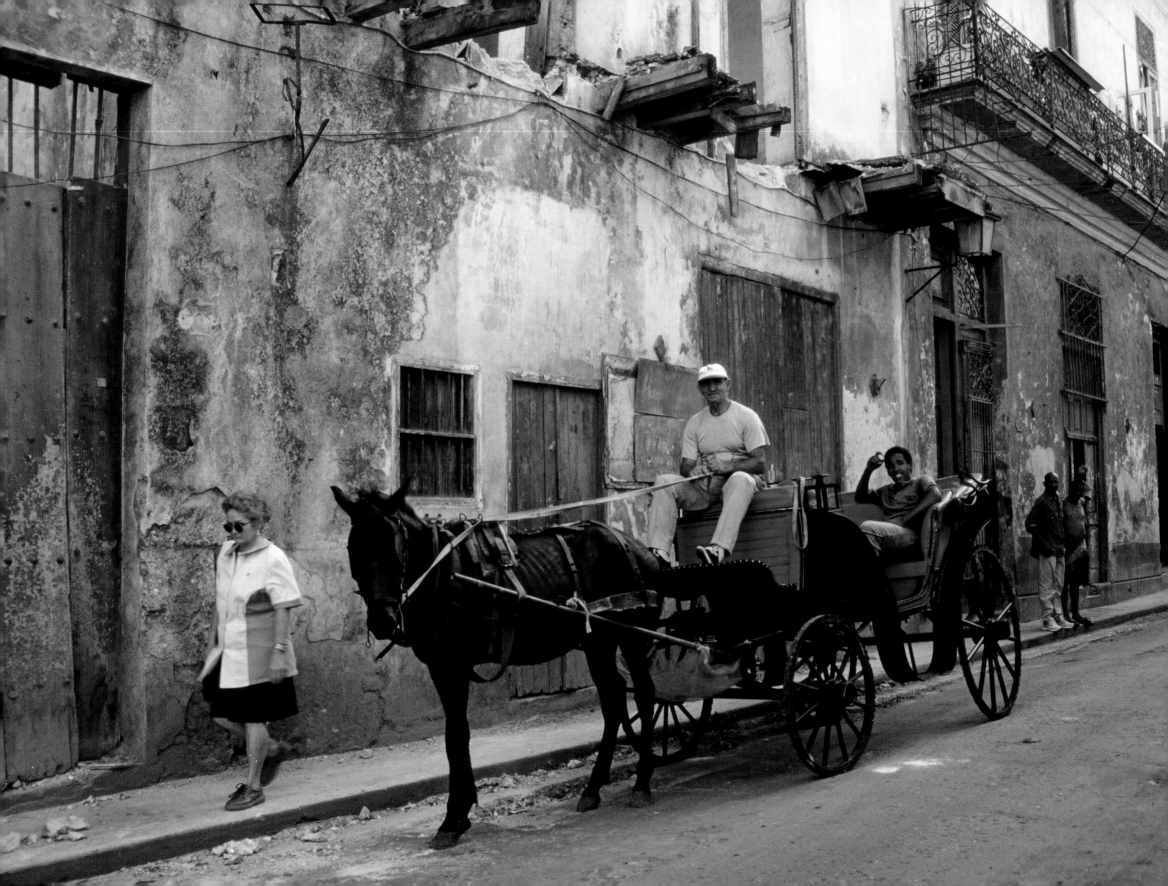

Page 116: Renovated American cars for sale by owners who found parts on the black market that were brought all the way from California.

A private businessman sells hardware items in front of his home in San Antonio de los Baños.

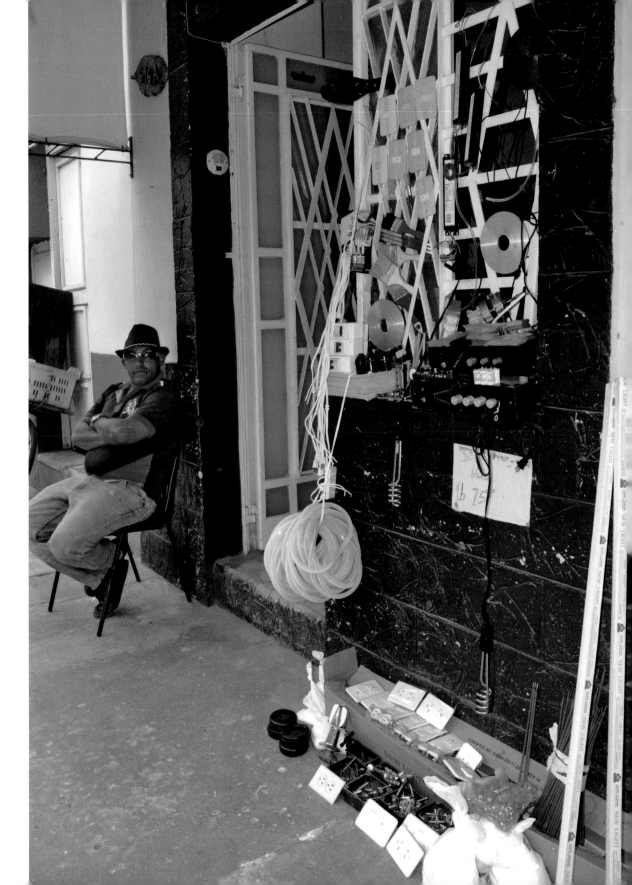

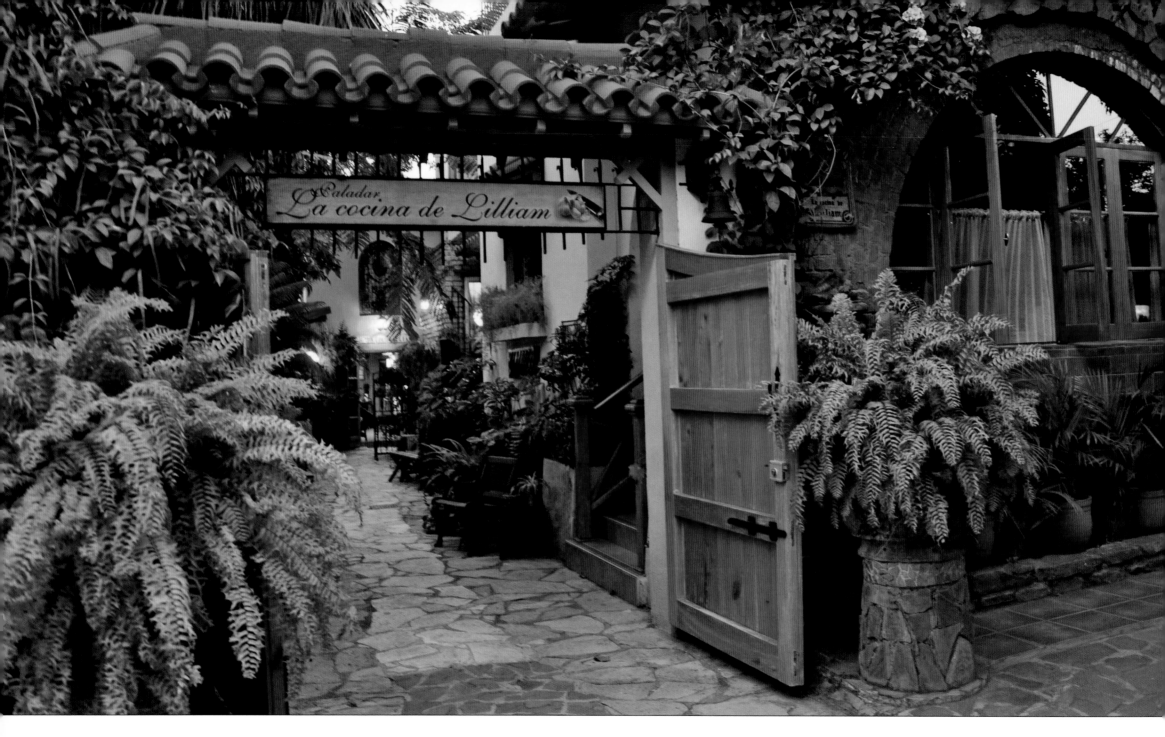

The entrance to Paladar La Cocina de Lilliam in Havana. Chef Lilliam Dominguez Palenzuela was one of the first five families in the 1990s to petition the Cuban government and receive permission to host a family-run, private restaurant in their home. *Paladars* in Cuba have become an alternative to state-run restaurants, providing work for many self-employed Cubans. They pay taxes to maintain their license and are subject to routine health inspections.

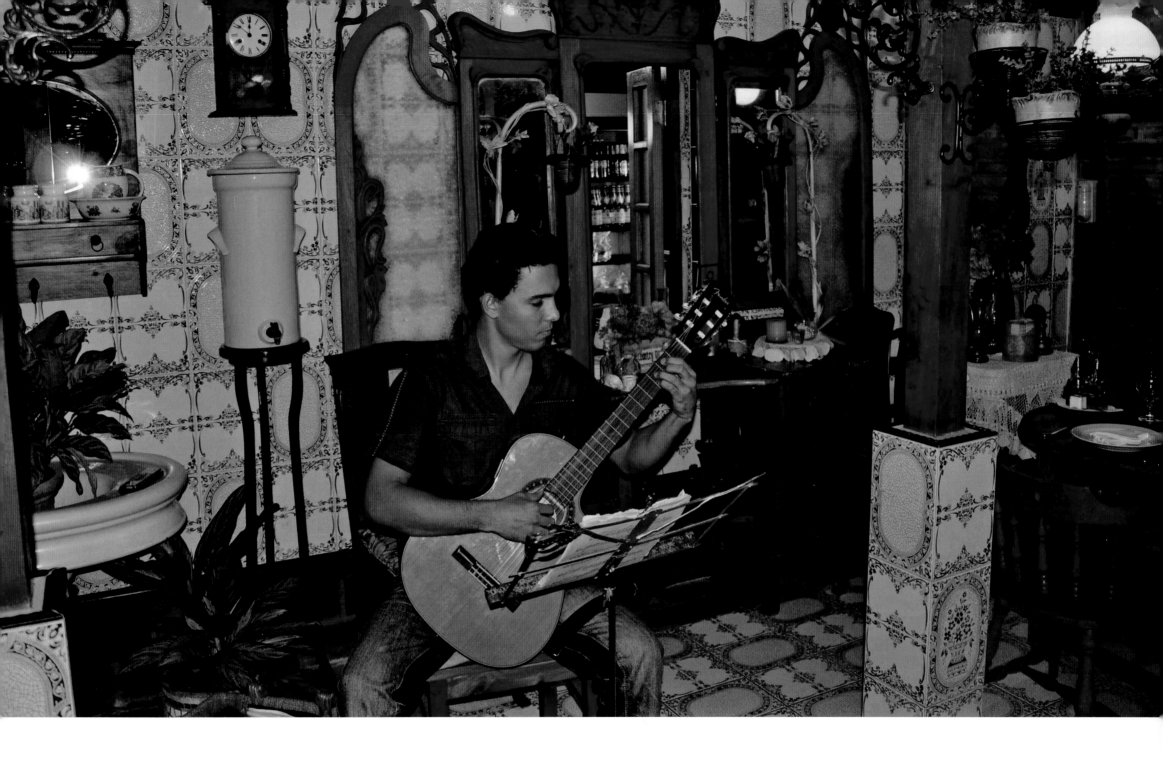

A musician plays classical music to entertain guests at Paladar La Cocina de Lilliam.

A private street vendor in San Antonio de los Baños.

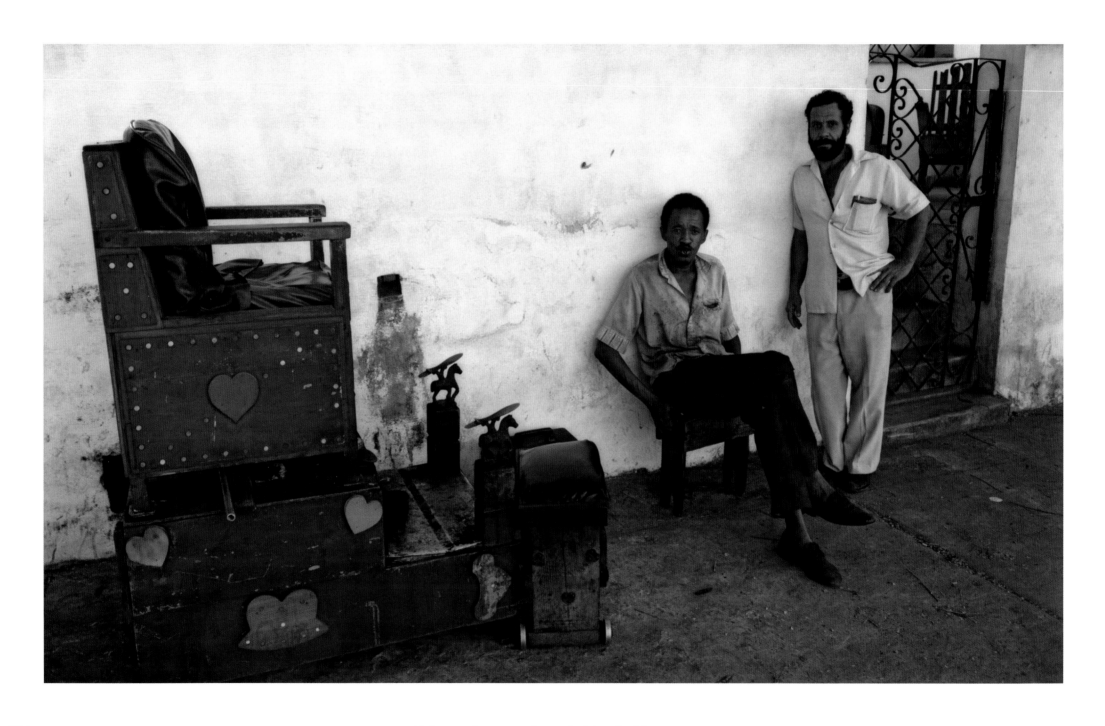

124 Private shoe repair and shine in Havana.

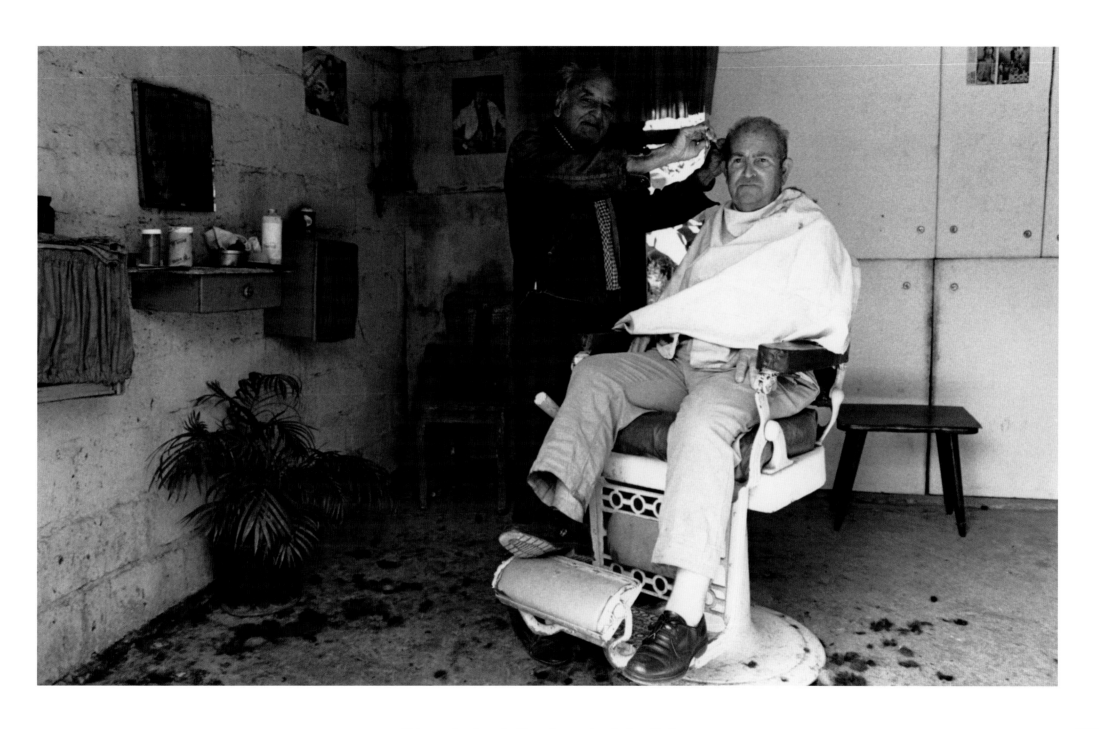

Private barber in San Antonio de los Baños.

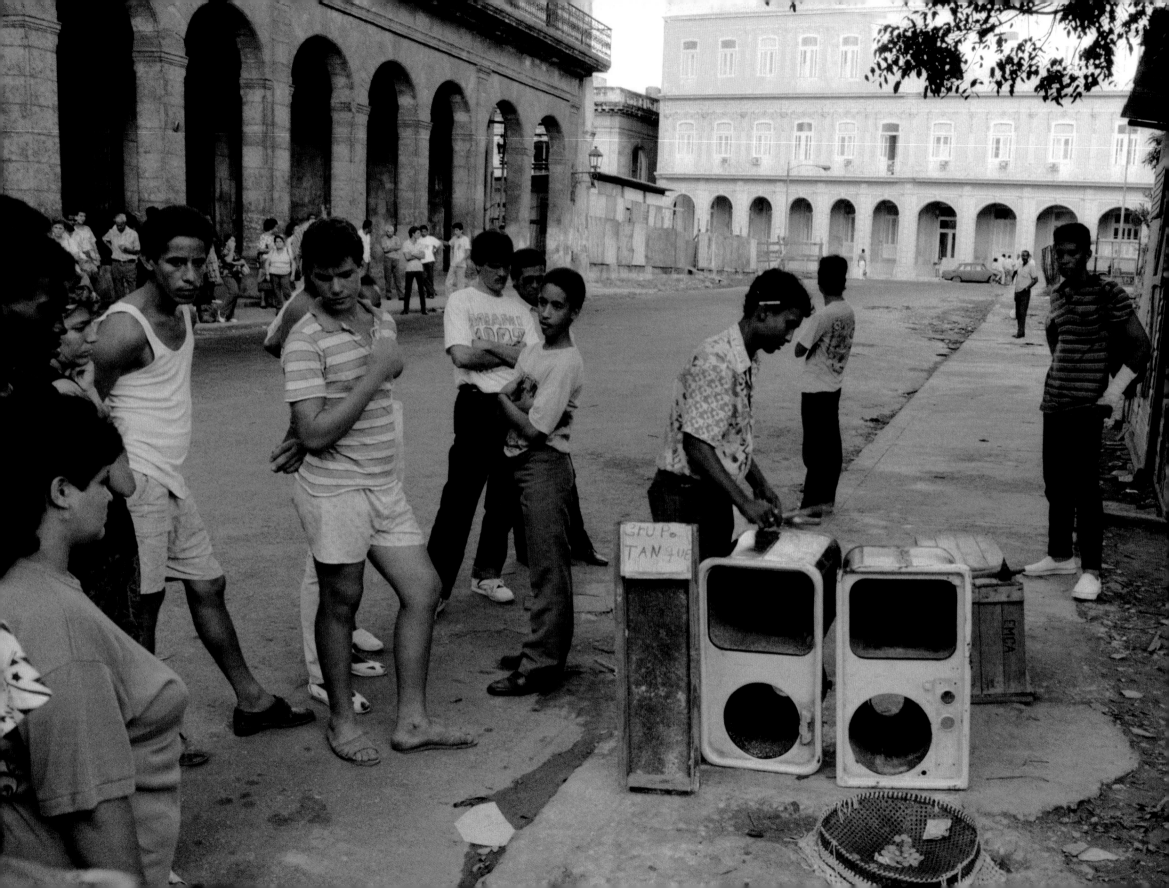

Until the Soviet Union dismantled, Cuba received many products from Russia. Here, a man has turned Russian-made clothes washers into a drum set. He calls himself "Grupo Tanque" (Tank Group) and plays for passers-by in Havana.

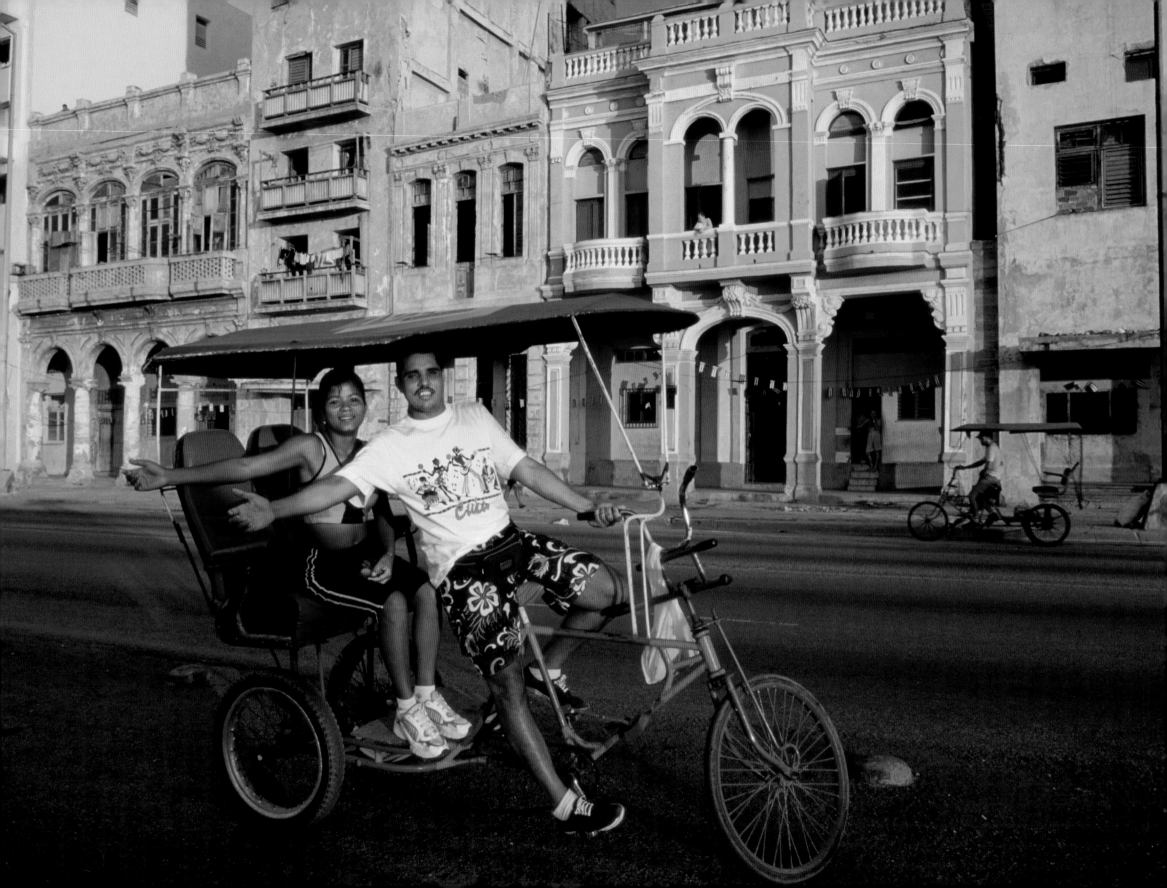

Opposite: Bicitaxis were one of the first private businesses allowed in Cuba in the 1990s. After Cuba lost Russian support due to the break-up of the Soviet bloc, the Cuban government introduced various economic reforms, which included legalizing the businesses of some small-scale, private entrepreneurs.

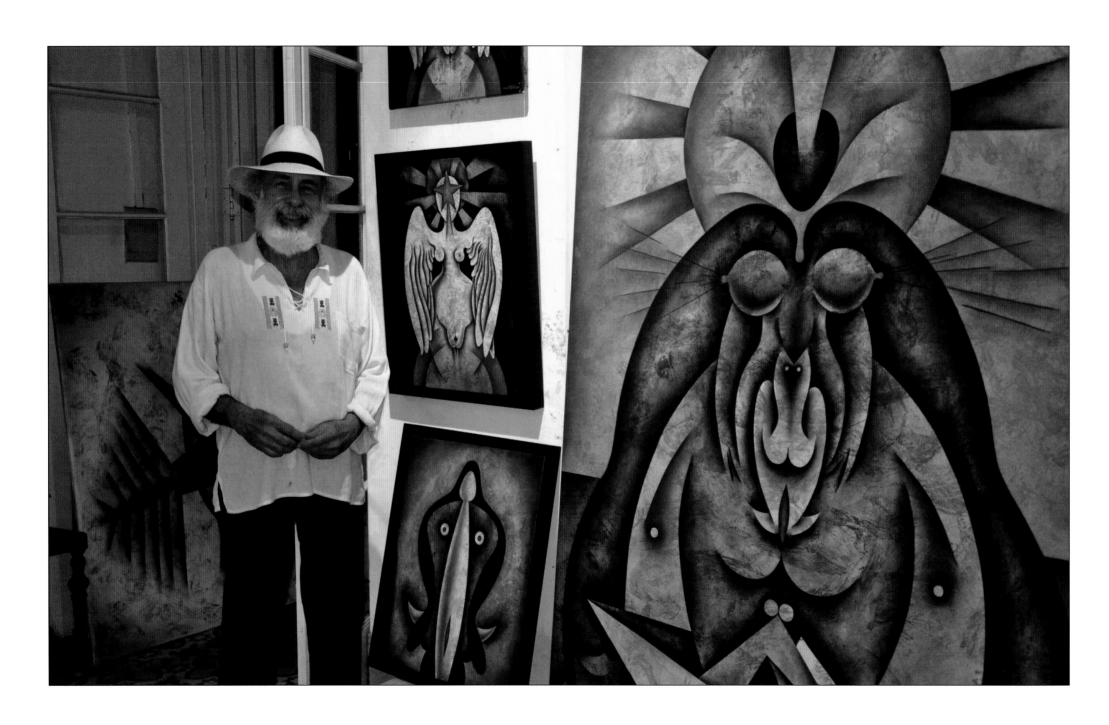

Artist Juan Moreira at home in Havana.

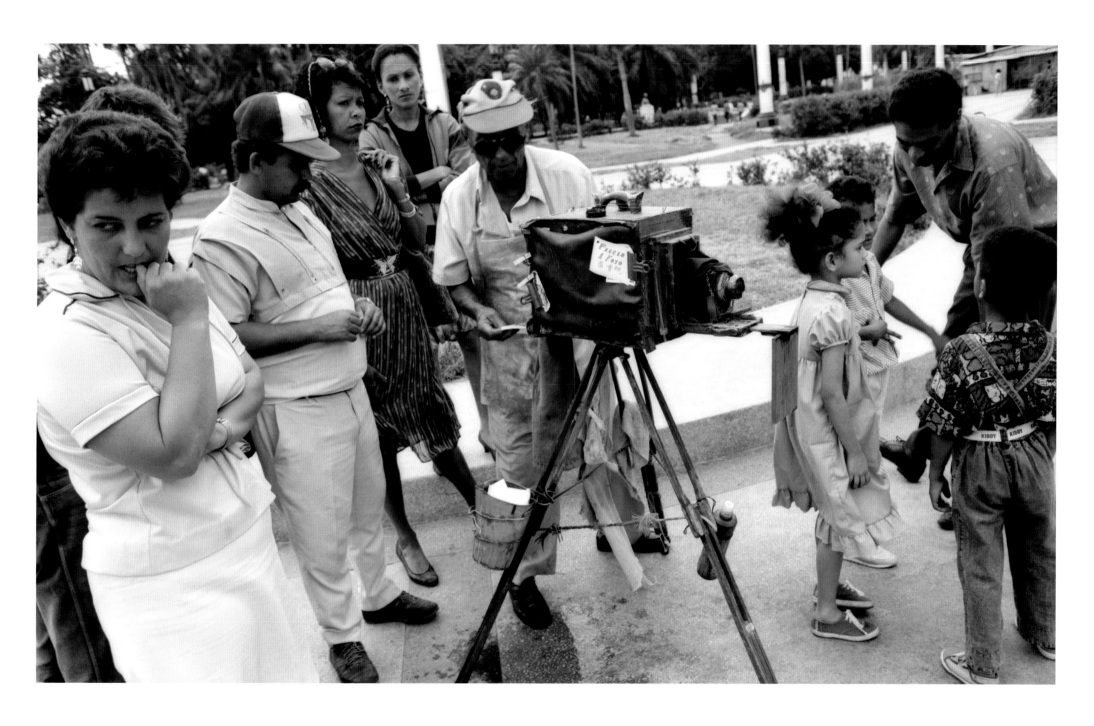

A photographer sells instant portrait photographs in el Parque Central (Central Park), a central and prominent place to visit in Havana. Many Cubans do not own cameras, so a photo session with a private photographer such as this one is a common way to get family portraits.

Pages 133–134: Stands sell T-shirts, art, and other items to tourists. In the 1990s, Fidel Castro implemented minor economic reforms, allowing *trabajo por cuenta propia* (private work) in an effort to improve Cuba's economy after the loss of Russian economic support and the resulting "*período especial*" (special period) in Cuba. Since the leadership transition from Fidel to Raúl Castro began in 2006, fully announced in 2010, an entire overhaul of Cuba's economic model has been instituted as state sector jobs are being eliminated, more private businesses are being permitted, and job options of small entrepreneurs are being promoted. The entrepreneurial sector continues to grow and former restrictions are being lifted. State-sponsored childcare is now available to parents running entrepreneurial businesses. The economic reform issues have become constant topics of discussion on state-run television and other media outlets, and advertising for private entrepreneurs is now allowed. Access to supplies remains a problem; however, since Cubans are now allowed to travel abroad, many entrepreneurs are leaving Cuba to get supplies in other countries. Others receive assistance from friends and family members who send the supplies or money.

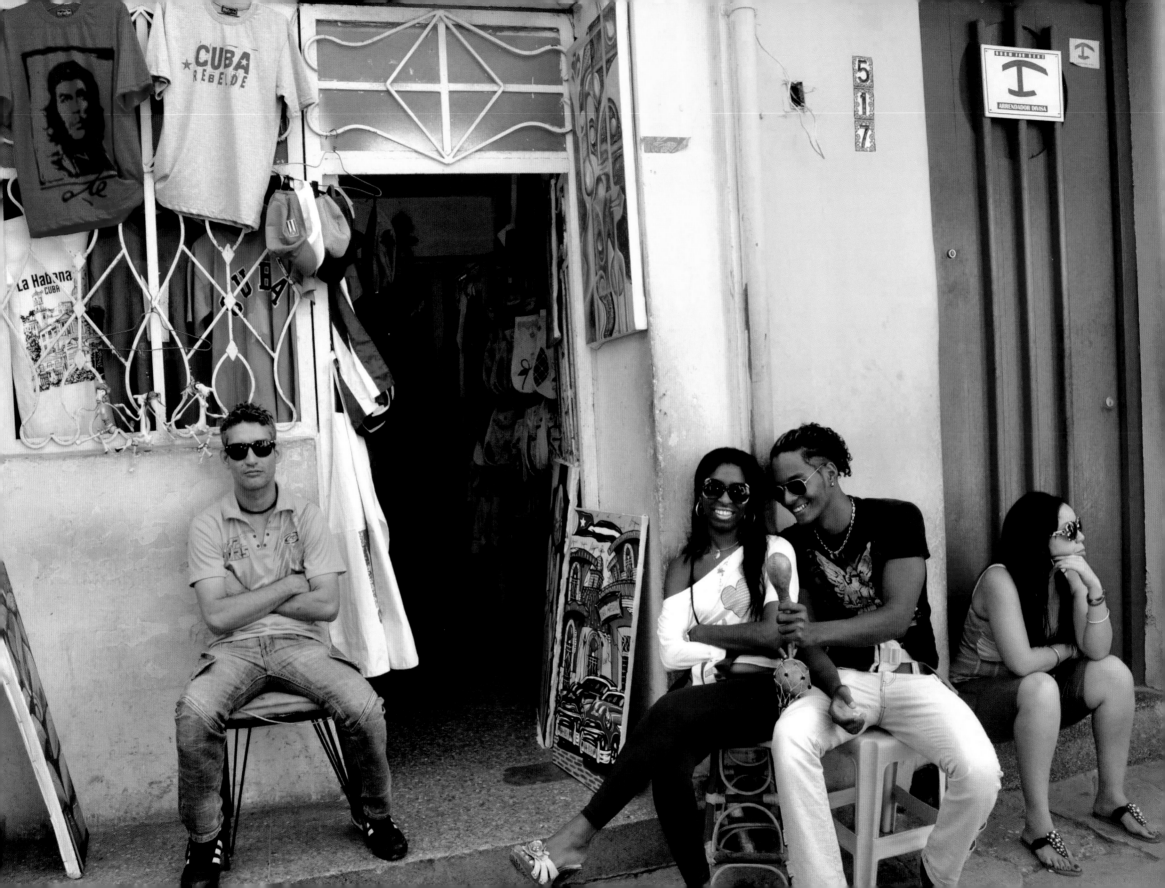

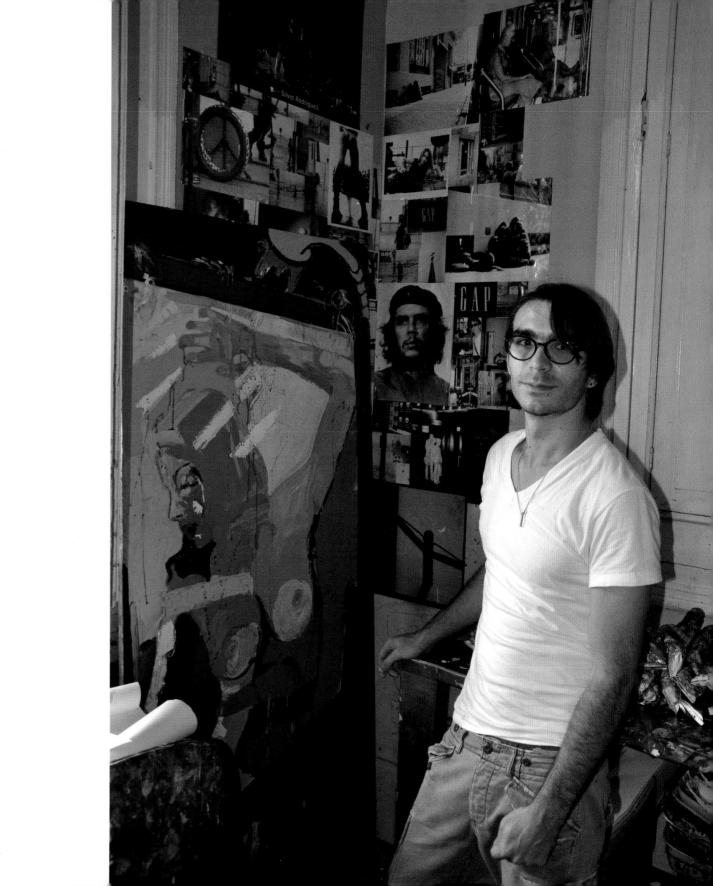

Artist Lancelot Alonso at home in Havana.

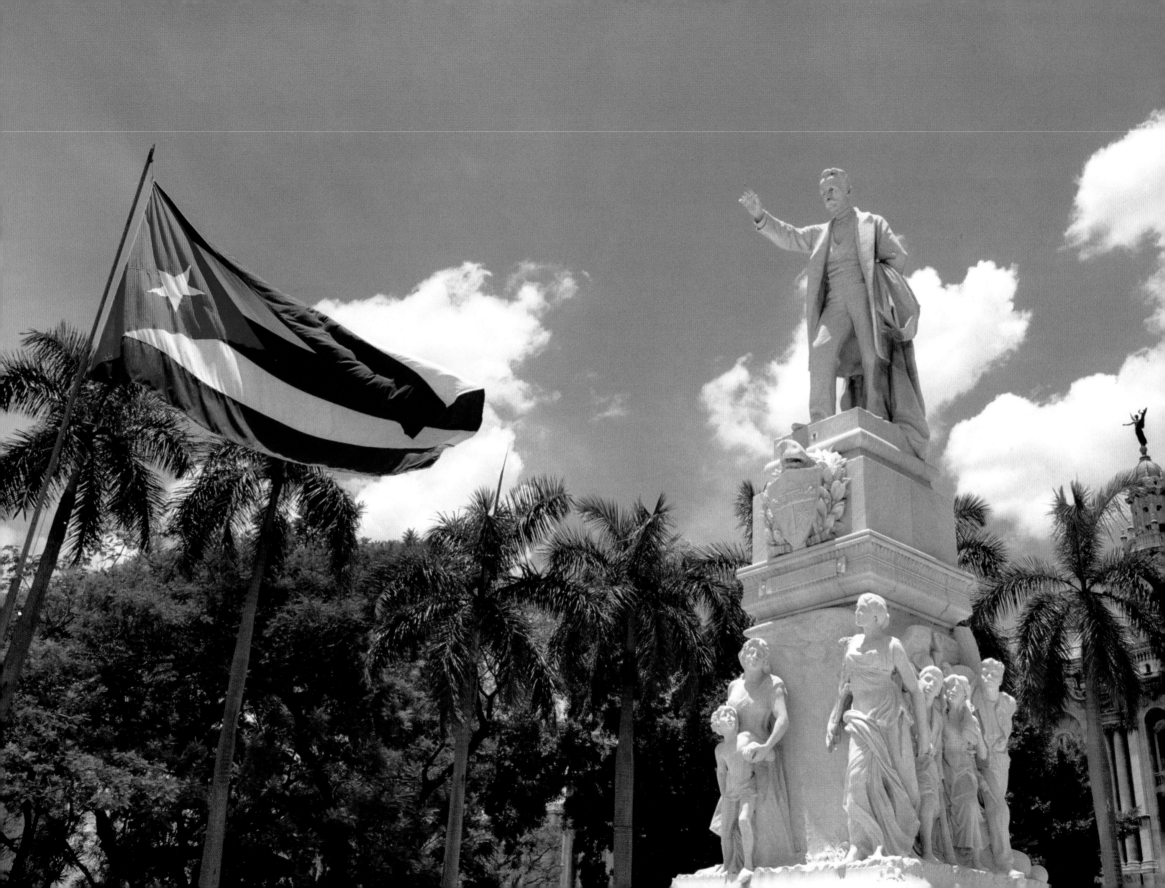

CHAPTER SIX

Doctrine / Doctrina

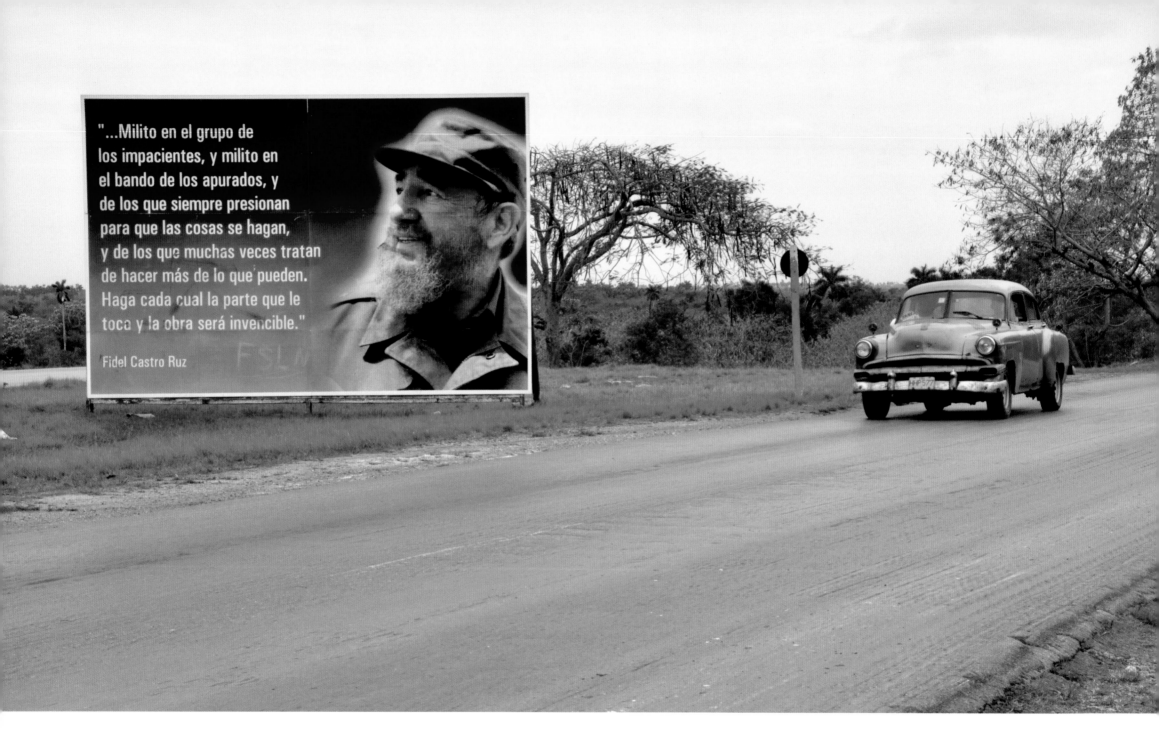

Ubiquitous government highway propaganda features a Fidel Castro quote: "In the middle of the group of those who are impatient, and in the middle of the group of people who are in a rush, and those who are always pressuring for things to be done, and to those who try to do more than they can manage. Do everything you can, because what you do will become invincible."

Page 136: A José Martí sculpture with the Cuban flag stands in Havana. Martí was a journalist, poet, and philosopher, and is regarded by Cubans as a national hero who fought for Cuba's independence from Spanish colonial rule.

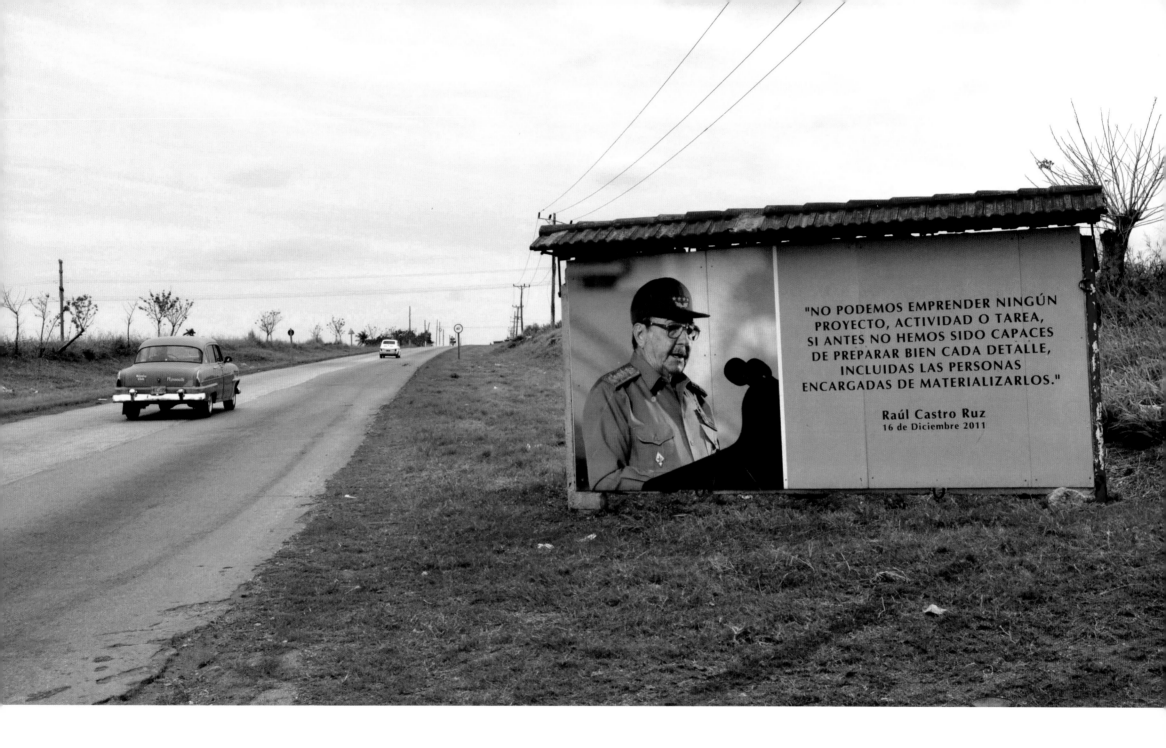

A Raúl Castro quote along the side of the highway reads, "We cannot begin any project, activity or work, if we are not capable of preparing every detail before, including the people that are put into action."

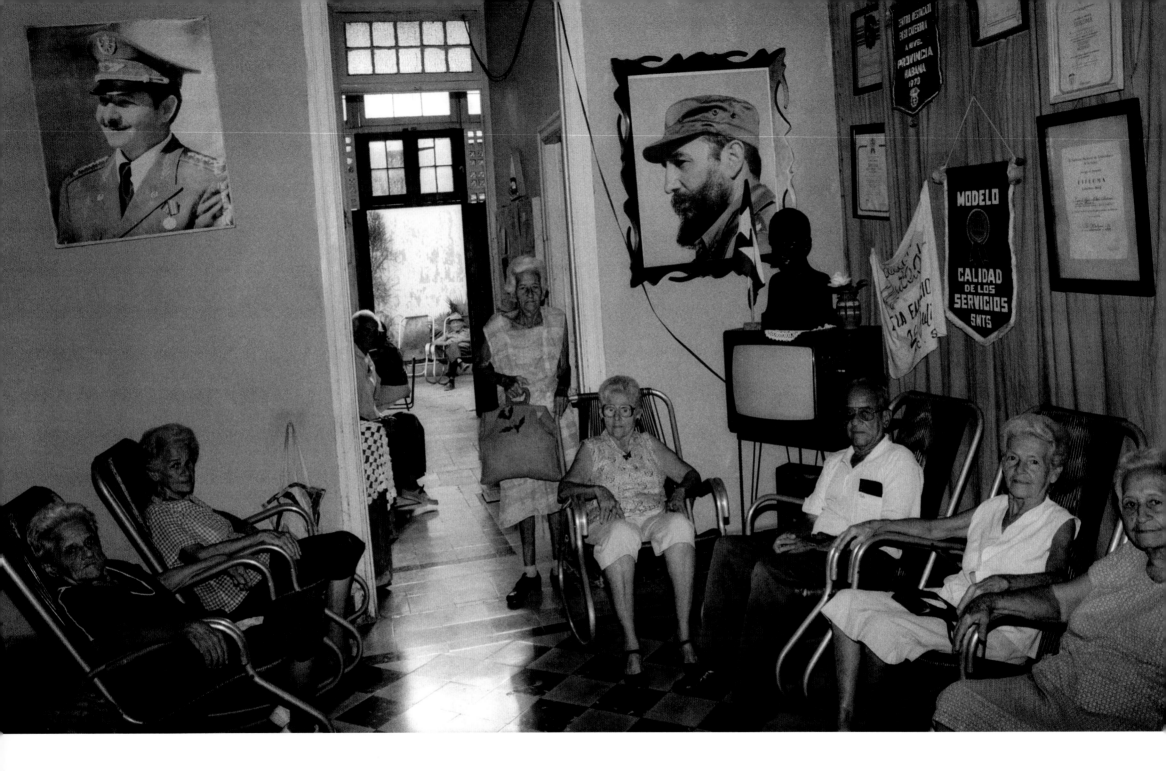

Casa de los Abuelos (House of Grandparents), San Antonio de los Baños.

A posting by the government, "*Resistir es luchar para vencer las dificultades y continuar el desarrollo*" (Resist and fight to win against all odds and continue the development [of our Revolution]), on the outside of a residential building in Havana.

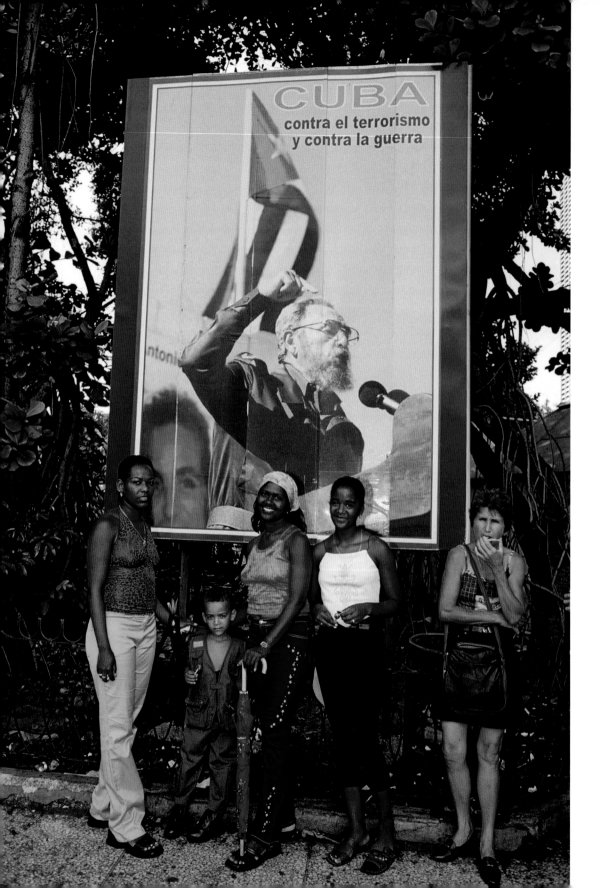

A poster stating "Cuba is against terrorism and against the war," located in front of La Coppelia, a popular ice cream parlor for locals in Havana. The posters were erected by the government after the US invaded Iraq in the early 1990s.

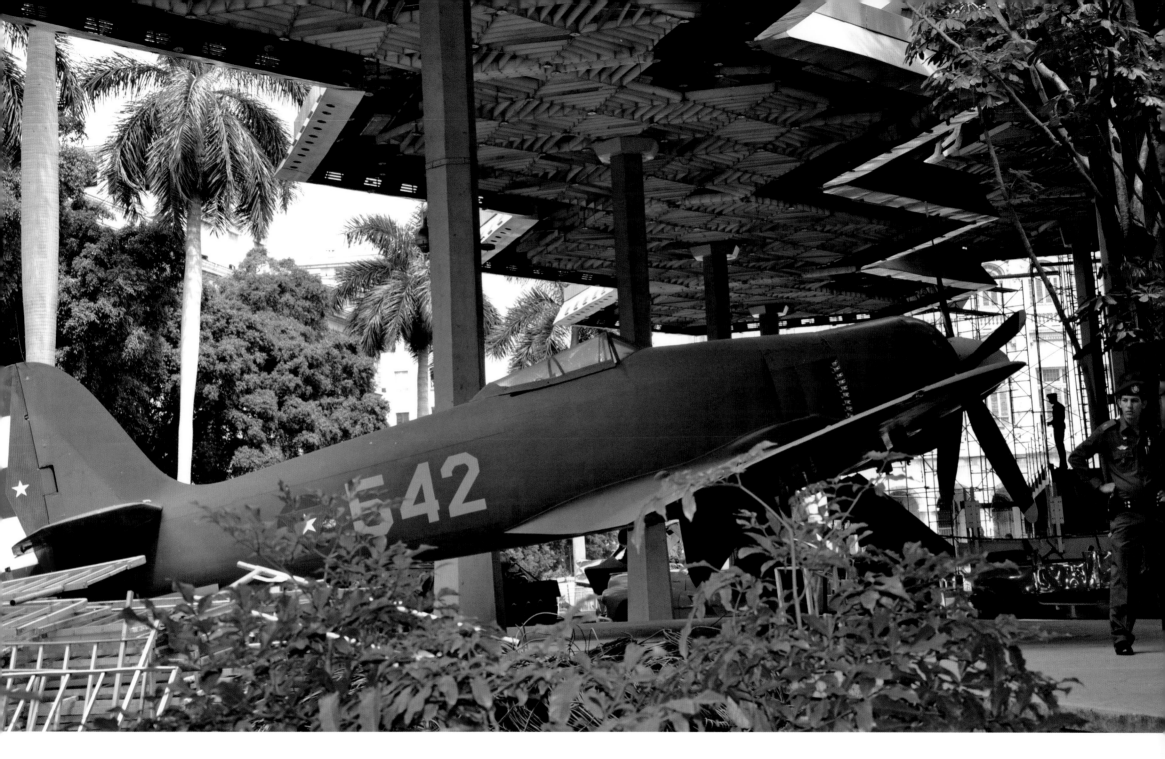

Standing guard outside the National Museum of the Revolution in Havana. The museum is housed in what was the presidential palace of all Cuban presidents from Mario García Menocal to Fulgencio Batista. It became the Museum of the Revolution during the years following the Cuban revolution.

A tourist bus passes the waving Cuban flag and José Martí sculpture in front of a Cuban government office building in Plaza de la Revolución (Revolution Plaza).

Formerly of the Ministry of Culture, Cuban Institute of Cinematographic Art and Industry (ICAIC), and the International School of Film and Television in San Antonio de los Baños, José Antonio Orta poses in front of a photograph showing the Colombian novelist Gabriel García Márquez, Fidel Castro, and Argentinean film director Fernando Birri at the inauguration of the school.

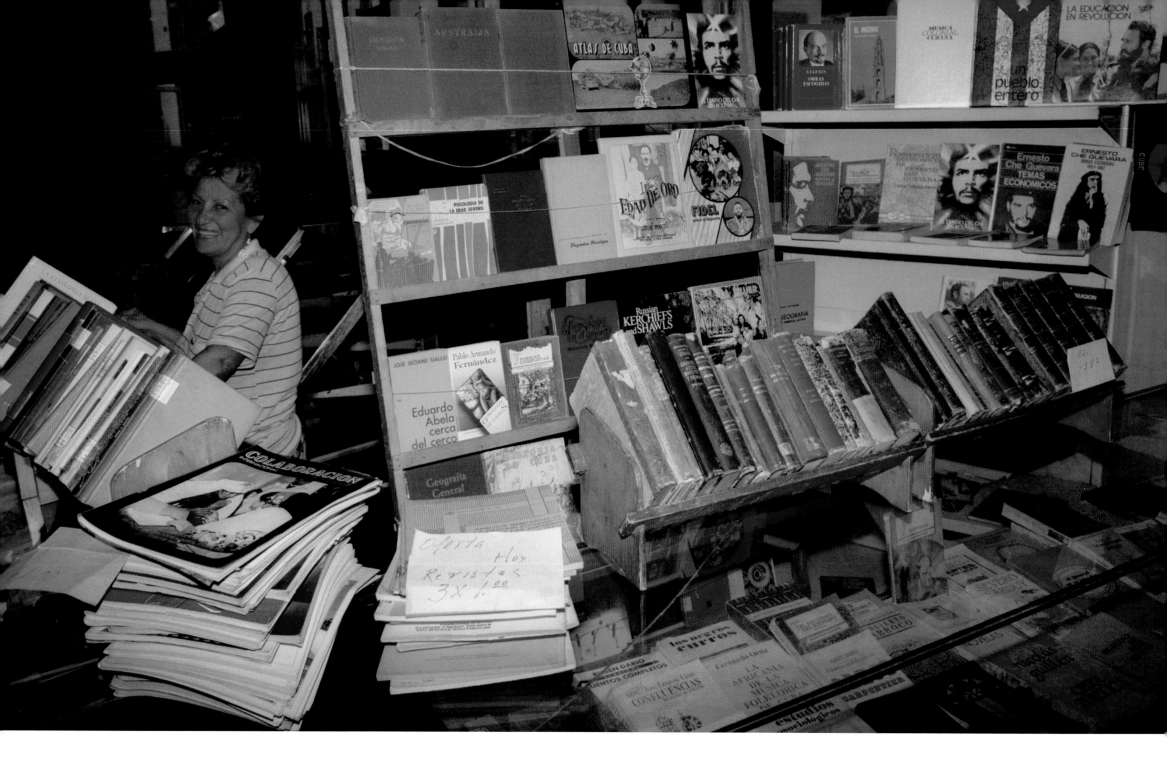

146 Books about the Cuban Revolution and its leaders on sale in Havana.

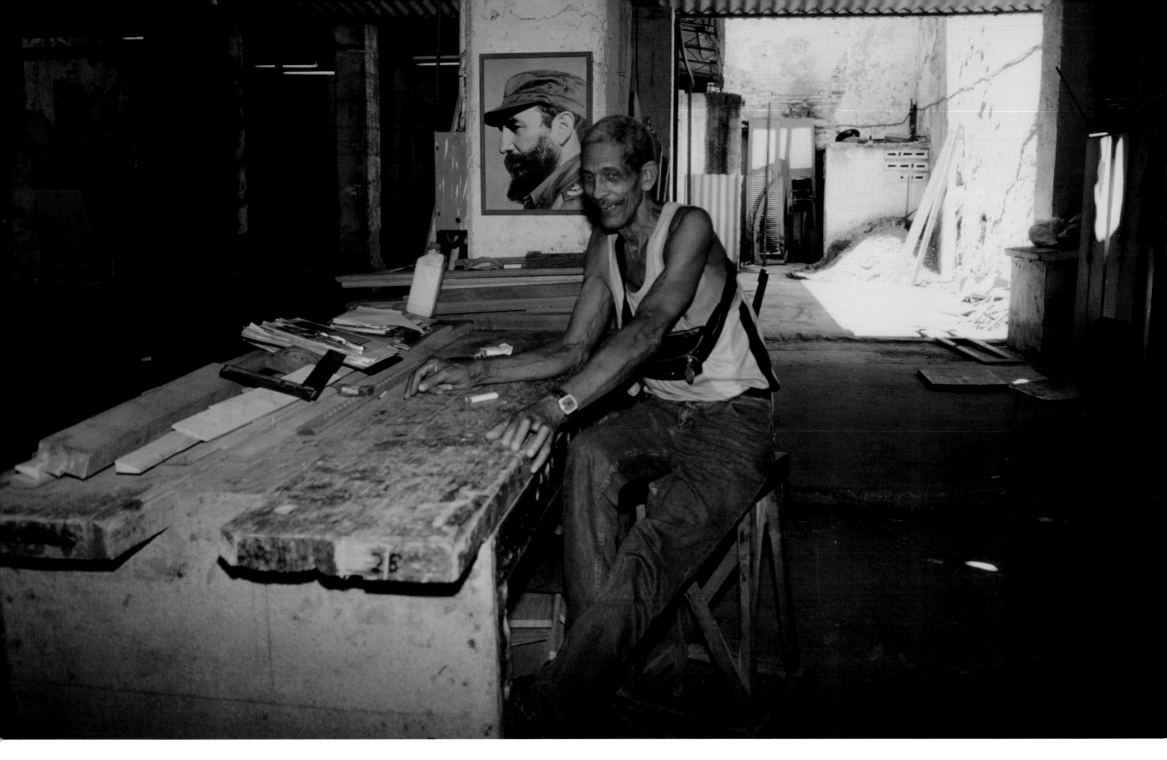

A government worker smiles and takes a break near a photograph of a younger Fidel Castro. Photographs of Fidel and his brother, Raúl Castro, are posted in all government offices and on national farmland.

A government slogan, "*Para ser revolucionario hay que creer en el hombre*" (To be a revolutionary, you need to believe in mankind), on a government farm in Matanzas.

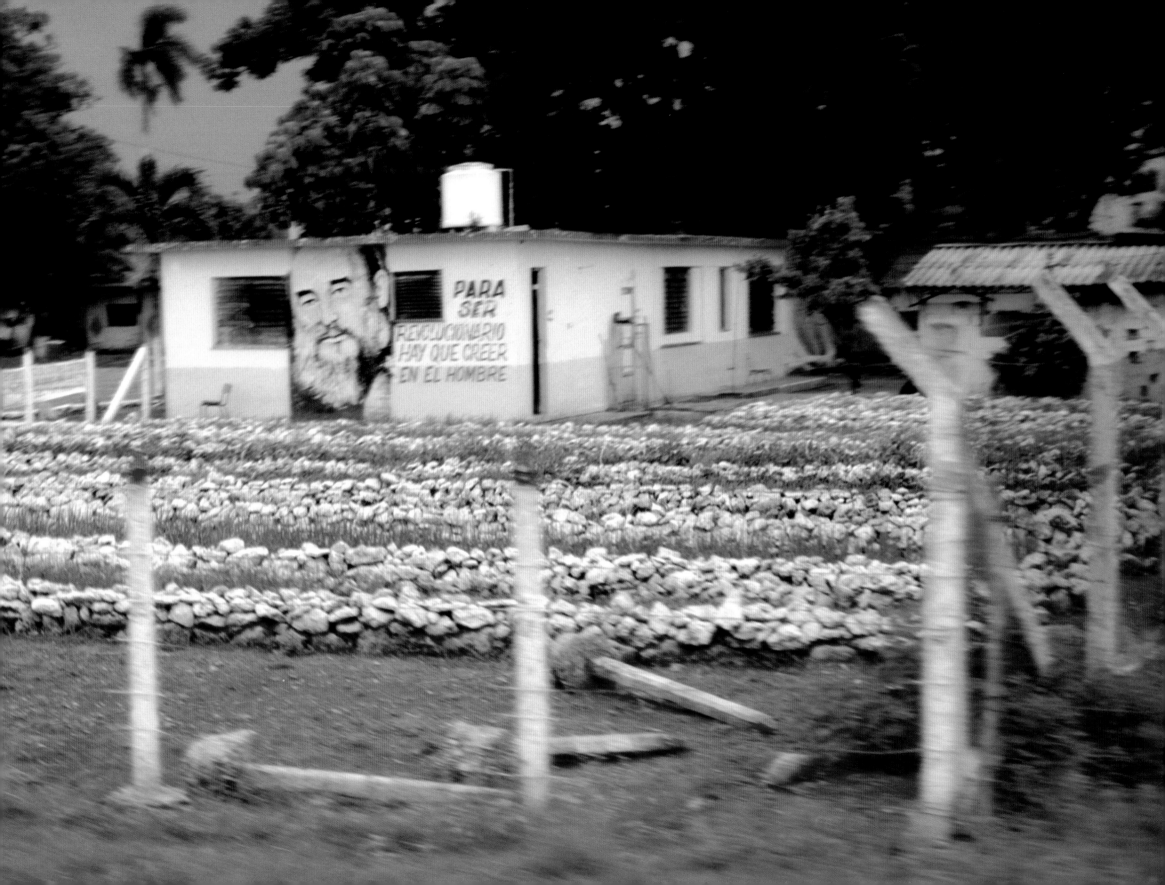

Opposite: Government-sponsored highway propaganda
for healthy living, San Antonio de los Baños.

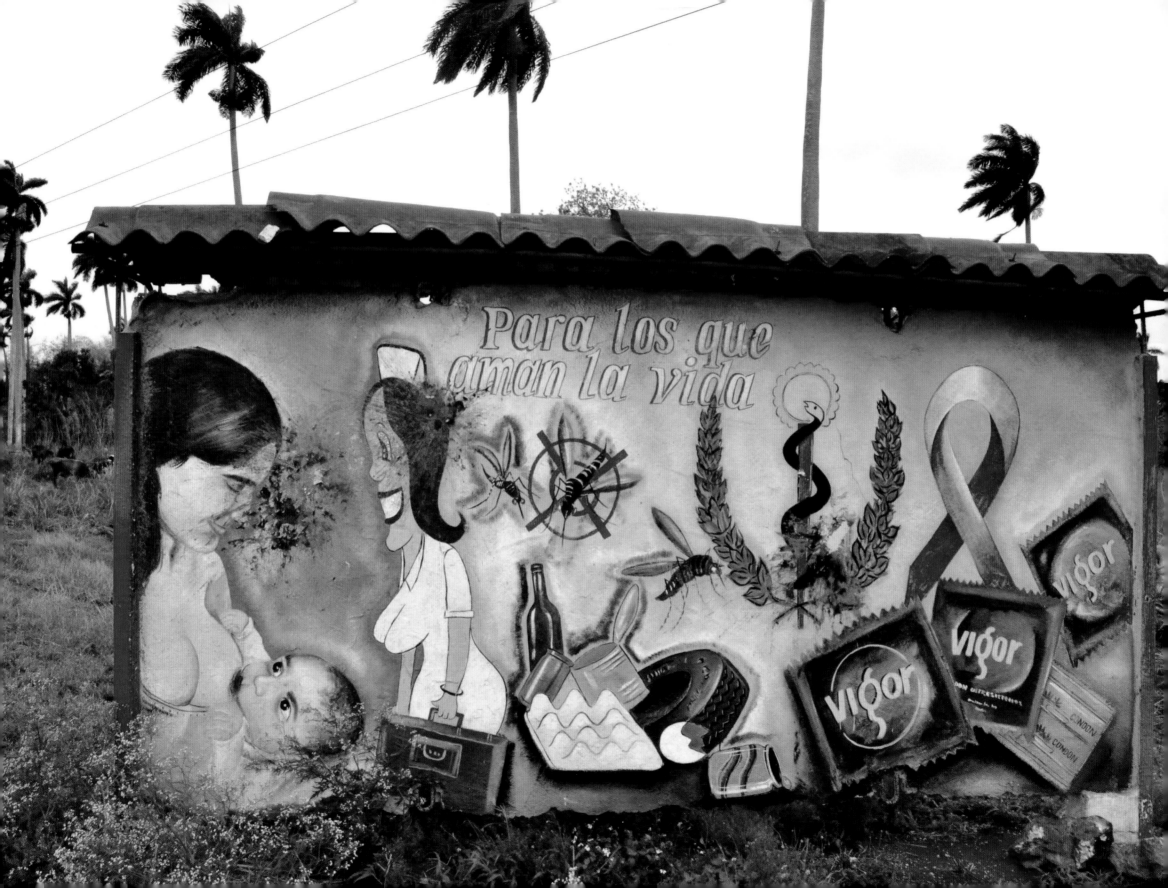

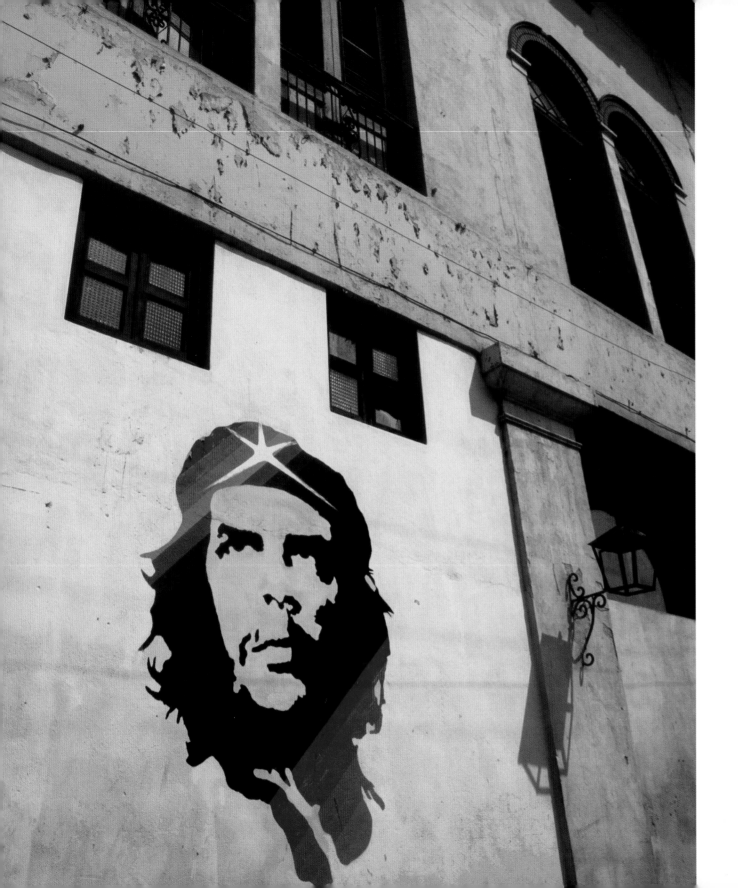

A painting of the ubiquitous and national revolutionary hero, Che Guevara, on a building in Havana.

Opposite: Students on a school field trip visit Plaza de la Revolución (Revolution Plaza) in Havana and stand below a large iron tribute to Che Guevara. Che's well-known slogan, "*Hasta la victoria siempre*" (Until the everlasting victory, always), identifies the Ministry of the Interior building.

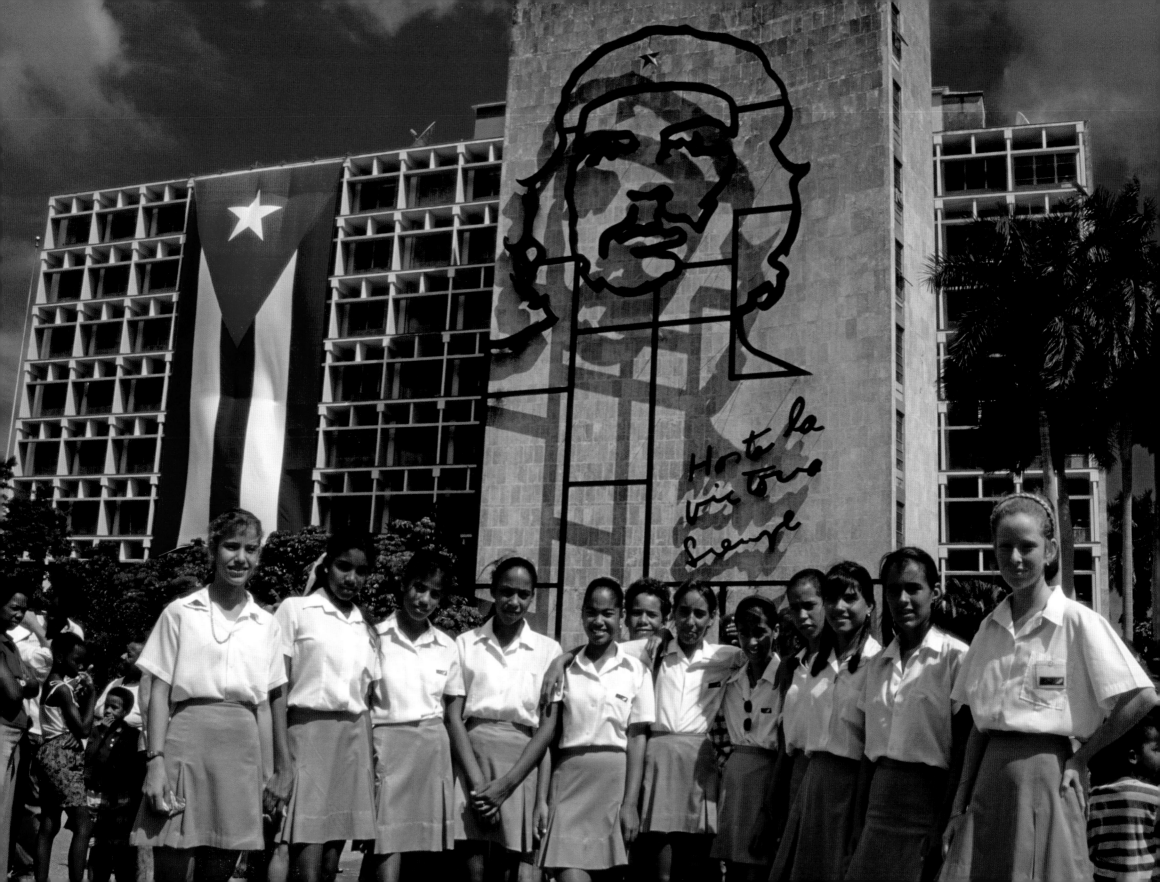

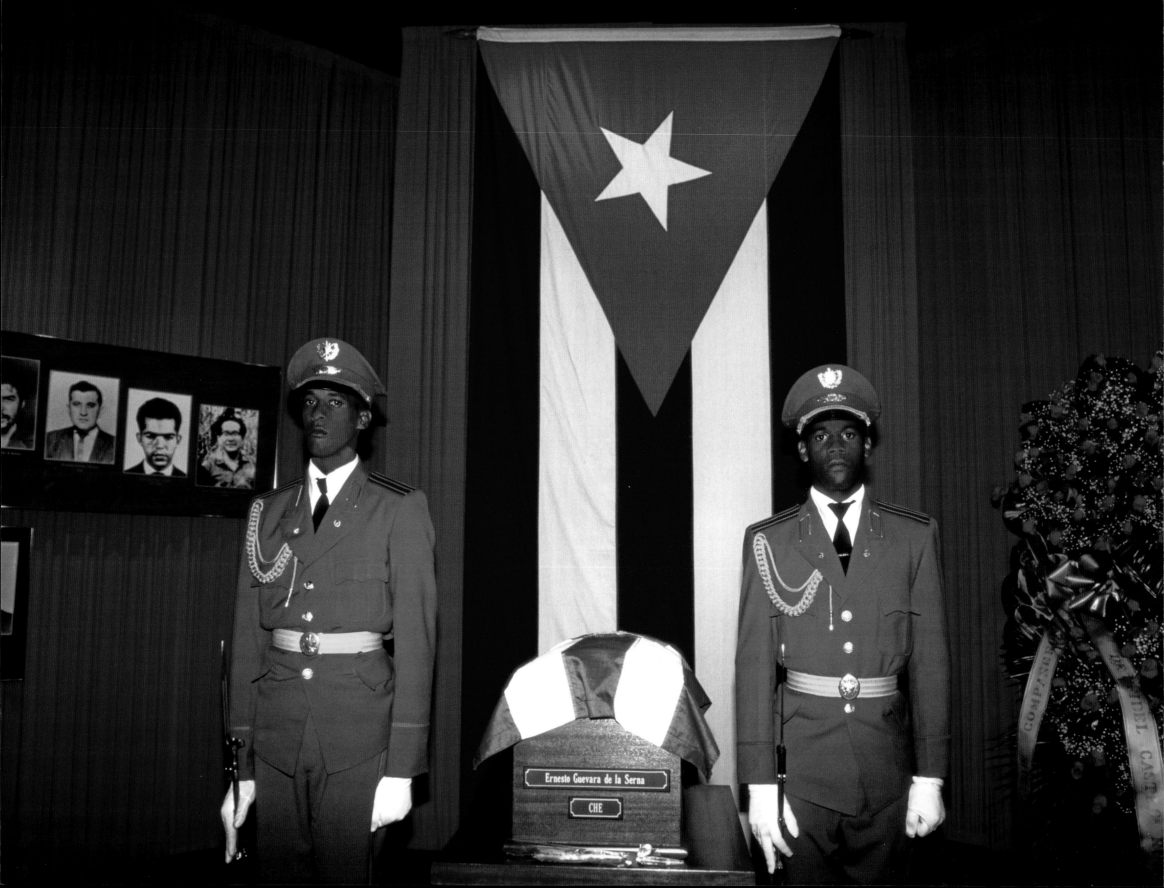

It is believed that Argentinean and Cuban revolutionary hero, Che Guevara, whose real name was Ernesto Guevara de la Serna, was executed in the schoolhouse in Bolivia in October 1967, after he and a small group of revolutionaries were captured by Bolivian troops. Che and his group of Cuban fighters were trying to ignite an insurgency against the government of René Barrientos, the Bolivian dictator. In 1997, when several retired Bolivian military officers claimed to have buried Che's remains, a team of Cuban, Bolivian, and Argentine experts launched a search that located his remains in Villagrande, Bolivia. Cuban leader Fidel Castro arranged for the remains to be buried in Cuba to honor Che's role in the Cuban Revolution. However, before the bones were buried, the Cuban government placed Che's coffin on display with National Guards and photographs of the other revolutionary heroes who were killed with Che, in a tent in Revolution Plaza. National buses were re-routed to bring schools, various organizations, and more than one hundred thousand people from around the country to Havana for the viewing of the coffin. Cuban officials invoked Che's ideals of socialist self-sacrifice and volunteerism to inspire support for a national campaign to make state-owned farms and factories more productive, as well as reiterate solidarity against the United States.

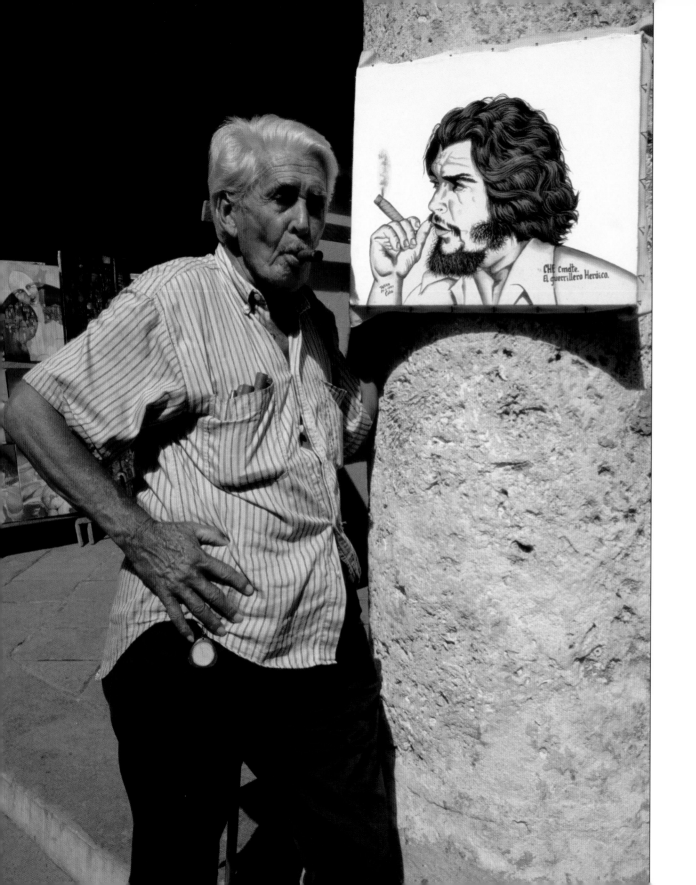

An artist poses with drawings of Che Guevara that are for sale to tourists in Havana.

A government-painted mural of
Che Guevara, Regla.

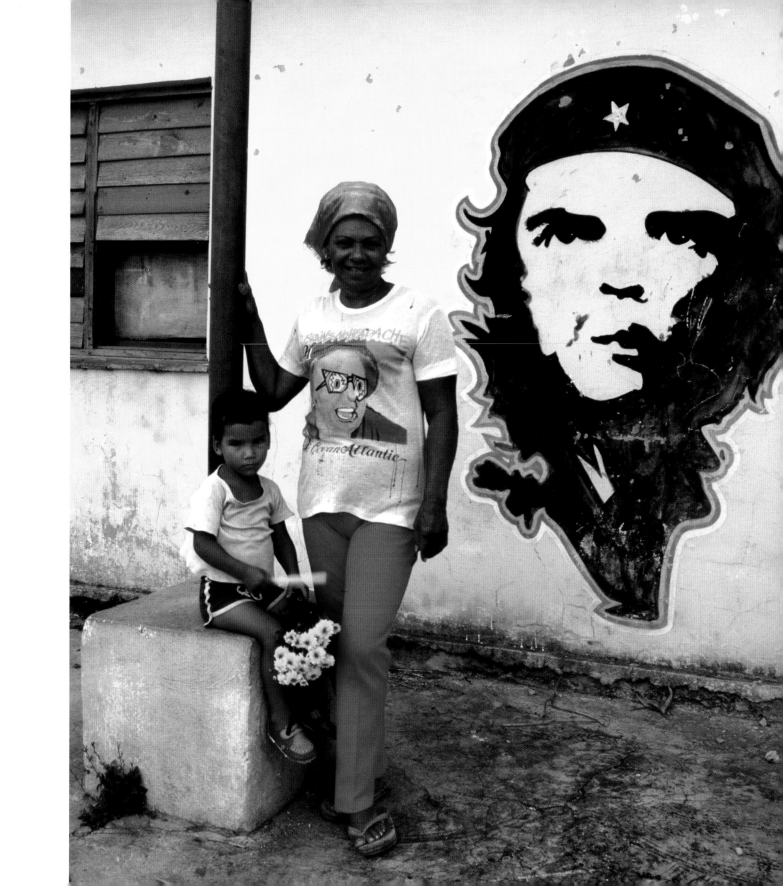

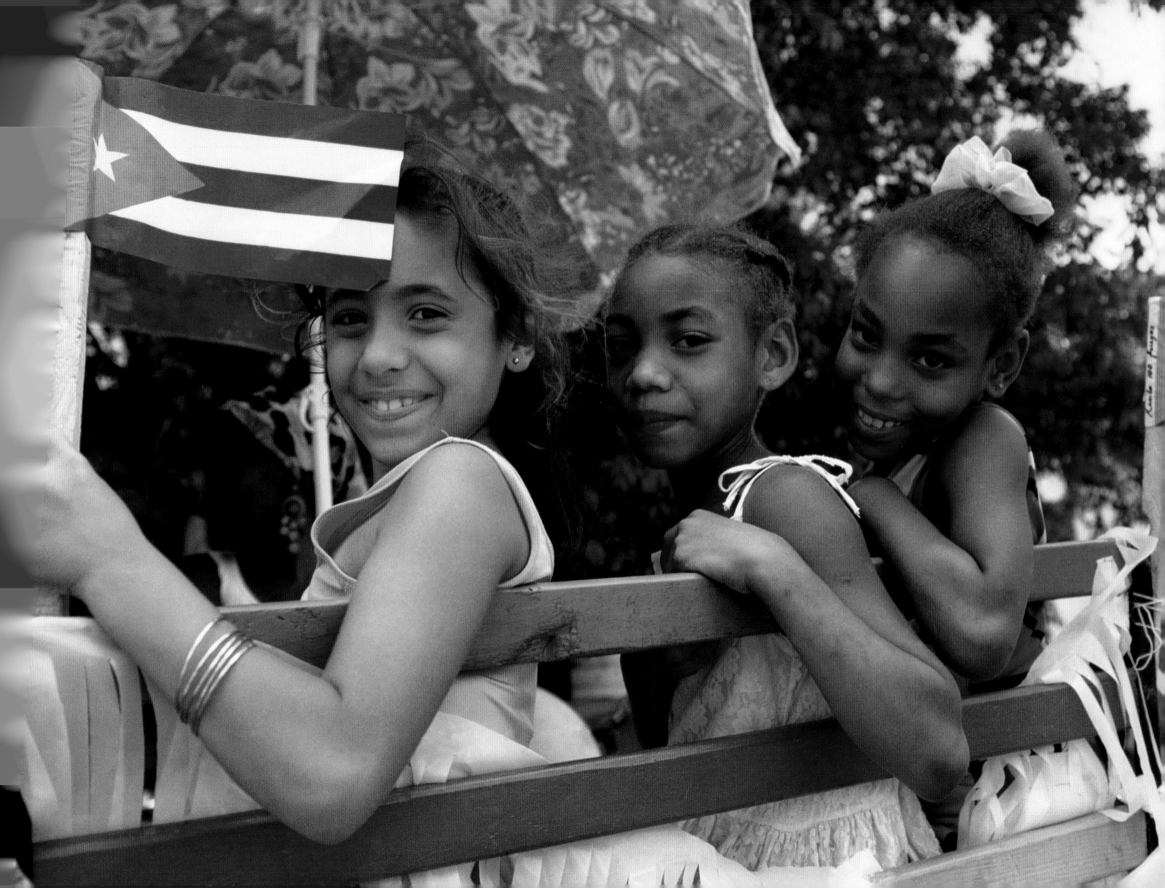

CHAPTER SEVEN

Patriotism / Patriotismo

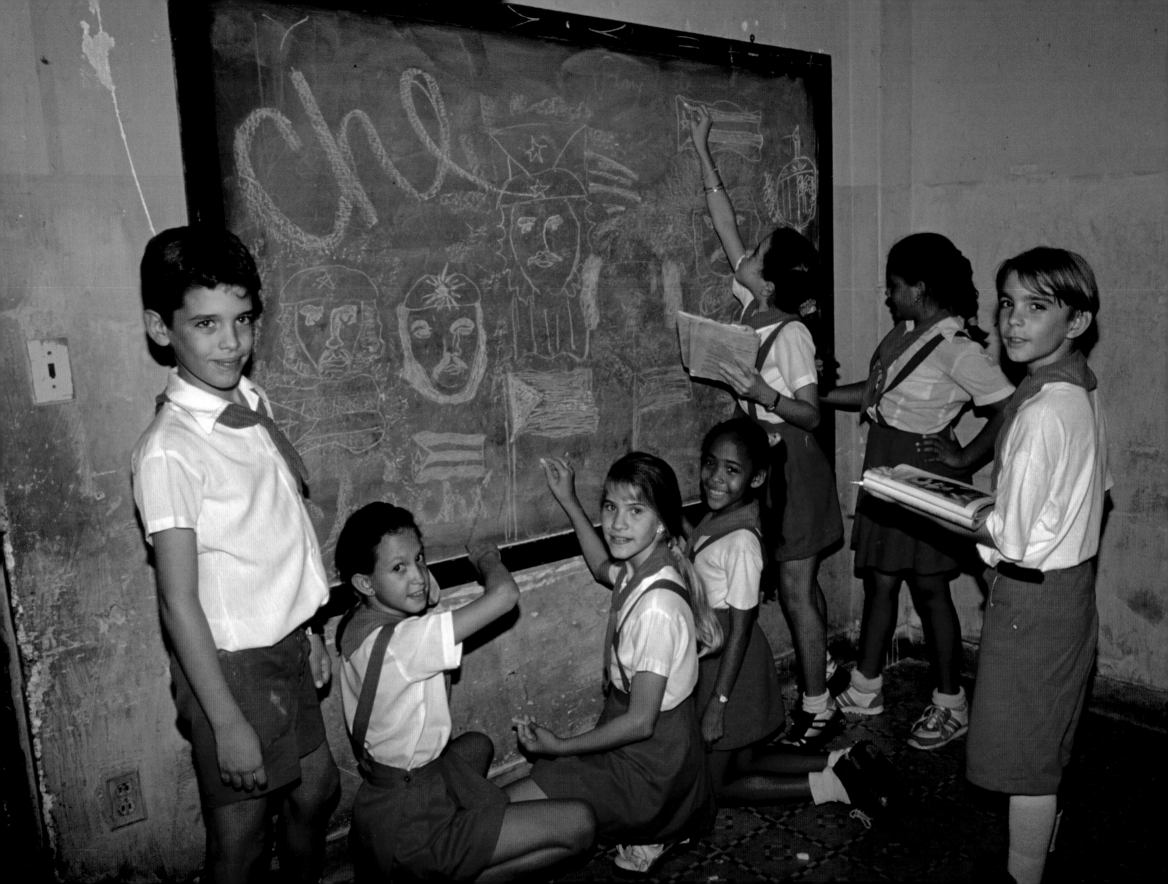

Page 158: Children wave the Cuban flag in a parade against the US embargo.

Opposite: Students study Che and the Cuban Revolution in elementary school.

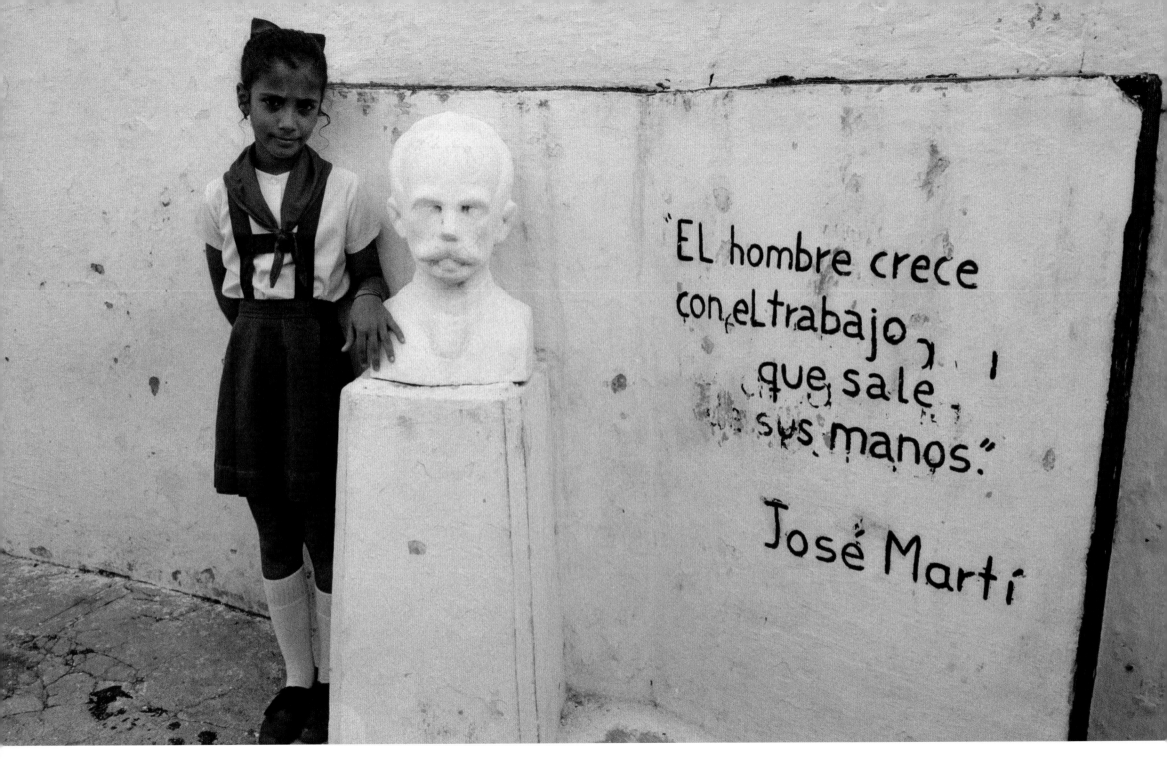

A schoolgirl poses outside her school in Havana, with a sculpture of the National Cuban poet José Marti. The quote reads, "*El Hombre Crece con el trabajo que sale de sus manos*" (A man grows from work with his hands).

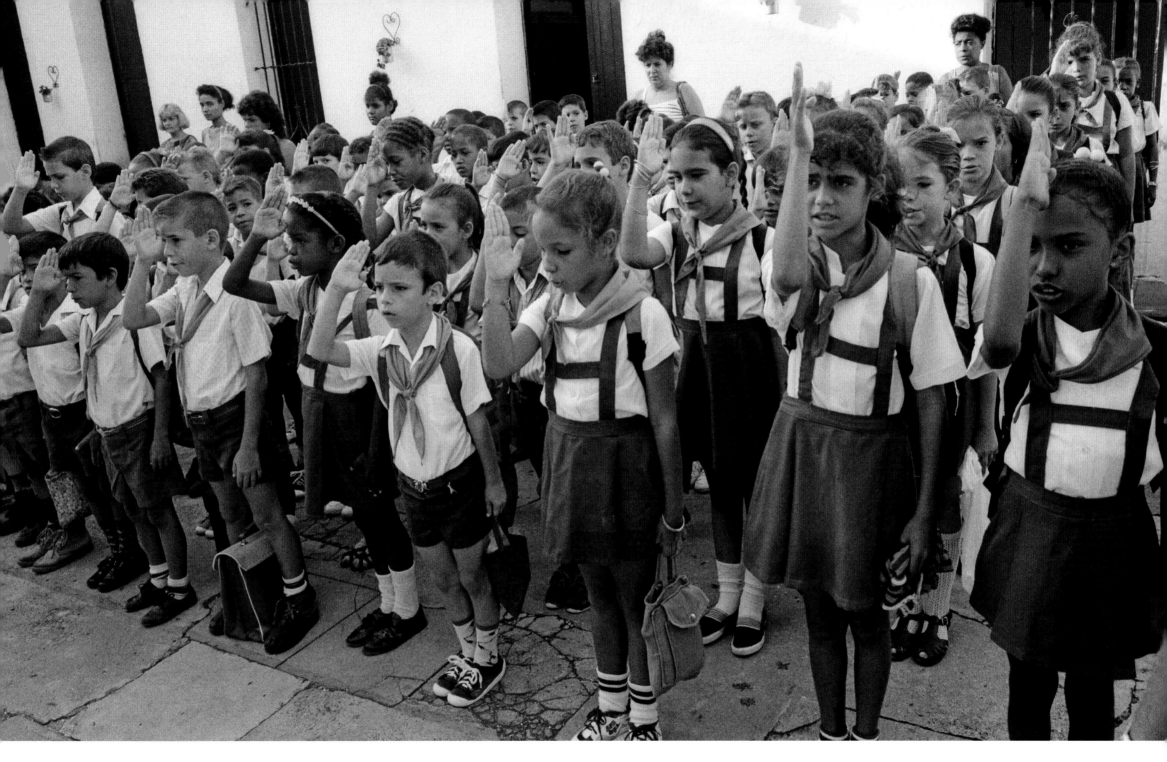

Elementary students gather, salute the national flag, and recite the morning pledge.

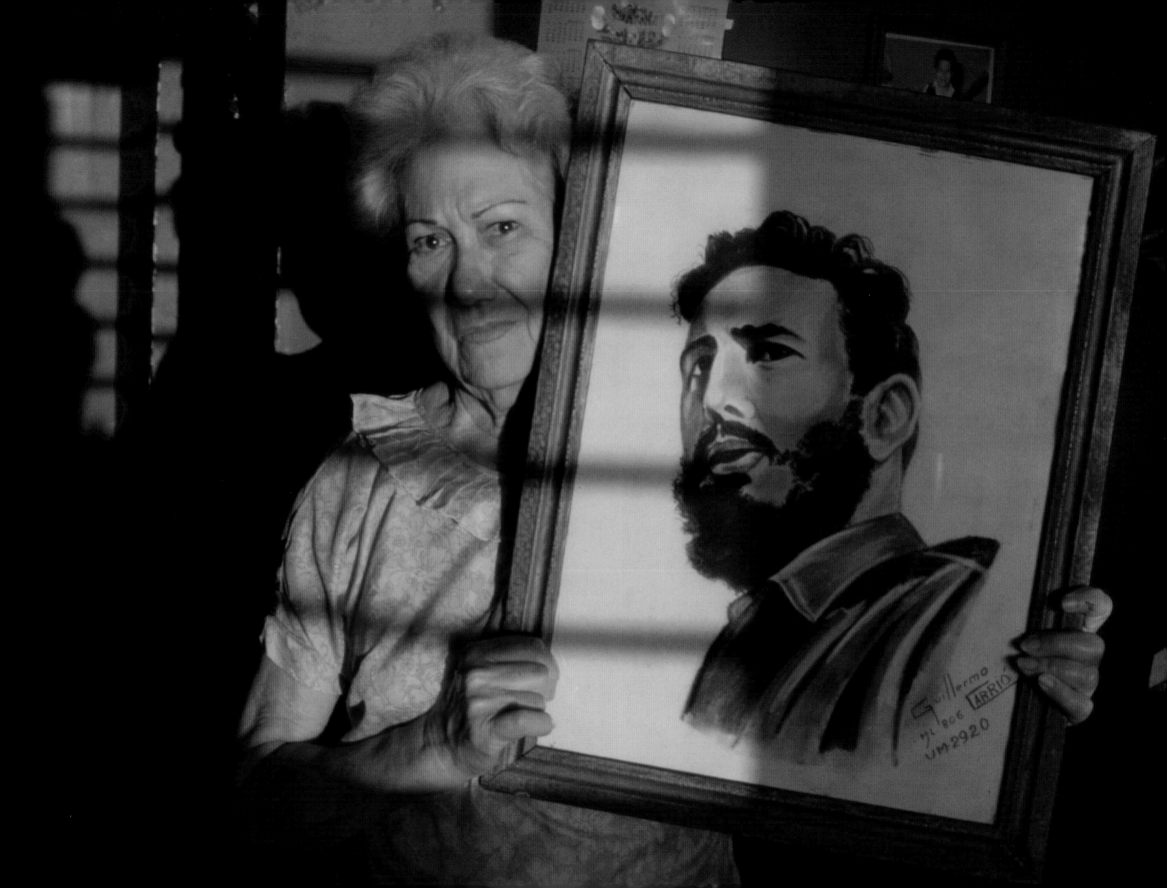

A woman poses with a portrait of a young, revolutionary Fidel that hangs in her living room in Guanabacoa.

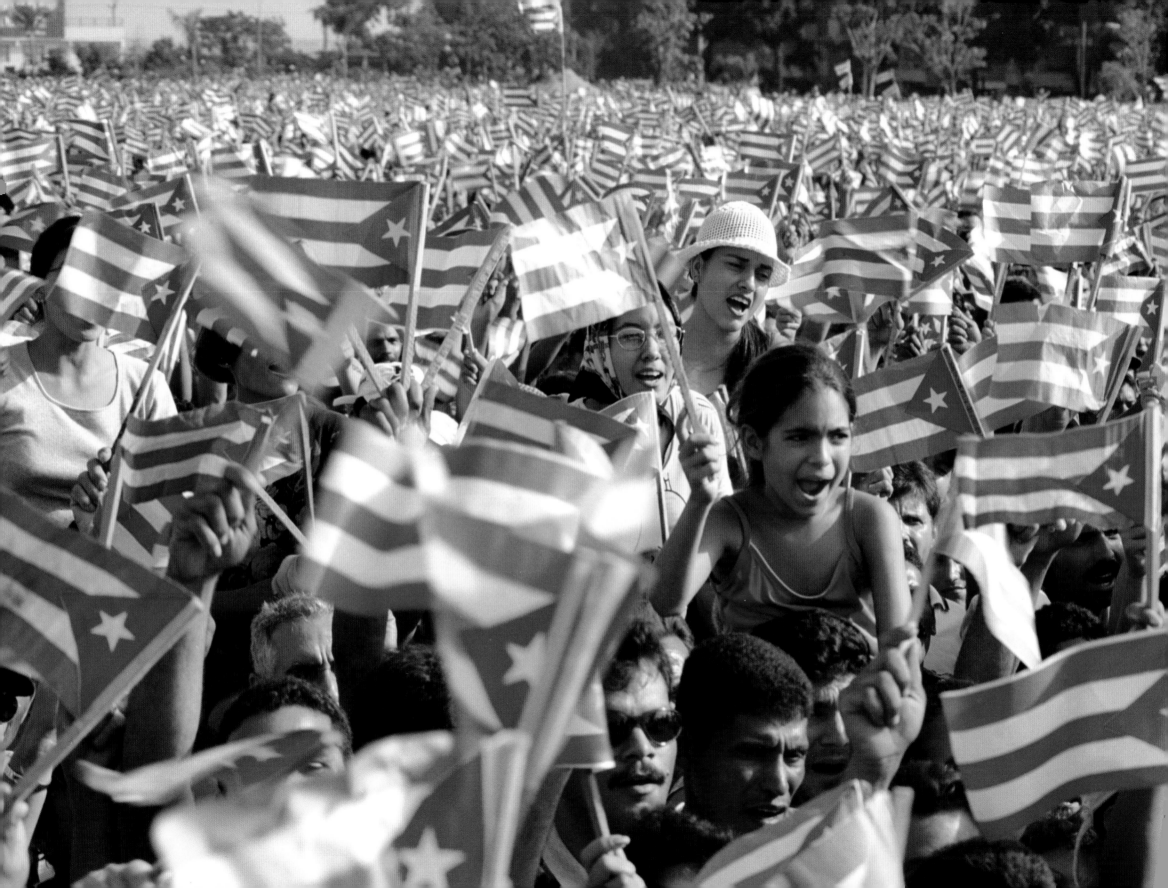

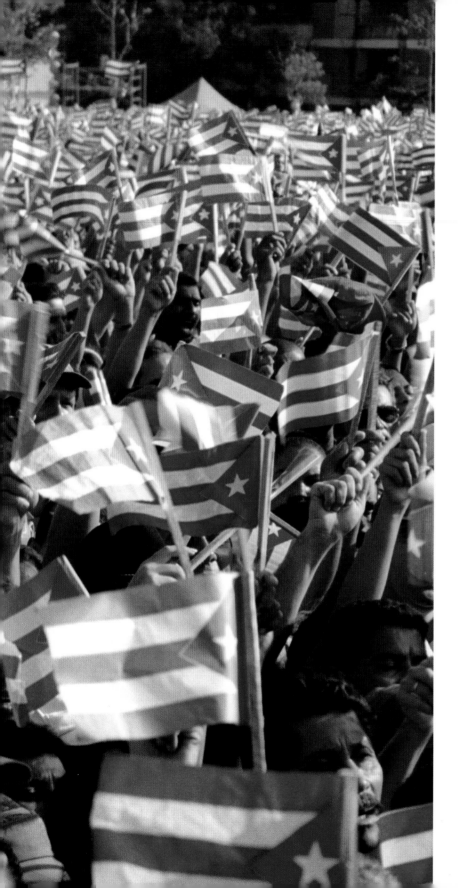

A government-organized rally celebrating Elian Gonzalez's return to Cuba. What has become known as "the Elian Gonzalez affair" was a heated international debate in 2000 on whether seven-year-old Elian Gonzalez, whose mother had drowned while attempting with Elian and her boyfriend to illegally immigrate to the United States, should stay in the US or return to his father in Cuba.

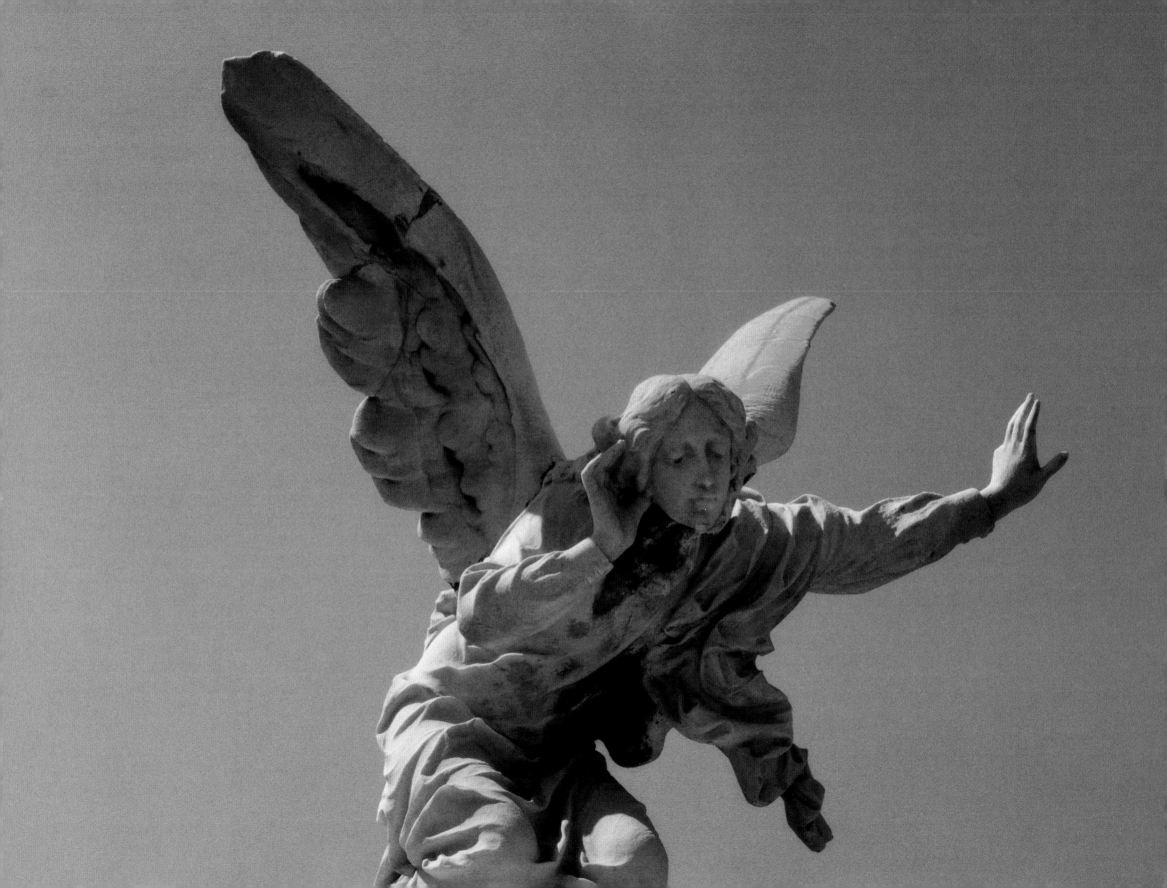

CHAPTER EIGHT

Souls and Spirits / Almas y Espíritus

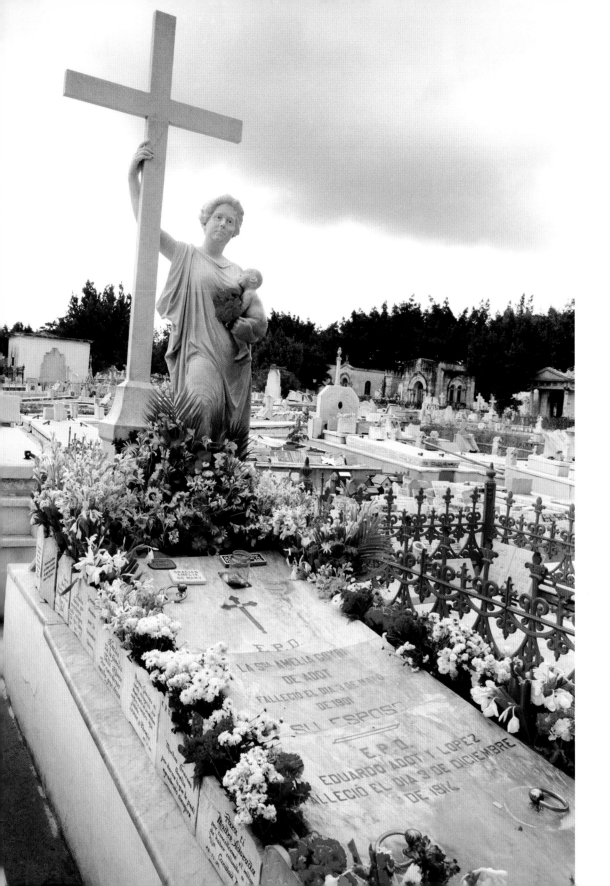

A famous statue of *La Milagrosa* (Miracle Worker) in the Cementerio de Cristóbal Colón (Columbus Cemetery).

Page 168: One of many angel sculptures built with marble brought from Italy, in the Cementerio de Cristóbal Colón, (Columbus Cemetery) in Havana. The cemetery is one of the most important in Latin America in historical and architectural terms. It was built in the 1860s by the Galician architect Calixto Arellano de Loira y Cardoso, a graduate of Madrid's Royal Academy of Arts of San Fernando, who became Colón's first occupant when he died before his work was completed.

A shrine in front of the Santería Museum in Guanabacoa. This structure shows the parallel between Santería worship and practice in Cuba and that of Catholicism. Santería combined the Yoruba religion of the African slaves with Catholicism and strands of some Native American traditions.

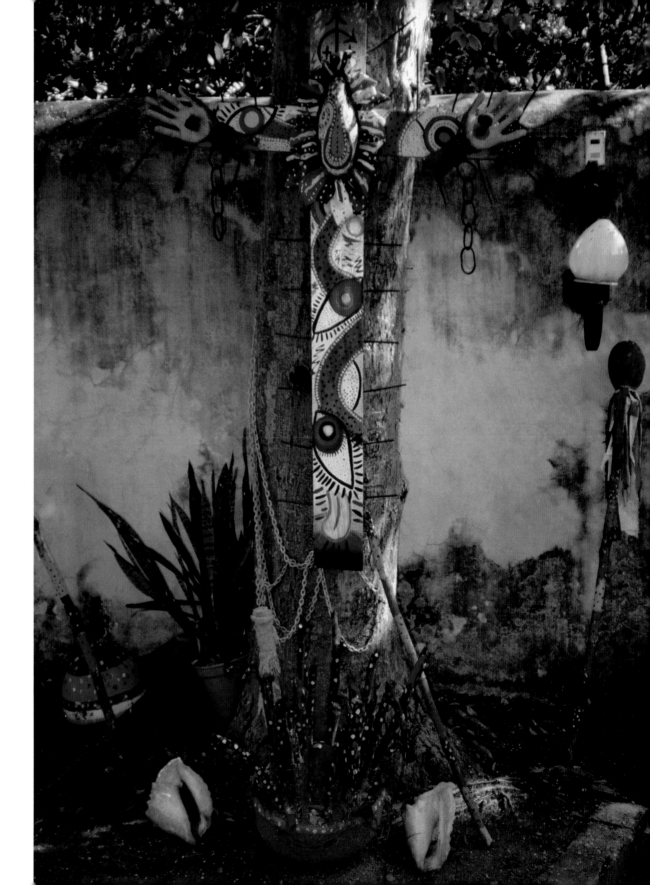

Opposite: The Cathedral of the Virgin Mary of the Immaculate Conception, in Old Havana, was built in a Baroque style with several Tuscan elements, mainly made of coral rock, and designed with asymmetrical features.

The Roman Catholic Church held a dominant position in Cuba during the colonial era as a result of Spain's colonization of the Americas. Yet in 1959, after Fidel Castro ascended to power, in accordance with the traditional anti-religious doctrine of Marxist-Leninist ideology, Cuba officially became an atheist state, closing churches, restricting religious practice, and leading most catholic priests and protestant ministers to flee into exile for fear of imprisonment and persecution.

In the early 1990s, after the collapse of the Soviet Union, the Cuban constitution was amended to remove the definition of Cuba as being a state based on Marxism-Leninism, and an article was added prohibiting discrimination on the basis of religious belief. After three decades of state atheism, the country had become mostly secular. Yet as the economic situation worsened, the Church became a very active entity, providing assistance with food, clothing, hope, and spiritual relief from difficult circumstances.

In 1998, the Catholic Church in Cuba with Fidel Castro officially invited Pope John Paul II to visit the island. Cuban Cardinal Jaime Ortega prepared the country by giving public mass ceremonies to thousands of people in the streets and distributing papal flags and posters around the island. Churches opened for services once again and Christmas became a national holiday. In 2012, Pope Benedict XVI visited Cuba. Following his visit, he wrote letters to both Cuban leader Raúl Castro and US President Barack Obama, encouraging them to resolve the "humanitarian questions of common concern, including the situation of some prisoners," and offering to facilitate negotiations at the Vatican.

In 2014, Pope Francis became a crucial participant in the secret negotiations between the governments of Cuba and the United States, which eventually led to a prisoner swap and the beginning of dramatic political changes toward restoring diplomatic relations between the two countries.

In 2015, church officials in Cuba report more rapid government approvals for the construction of new churches and plans for renovating deteriorating and decaying old churches.

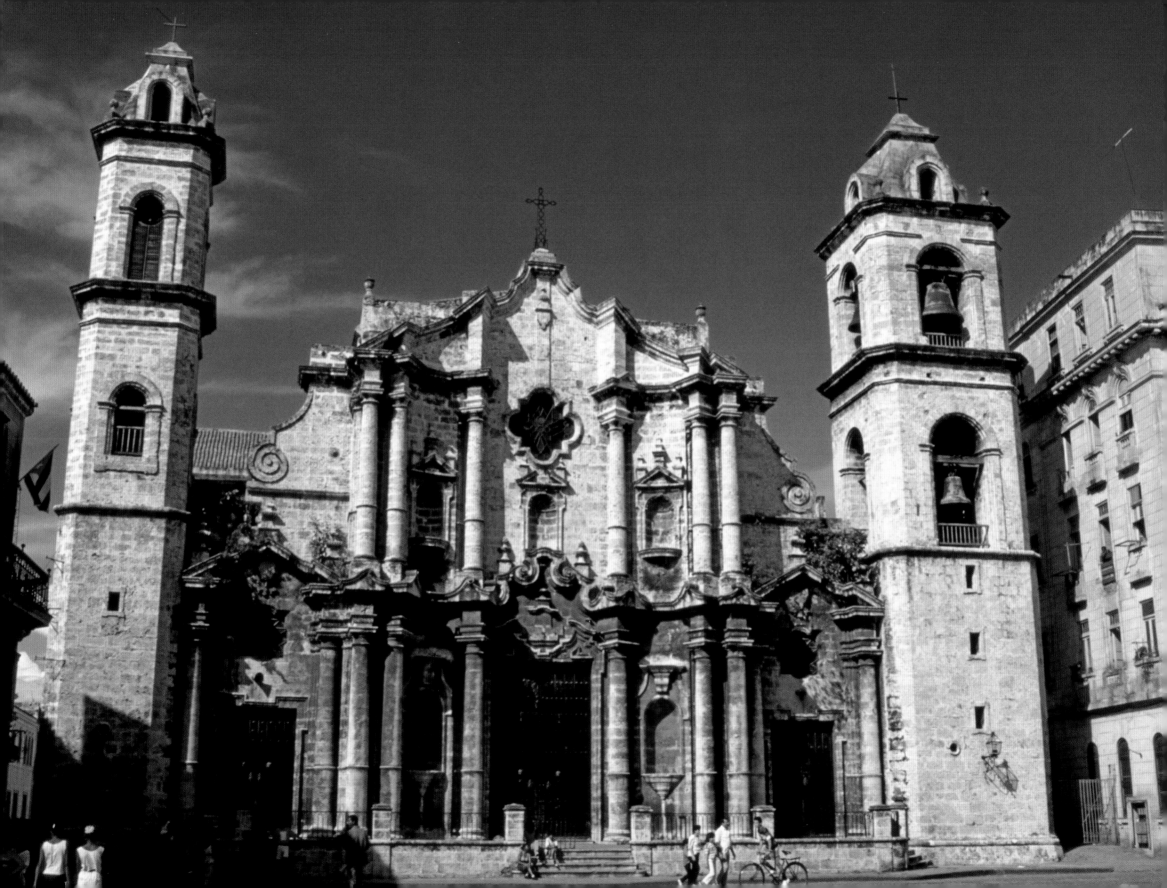

Opposite: The entrance to El Patronato synagogue, also known as La Casa De la Comunidad Hebrea de Cuba (House of the Jewish Community in Cuba), in Havana. Cuba's Jewish community traces back many centuries, but after Fidel Castro declared Cuba an atheist state with a communist system, nearly ninety-five percent of the Jewish community in Cuba fled for the United States. Although Jews were not persecuted specifically, they suffered economically when the new government nationalized their private businesses and property.

After the collapse of the Soviet Union and Cuba's loss of economic support from Russia in the early 1990s, the Cuban constitution was amended to prohibit discrimination on the basis of religious belief. The American Jewish Joint Distribution Committee (JDC) became instrumental in rebuilding Cuba's Jewish population. The JDC sent rabbis and community organizers to help with education and services, as well as arranged for the shipment of special foods for Jewish holidays and basic medical necessities, which were scarce on the island. B'nai Brith and other international Jewish organizations also provide much needed supplies to Cuba's Jewish community. Synagogues and Jewish community centers have opened around the country, teaching Hebrew and providing necessities, social services, meals, and medicines, while also organizing and hosting community events and celebrations for a growing population of Cuban Jews.

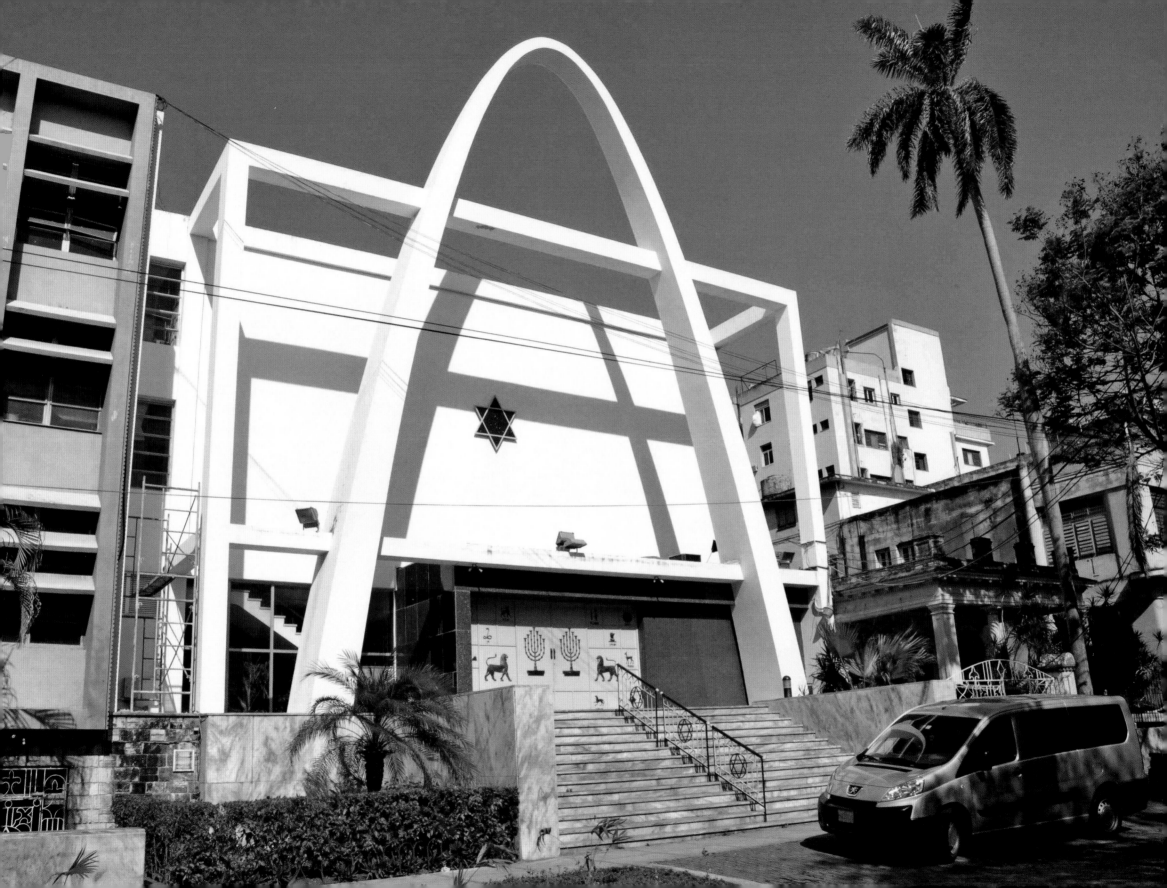

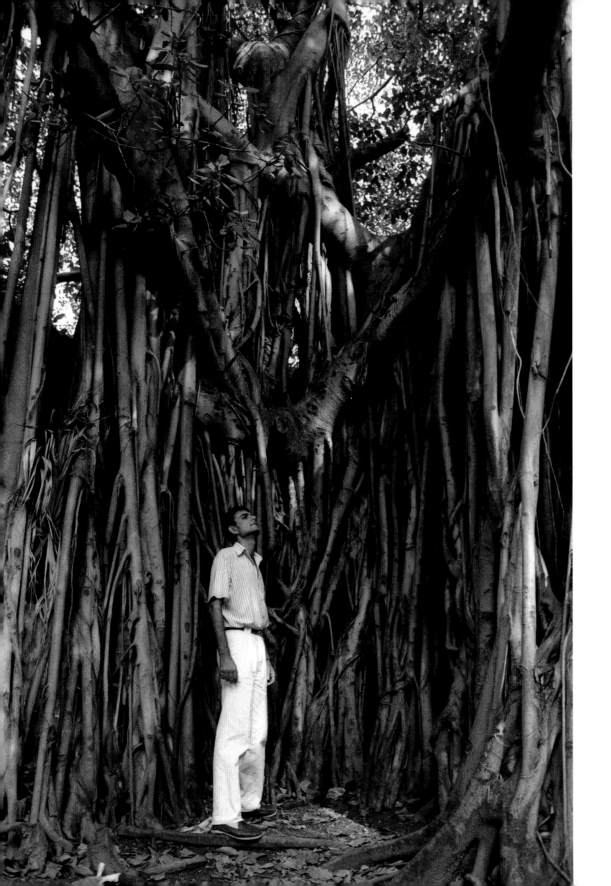

Here and opposite: Massive ficus trees with dangling aerial banyan roots in Havana.

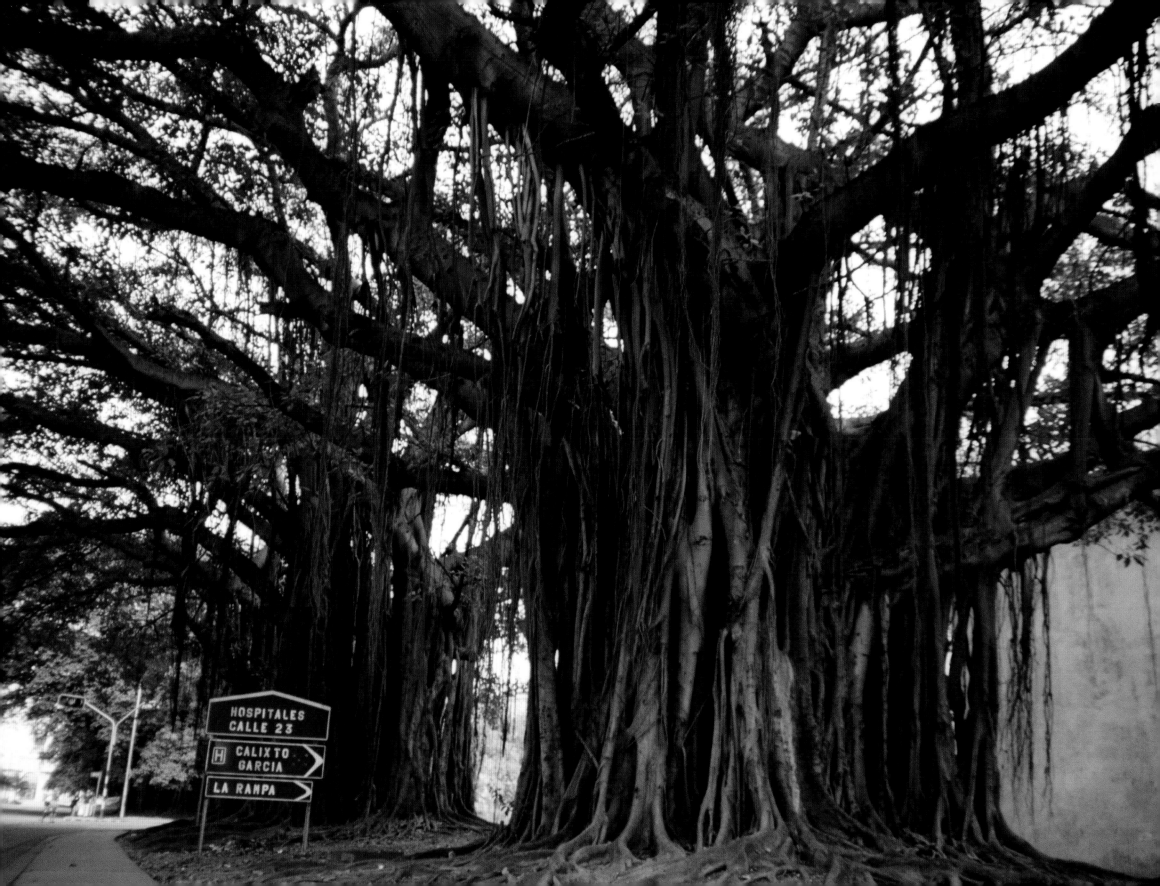

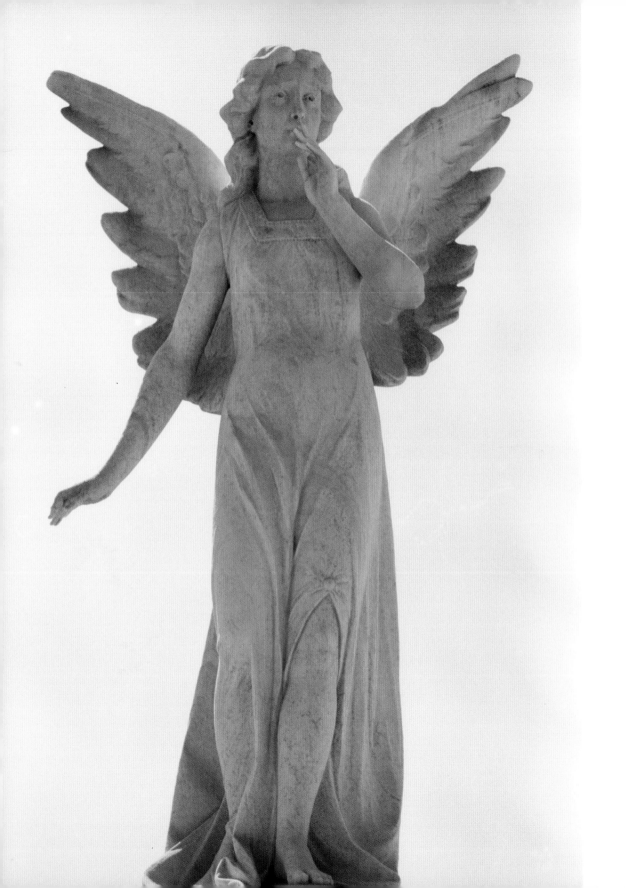

One of many angel sculptures built with marble brought from Italy, in the Cementerio de Cristóbal Colón (Columbus Cemetery), Havana.

Opposite: Marble plaques from Cubans with messages of appreciation and thanks to Amelia, La Milagrosa, (The Miracle Worker) in the Cementerio de Cristóbal Colón (Columbus Cemetery).

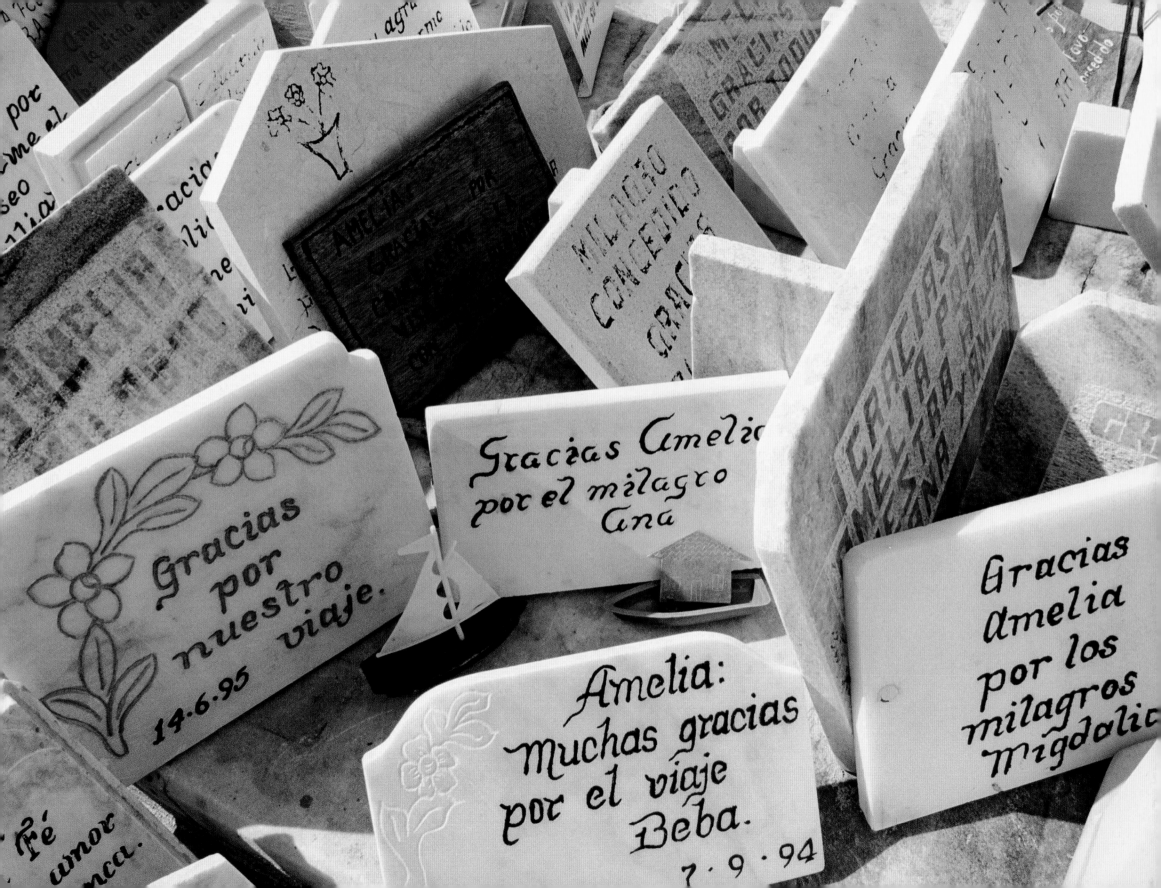

The Catholic Church of San Antonio de los Baños.

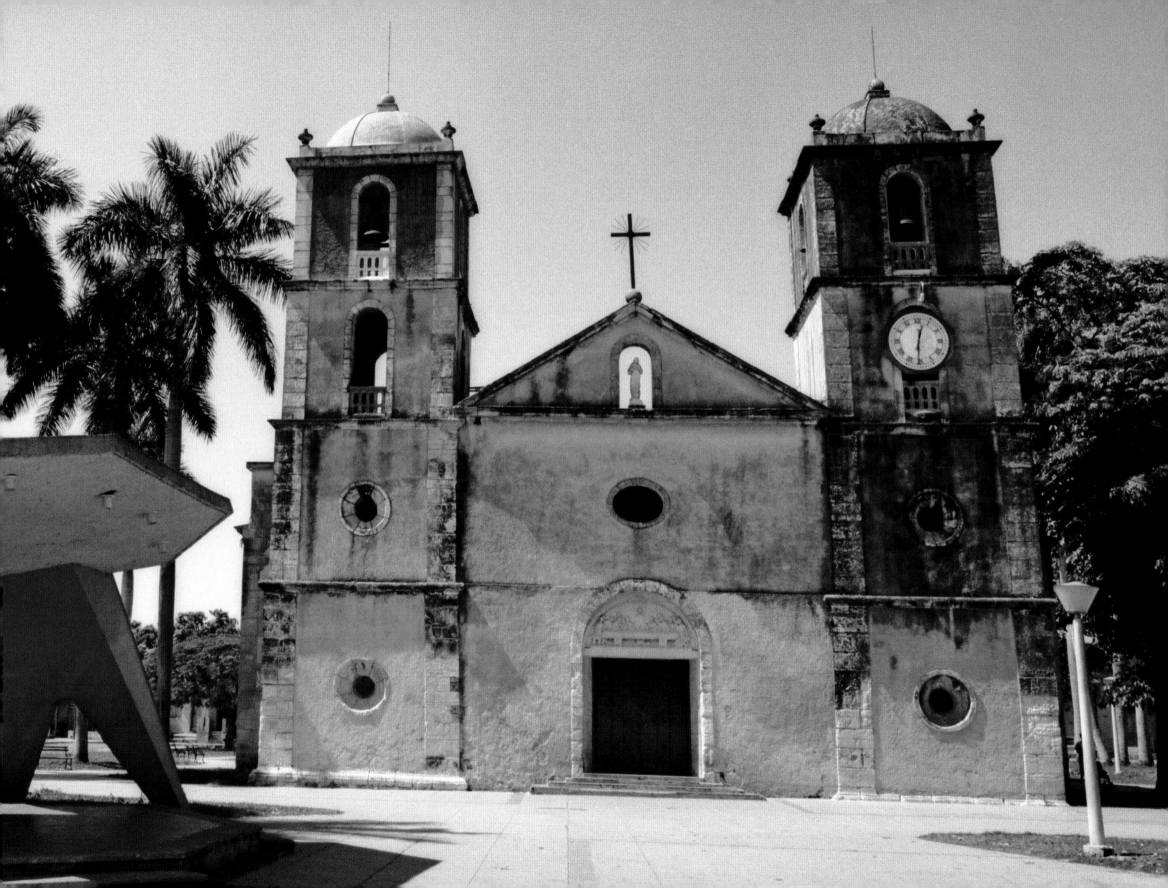

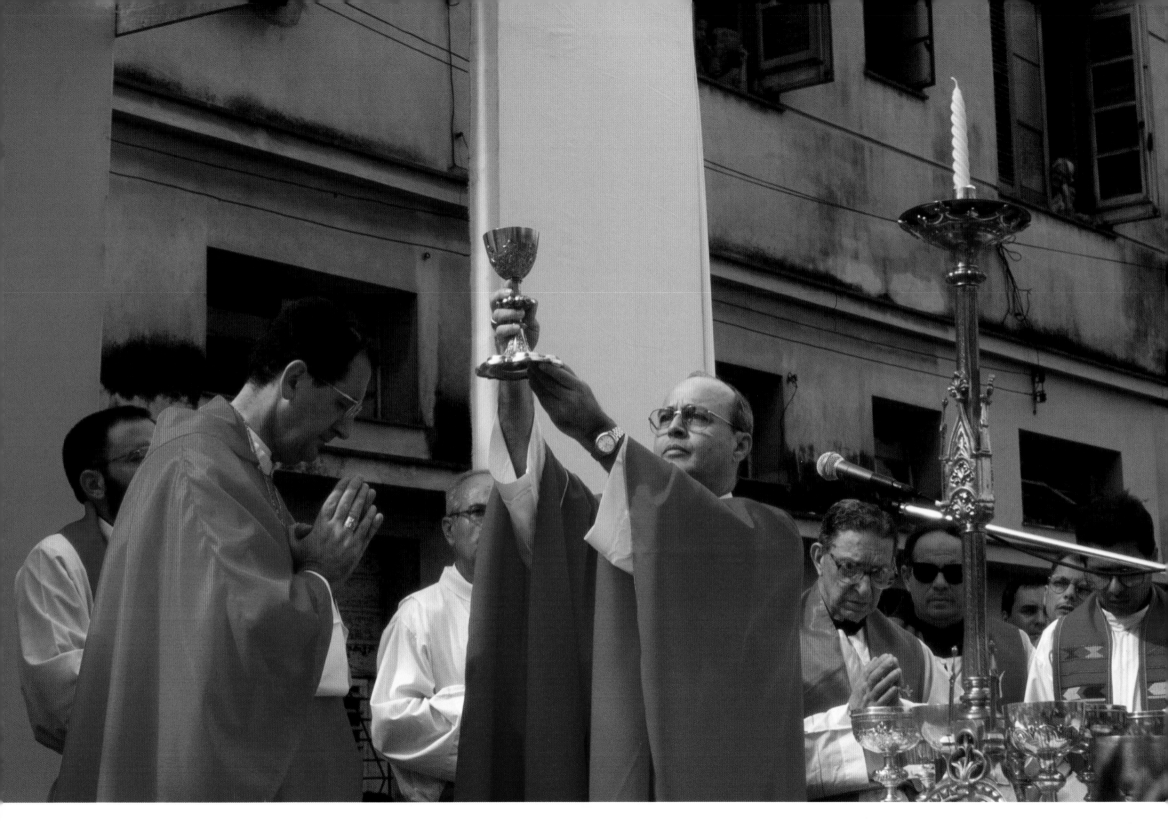

Cuban Cardinal Jaime Ortega conducts a public mass in the streets of Havana in preparation for Pope John Paul II's visit.

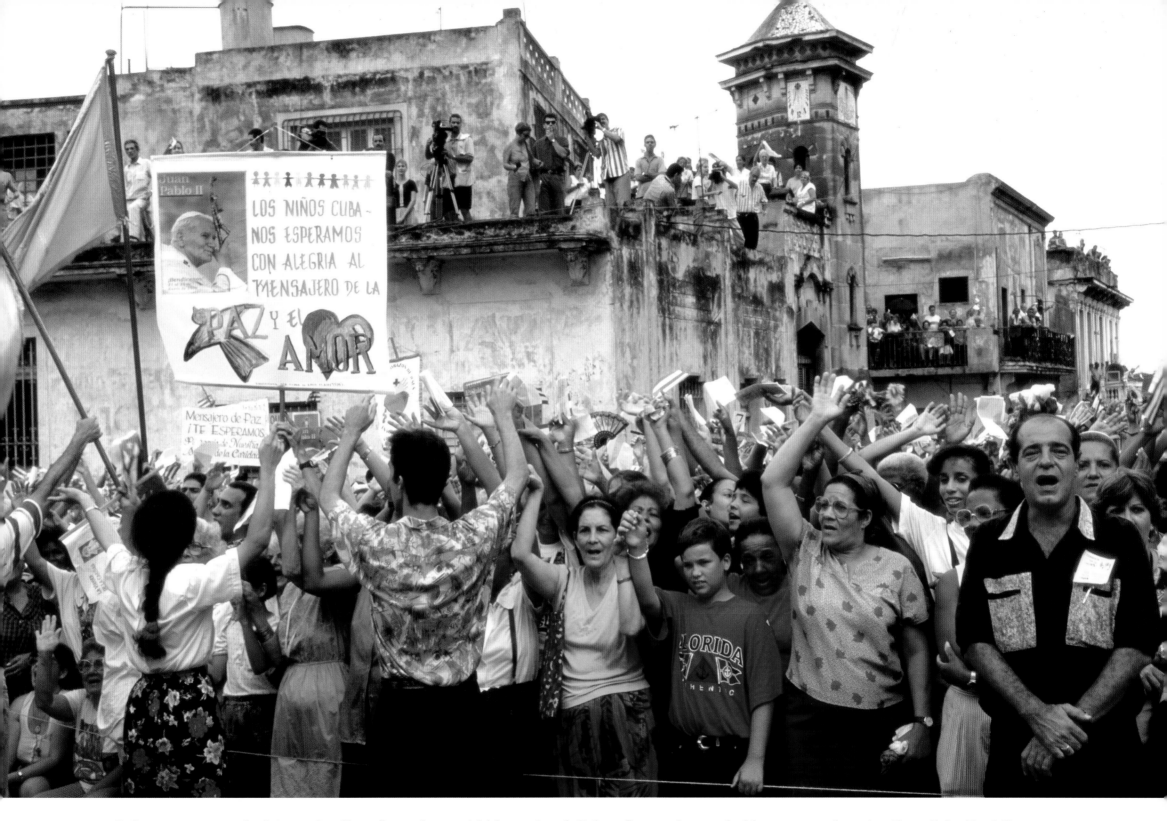

Cubans wave papal white and yellow flags along with the national Cuban flag, and some hold posters welcoming Pope John Paul II.

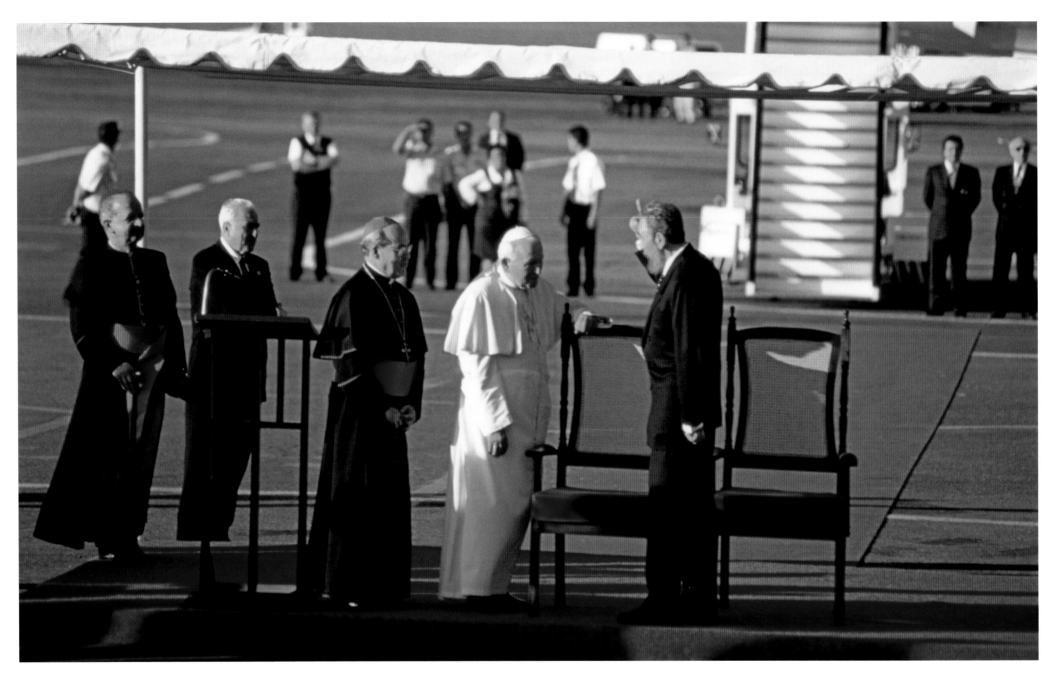

In 1998, Cuban leader Fidel Castro wore a suit rather than his typical military uniform when greeting Pope John Paul II at the airport in Havana. The pope made an official and historic visit to Cuba, touring the country and giving public mass to thousands of Cuban citizens.

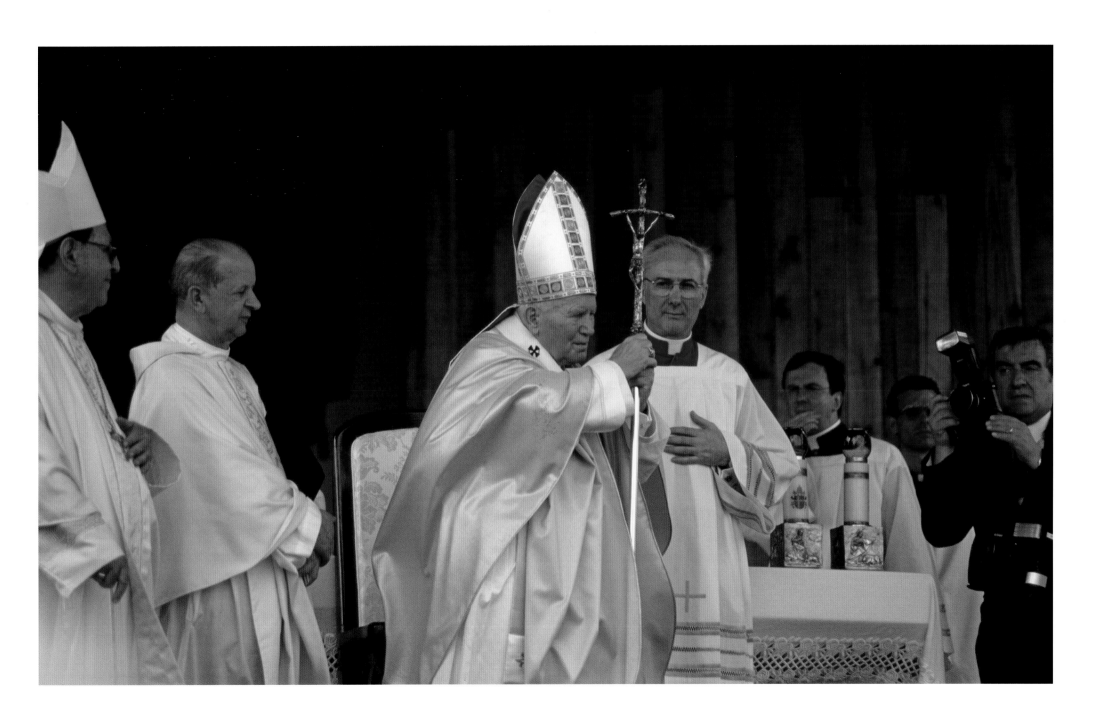

Pope John Paul II gives mass in Camagüey.

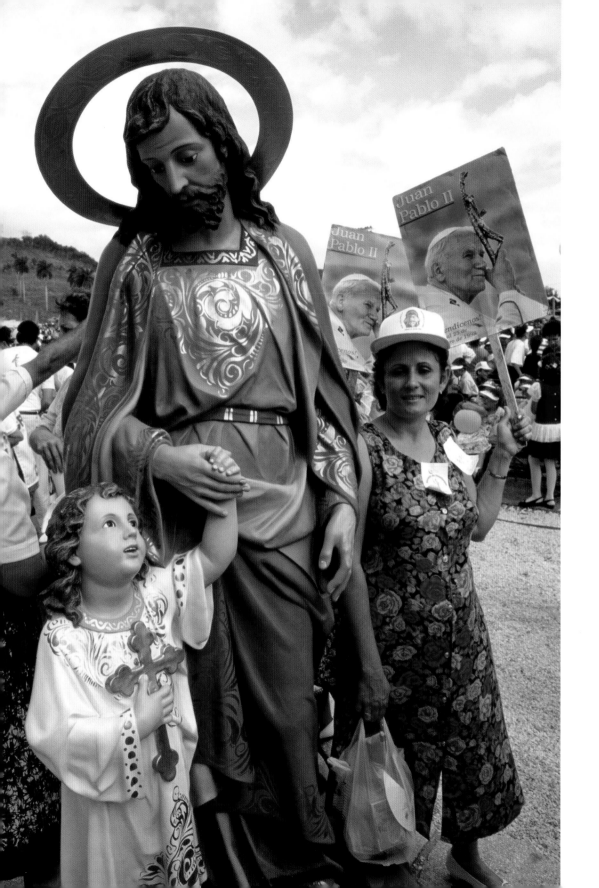

A statue of Jesus Christ beside people waiting to see the pope.

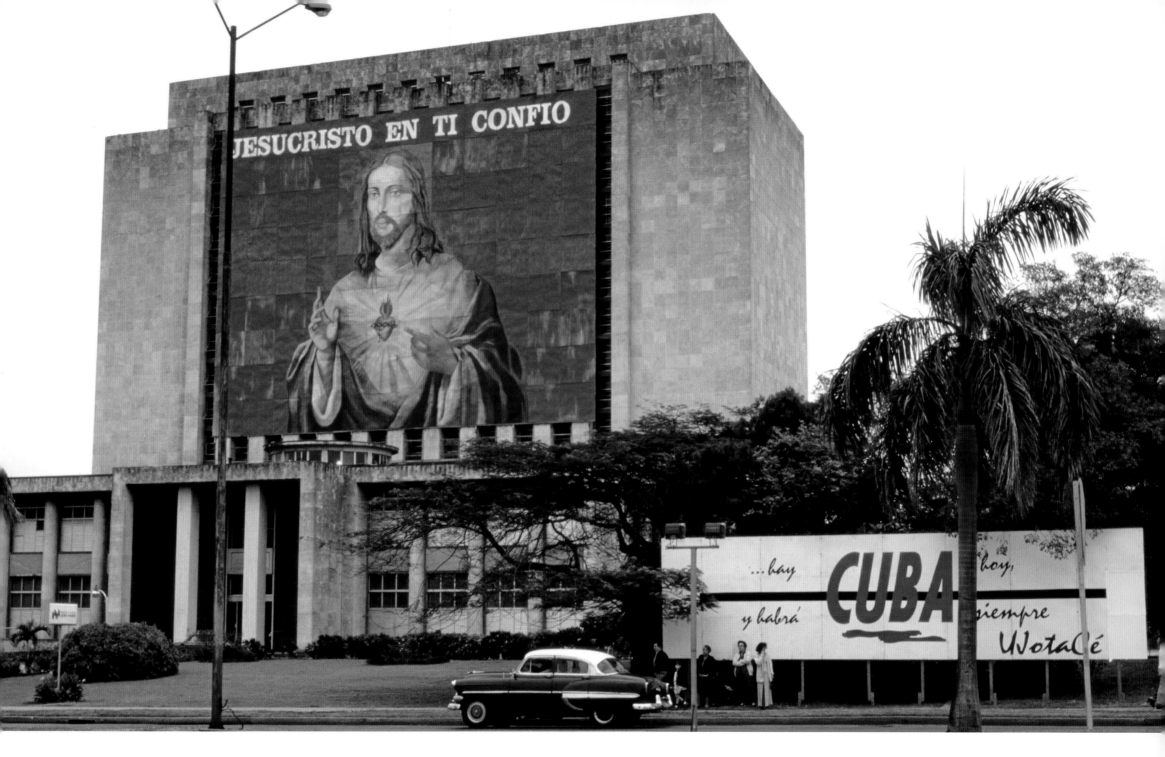

A mural of Jesus Christ with the words "We believe in you," was erected in Havana's Plaza de la Revolución (Revolution Plaza) in honor of Pope John Paul II's historic visit. The mural was immediately removed upon the pope's return to Italy.

187

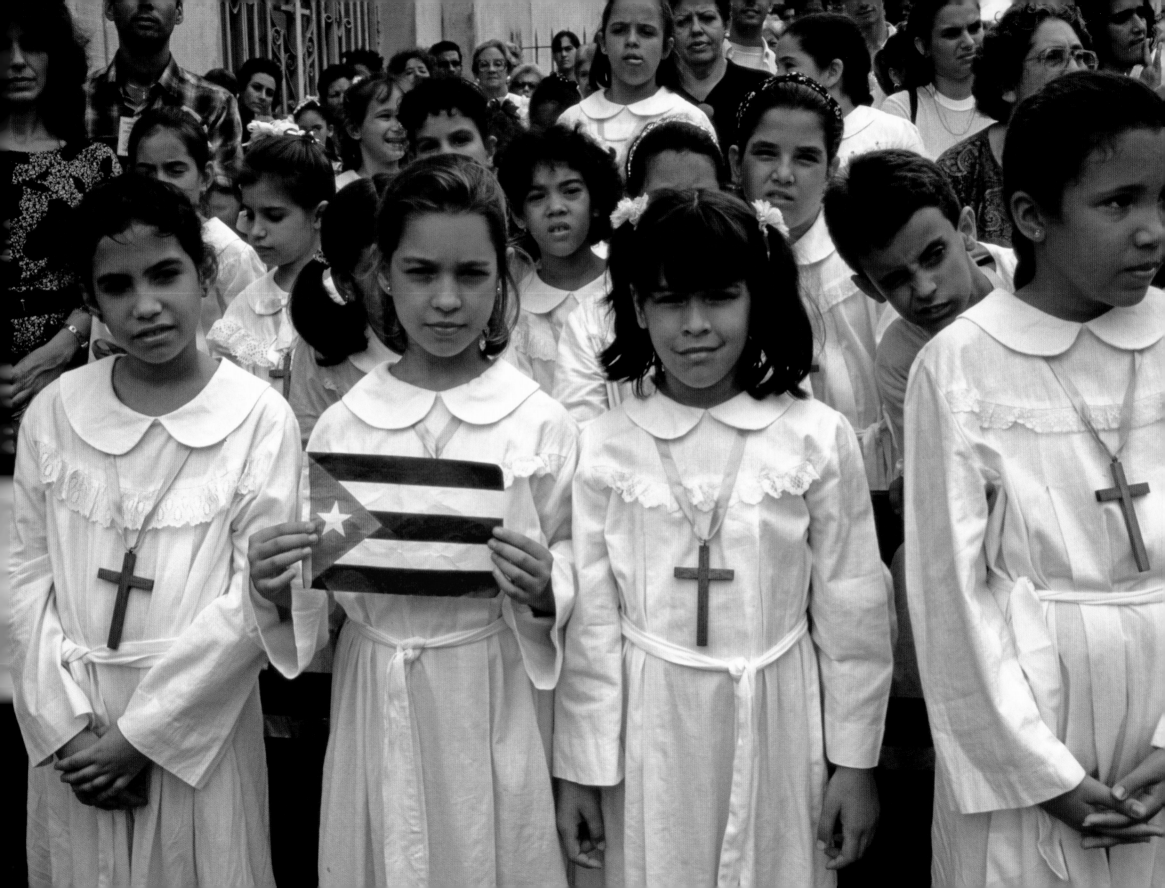

Opposite: When Pope John Paul II visited Cuba in 1998, Cuban children were able to publicly wear Catholic crosses.

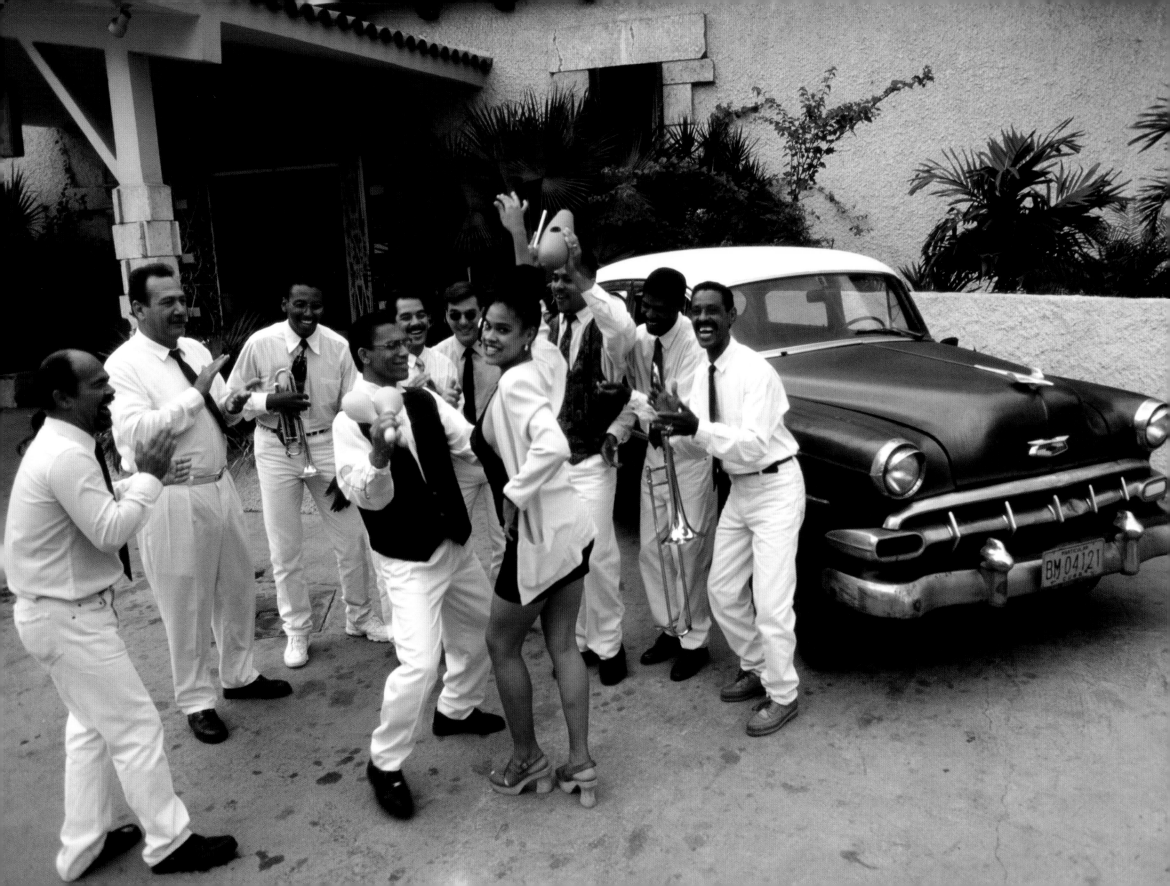

CHAPTER NINE

Masters of Music / Maestros de la Música

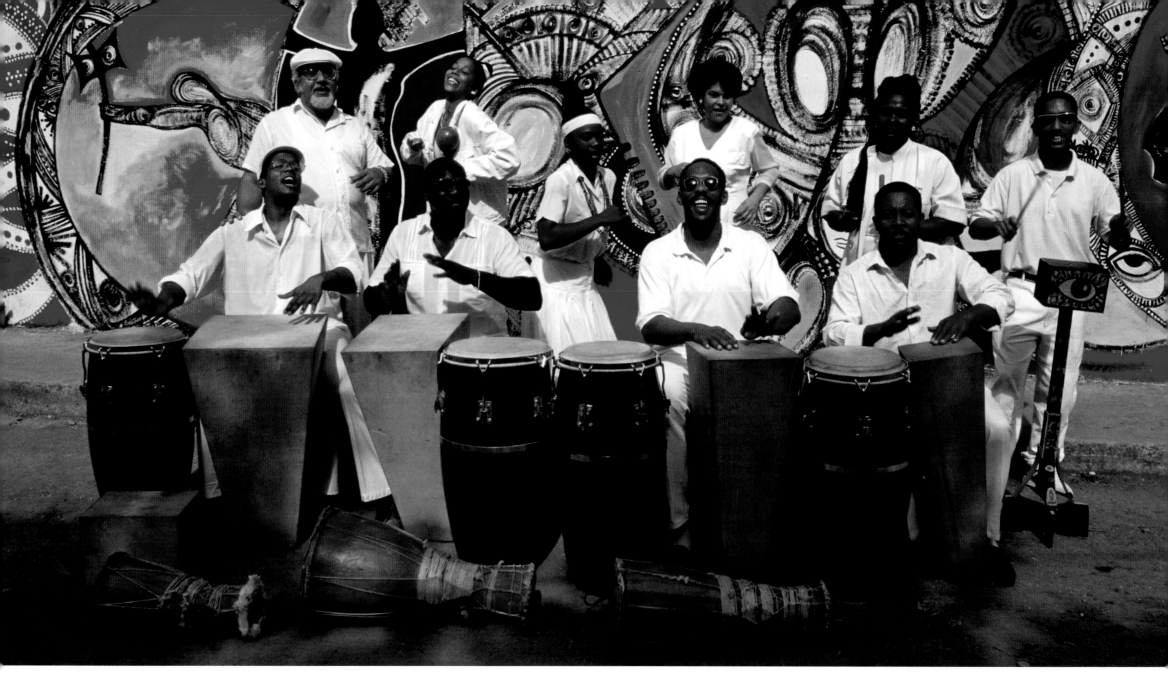

Founded more than fifty years ago, Clave y Guaguanco is a prominent rumba group from Havana whose drummers, singers, and dancers perform regularly in the Callejon de Hamel (Hamel's Alley).

Page 190: La Calle band in Havana.

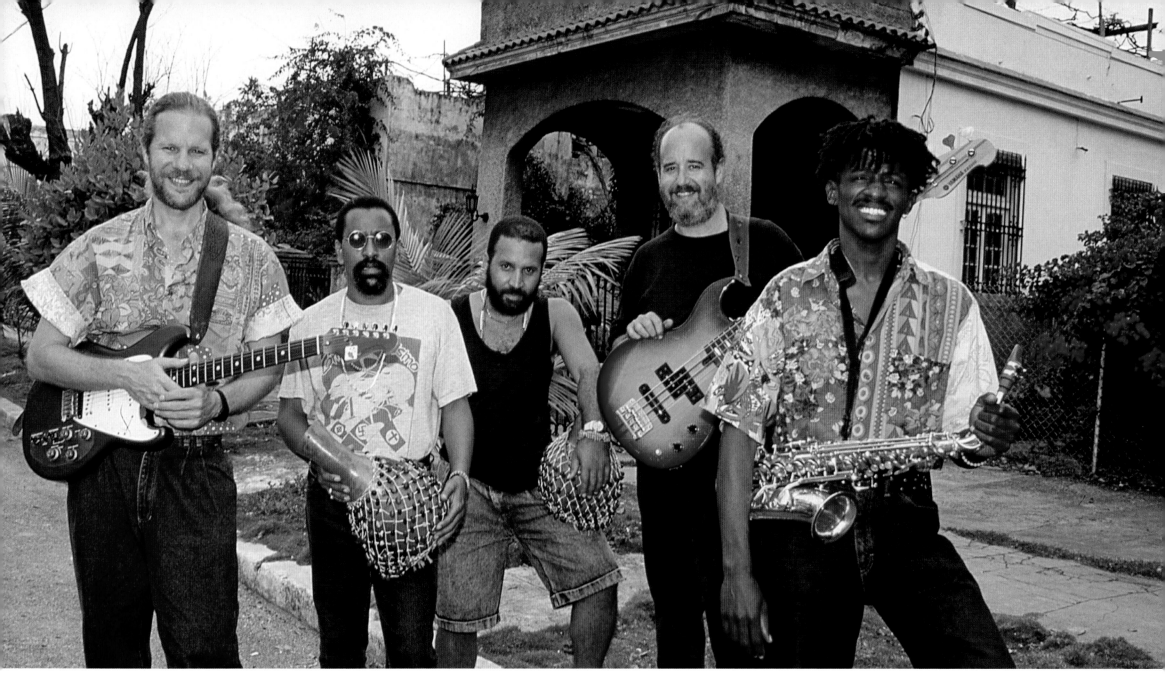

The ensemble Grupo Mezcla was founded in 1989 by California-born Pablo Menéndez (far left), who combined multi-generational musicians to incorporate elements of Afro-Caribbean heritage, jazz, trova, and even rock into their music.

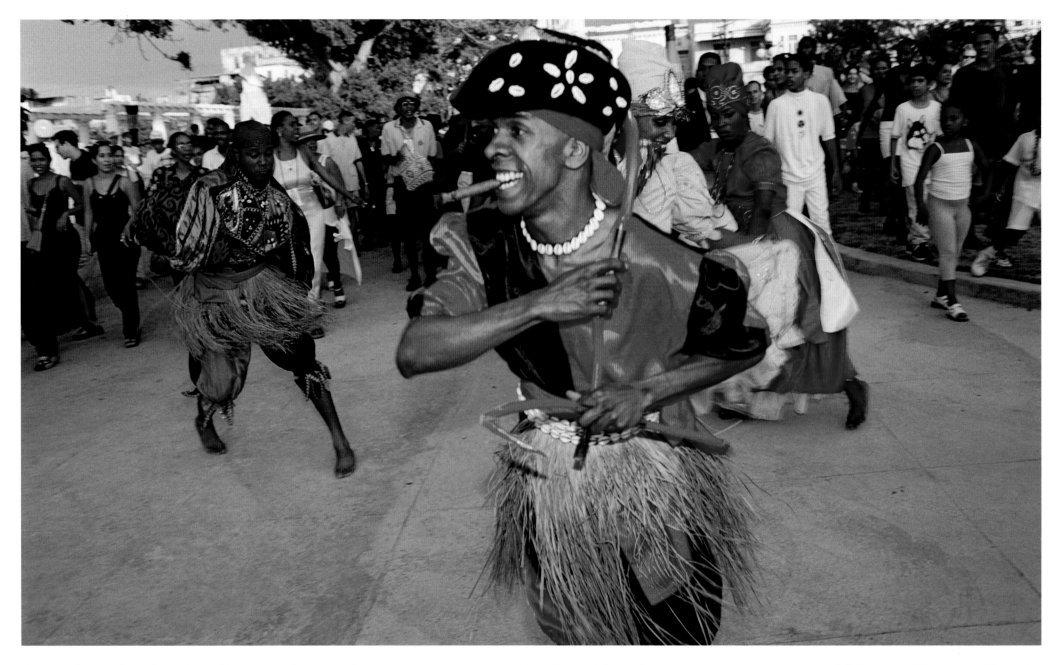

A man dressed as the orisha Eleguá performs a dance to communicate with other orishas. Sometimes represented as a child or an elder man, Eleguá represents both the beginning and the end of life.

Pages 194–195: The Grammy award-nominated Cuban group Los Muñequitos de Matanzas perform in Harlem, New York in 1992. For more than forty-five years, its members have performed songs and dances representative of orishas and the more secular Cuban rumba, which arose on the docks of Matanzas. There, Cuban slaves, forbidden to play their traditional African drums, beat rhythms on boxes as they were unloading them. Eventually, those jam sessions evolved into one of Cuba's greatest musical forms, rumba. As a result of relaxed visa restrictions and efforts by the Clinton administration to further cultural exchange with Cuba, the group was the first Cuban musical group to tour in the US since the embargo against Cuba was enacted in 1960.

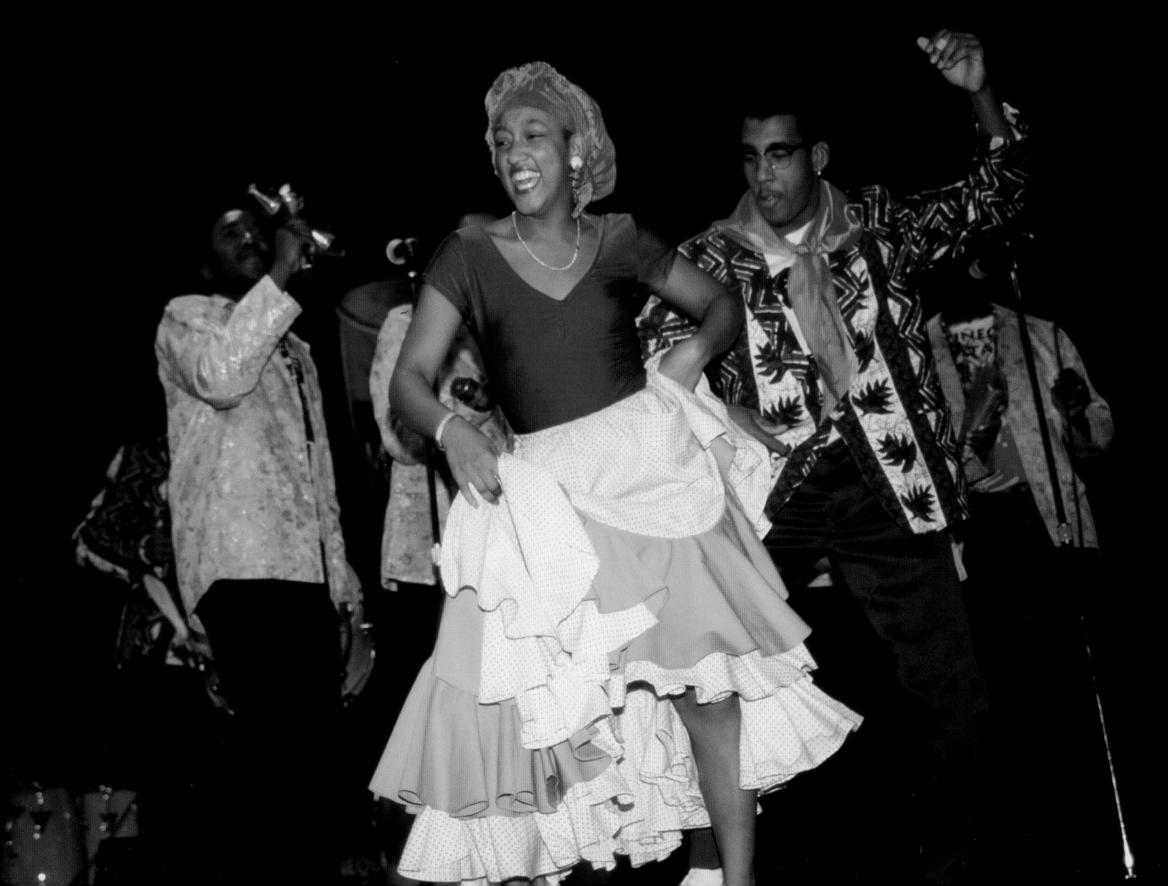

Ibrahim Ferrer became famous through Ry Cooder's
Grammy Award-winning song "Buena Vista Social
Club." In 2004, Ferrer, who had performed in the US
previously, won his own Grammy, but was denied
permission to enter the US to receive his award. In
2005, Ferrer passed away in Havana.

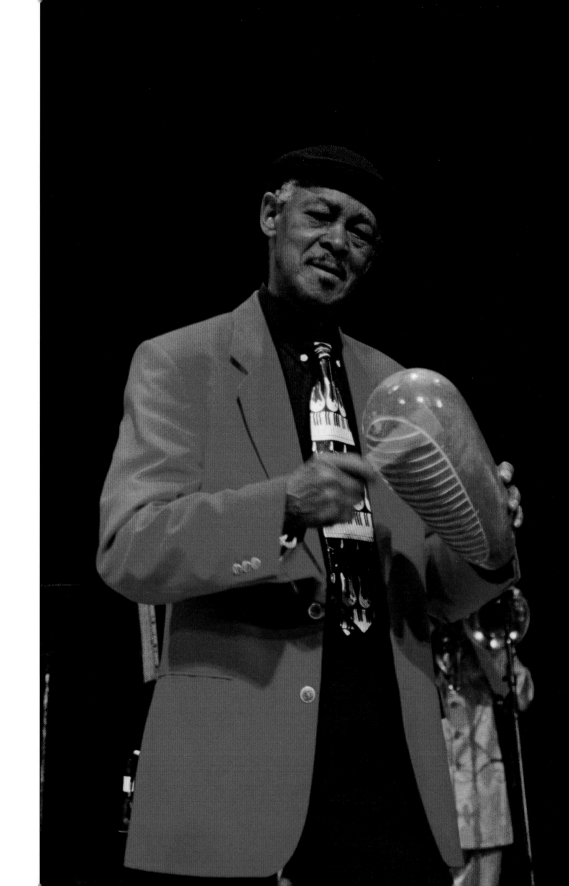

Lázaro Ros devoted his career to preserving and maintaining African traditions in Cuban music. He is the country's premier *Akpwon* (singer of sacred Afro-Cuban chants), and his performances are ceremonies designed to summon the orishas. Lázaro's voice was often accompanied by a chorus and hourglass-shaped three-drum bata ensemble, the traditional instrument for calling the gods. The bata drummers, who play in groups of three, use rhythmic patterns unique to each spirit being invoked. Lázaro died at age seventy-nine, in 2005.

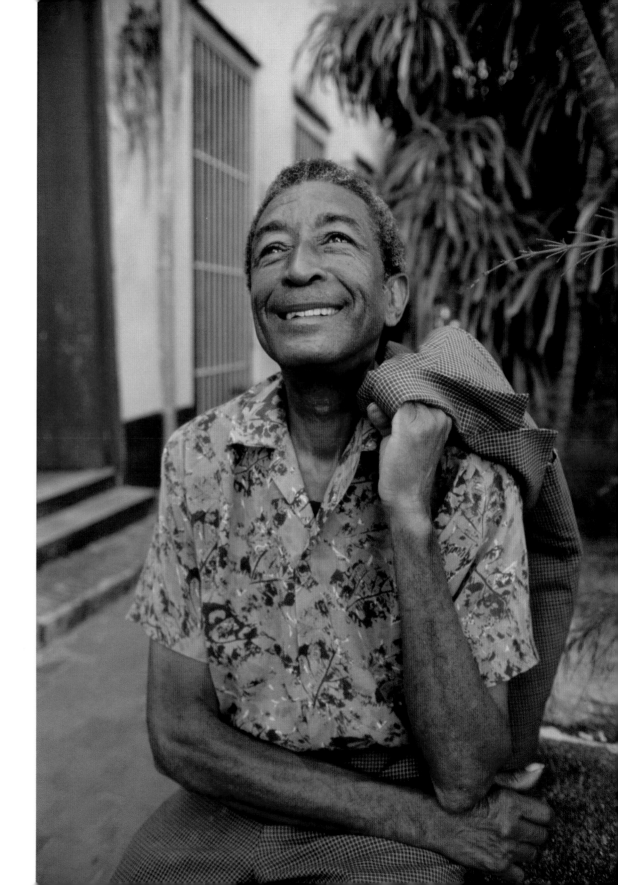

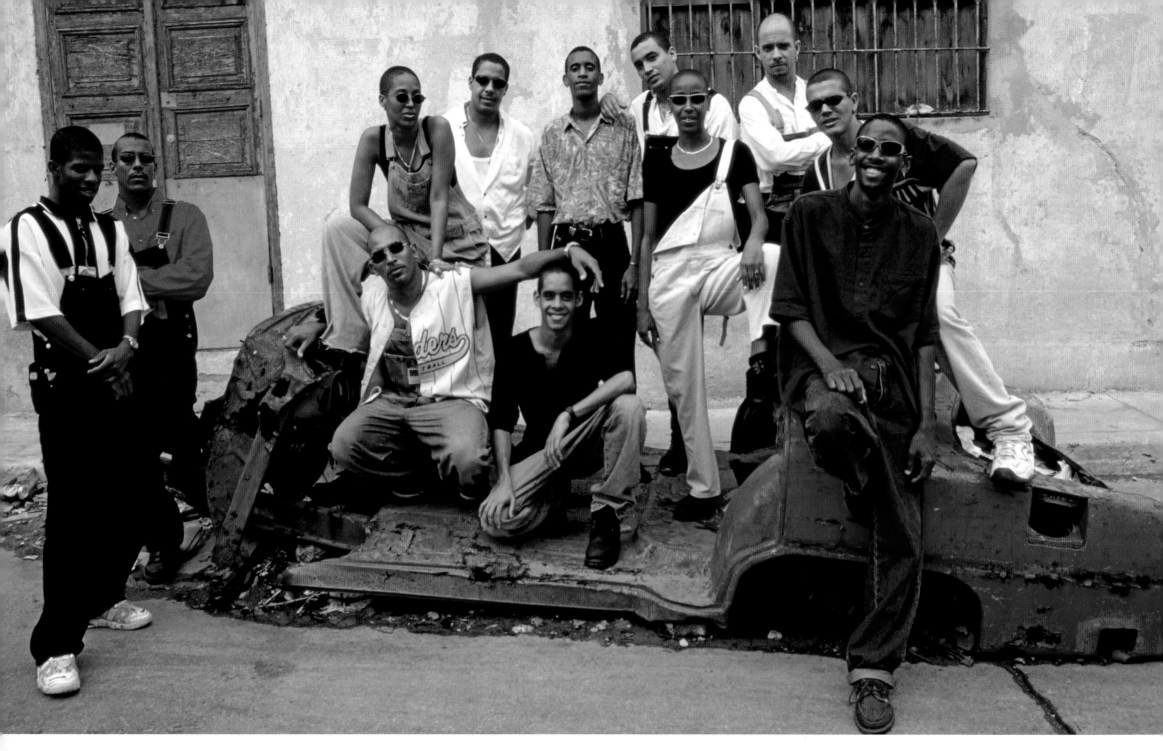

Bamboleo, a Havana-based Cuban salsa and timba band formed in 1995, is representative of the "timba brava" generation of Cuban bands in the 1990s.

Vannia Borges, the popular singer from the group Bamboleo.

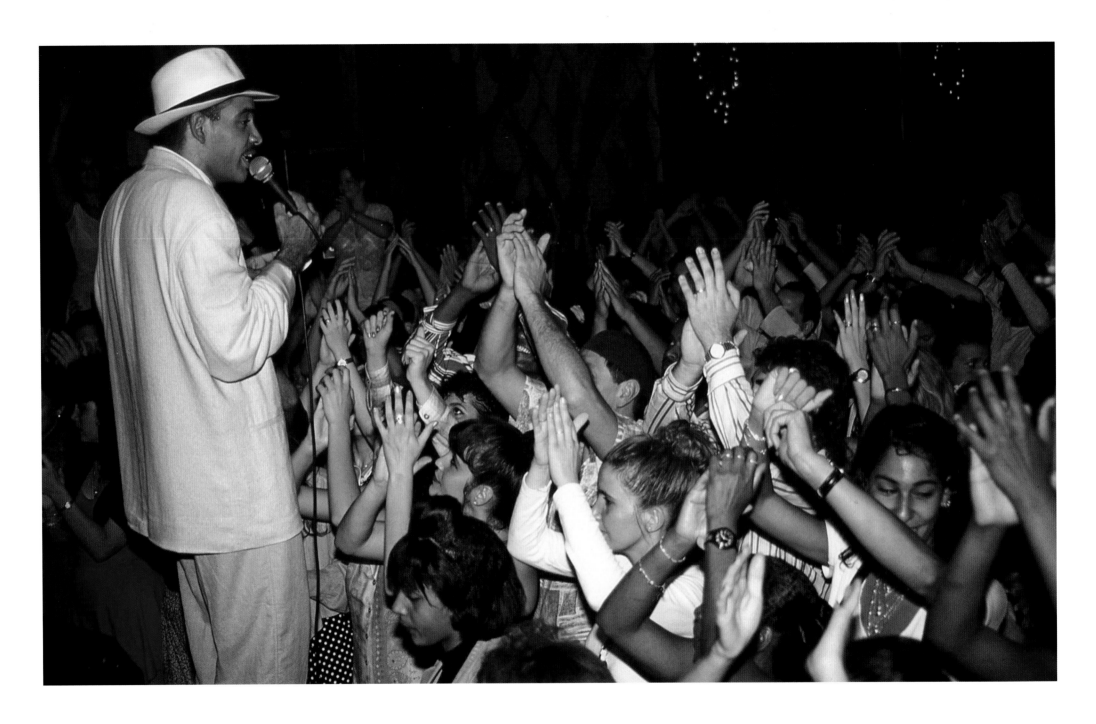

The salsa singer Manolín, "El Médico De La Salsa," performs in Havana's Palacio de la Salsa.

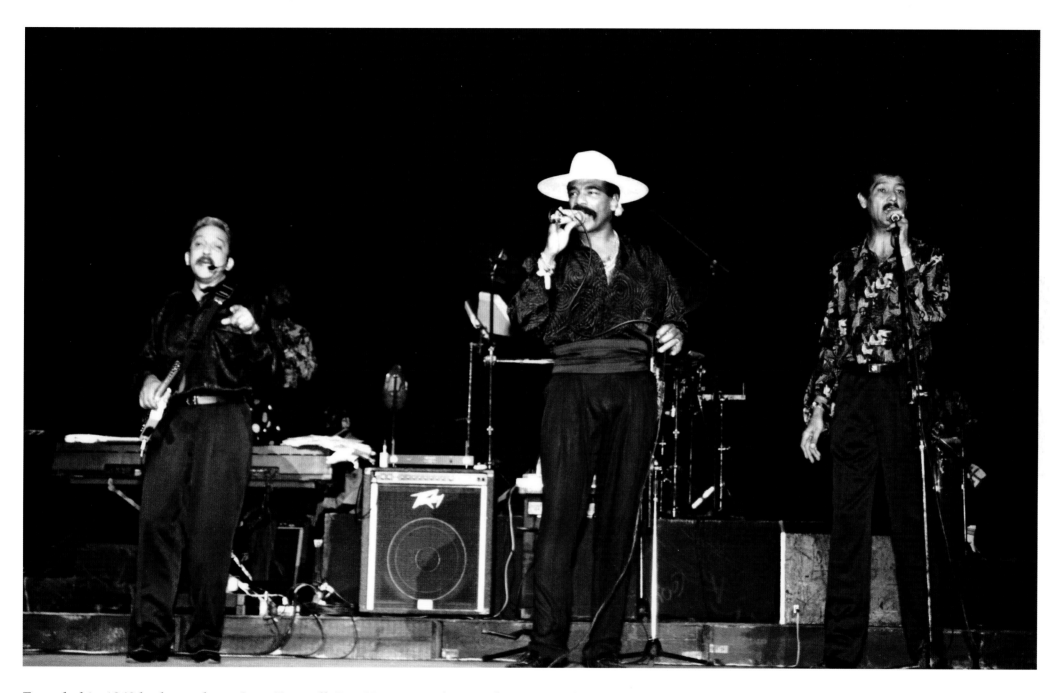

Founded in 1969 by bass player Juan Formell, Los Van Van is known for its popular dance music that has evolved and influenced generations of musicians while also entertaining mass crowds of fans for decades. Their lyrics reflect daily Cuban life with both spiritual and sexual innuendo. Since Juan's death in 2014, the group has been led by Juan's son, Samuel Formell.

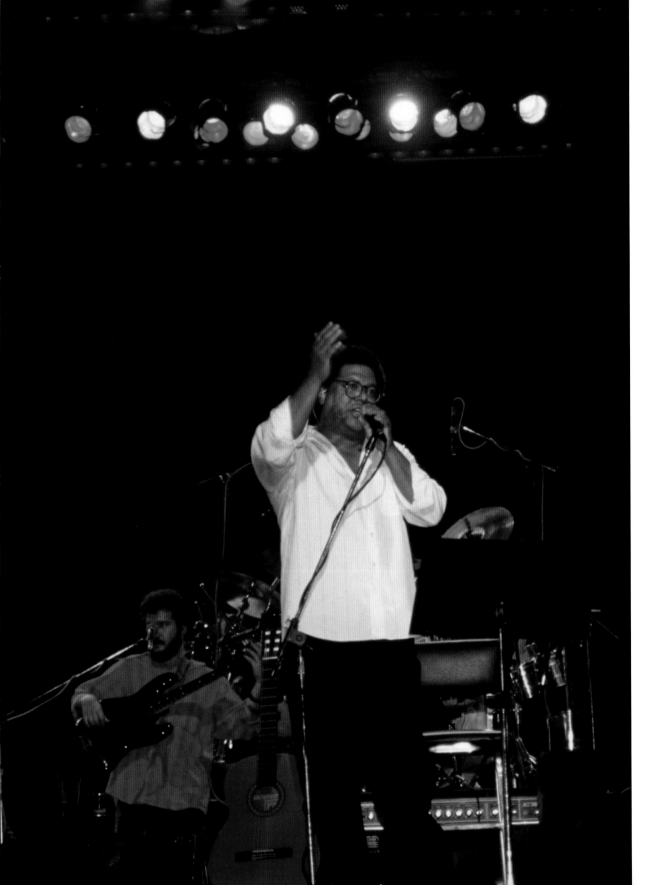

Pablo Milanes, a legendary singer, song writer, guitarist, and one of the founders of the nueva trova movement.

Silvio Rodriguez, also a founder of the nueva trova movement, is most known for his evocative lyrics, which have become classics in Latin American music, symbolizing romance, revolutionary politics, and idealism.

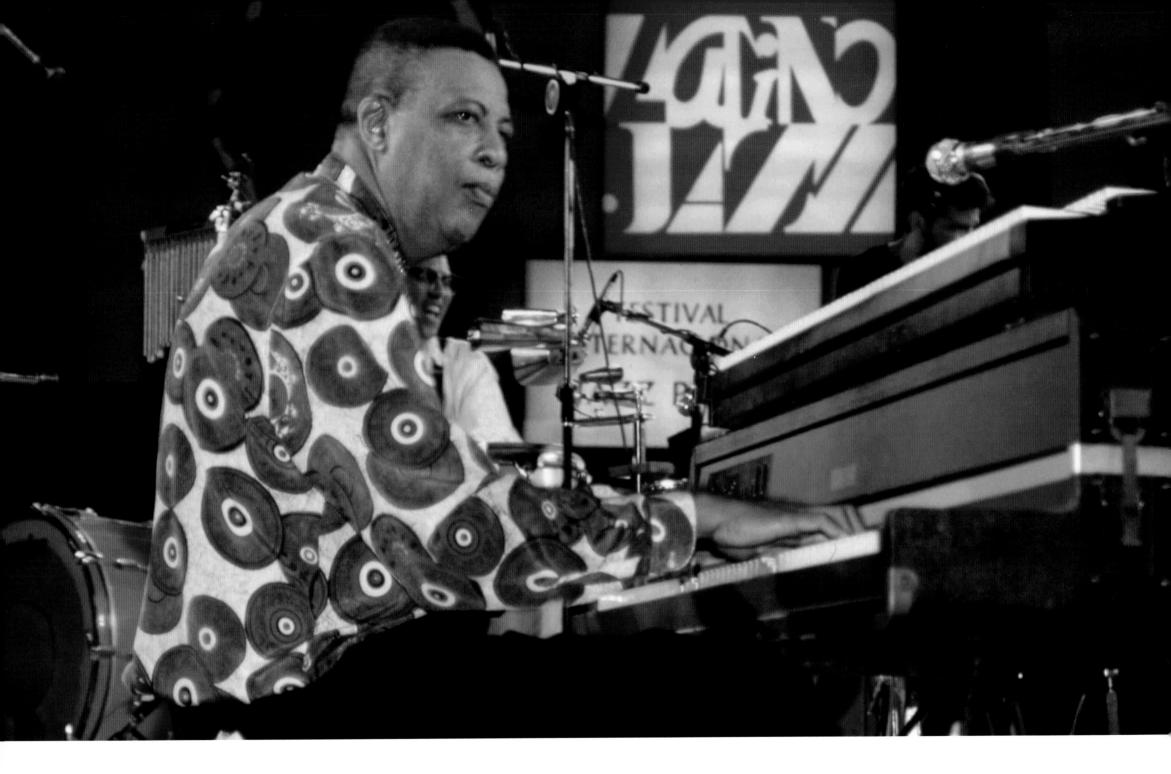

A performance by the acclaimed pianist Chucho Valdéz, whose career spans more than fifty years.

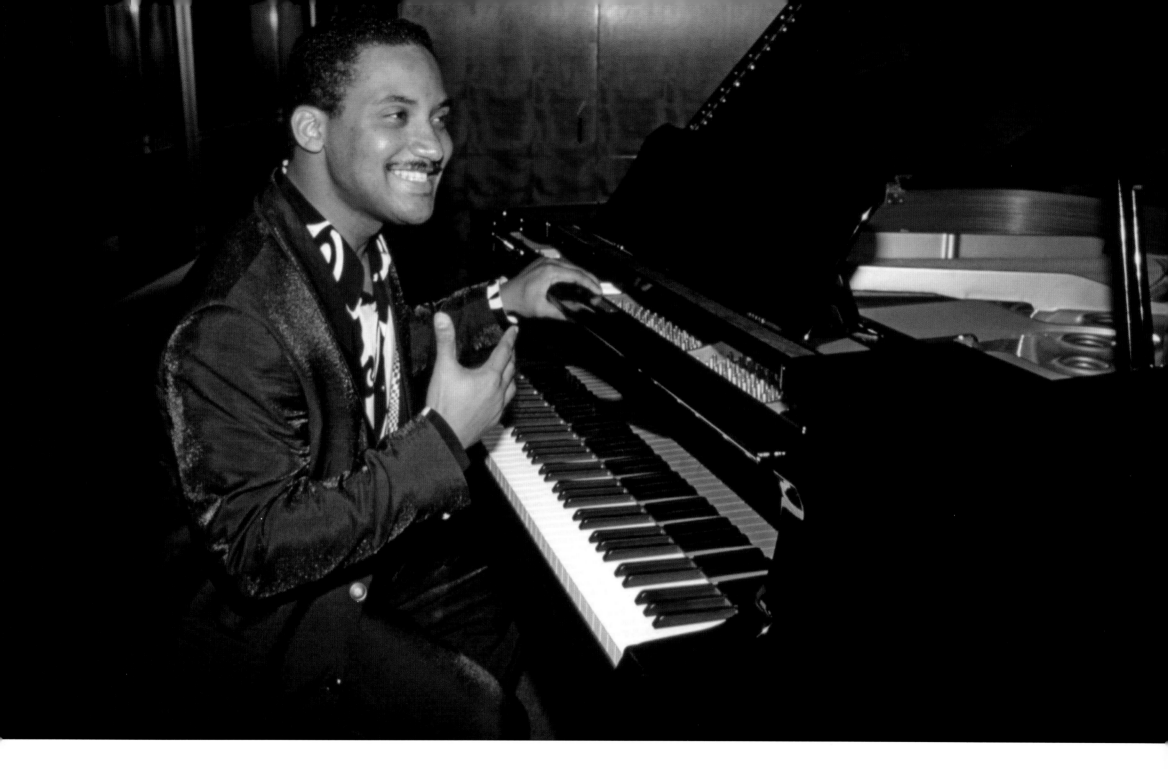

Gonzalo Rubalcaba, a Grammy Award-winning jazz pianist and composer who combines both American and Cuban influences into his work.

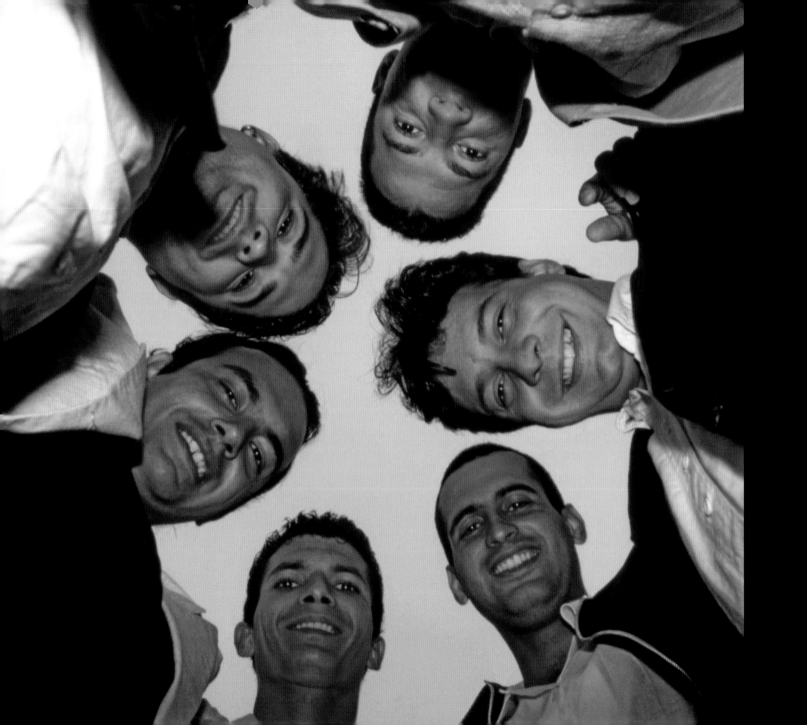

Vocal Sampling's sounds are like that of a full Latin orchestra and salsa band, but their music actually consists of six Cuban men singing a capella and making sounds with their hands and mouths, vocally reproducing both classic and modern Cuban music.

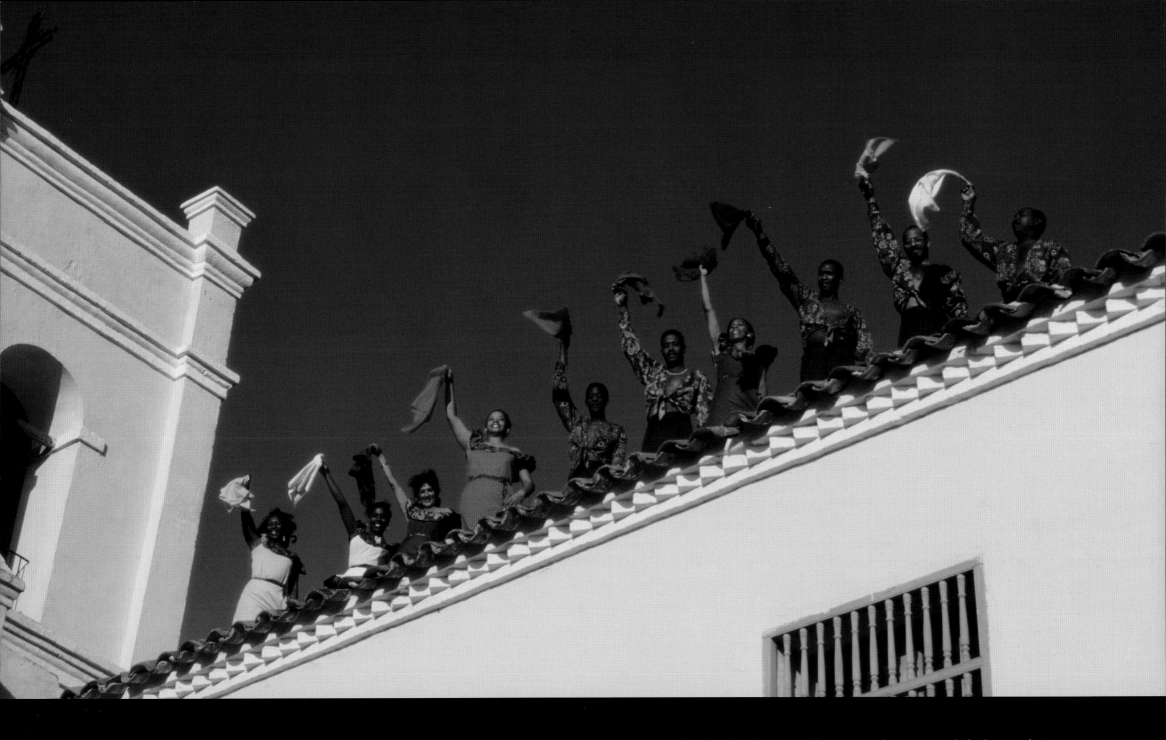

The members of the group now known as Desandann have been called the "Creole Choir of Cuba." They are of Haitian descent and dedicate their music to sharing the stories and culture of their Haitian roots. A vocal and percussion ensemble, they combine Caribbean rhythms, using the power of the voice to connect with a higher consciousness and ease hardship with a sense of humor, joy, and love.

Acknowledgments

With much gratitude and appreciation, I would like to thank all the people, organizations, and institutions who have been outstanding supporters of my work and adventures in Cuba, as well as all those who have helped make this book possible: my husband, José Luis Alonso, and daughter, Alicia Alonso; all our family and friends, especially the Alonso family in Cuba and Carris family in New York; Rachel Faro, Cuban music specialist and president of Ashé Records; Caridad Diez, musicologist and producer and manager of *Los Muñequitos de Matanzas*, who made so many of my trips possible and believed in the power of my photographs to help promote and share the unique and wonderful sounds of Cuban music; Sandra Levinson, executive director of the Center for Cuban Studies/Cuban Art Space, who was one of the first to exhibit my photographs of Cuba; José Antonio Orta, formerly of the Cuban Ministry of Culture, ICAIC, and the International Film and Television School; Jeffrey DeLaurentis and the US Interest Section in Havana; the US Treasury Department; Amy Kool; Linda Kenepaske; Vicki Gold Levi, photo collector; Valerie Feigen and her daughters, Alexandra and Danielle Eisman; Joanne DeCarlo, photo editor/producer; Marazul Travel; JCP Travel; Divermex; and Havanatur Tour and Travel.

Additionally, I give special thanks to all the editors and publishers who gave me photo assignments in Cuba and published my photographs, with very special thanks to *Newsweek* magazine and online with the many talented and supportive people I had the honor of working with, especially Jimmy Colton, Guy Cooper, Hillary Raskin, Joan Engels, Myra Kreiman, and Charlene Pinkney-Goldberg in the photo department; Tony Kleva and all the people at the traffic desk and in the photo lab; Alexis Gelber, Sarah Crichton, and Aric Press, editorial editors; Peter McGrath, Michael Rogers, and Jennifer Bensko, online editors; the exceptional and experienced photographers Bill Gentile, Wally McNamee, Lou Dematteis, and Susan Meiselas, who encouraged and taught me how to work in the field on assignment; Sarah Greenberg Morse, curator and former associate photo editor for *BusinessWeek* magazine; Matthew Morse, former editor of *WatchTime* magazine; Cigar Aficionado; *Rhythm Music* magazine; Ramiro Fernández, photo editor, collector, and former director of photography for *People en Español*.

I would like to thank the other music producers with whom I have had the pleasure of working, photographing Cuban musicians, then enjoying their musical talent, such as Bruce Lundvall of Blue Note, Ned Sublette of Qbadisc, and Jimmy Durchslag of Bembé Records.

I would also like to express warm wishes of gratitude to everyone who has exhibited my photography, especially Tony Impavido and the Film Society of Lincoln Center; Banff Center for the Arts; Nikila (Nikki) Cole, film and television director; the Americas Society; Laird W. Bergad and the Center for Latin American, Caribbean, and Latino Studies of the Graduate Center at the City University of New York, who granted funding in 2003, which has made many of my photographic exhibits since then possible; John Scott, art conservator and curator of Up Front Art Gallery; Georgia Stamoulis; Véronique de La Bruyère and Gallery 668; Katia Canton and the Museum of Contemporary Art in São Paulo, Brazil; Dr. Scott Fine, Erik Sheets, and everyone at Gallery 265; and the many people who have come to my exhibitions.

I would like to especially acknowledge and thank the following Cuban artists and locations (in order of their appearance in the book): Salvador González Escalona and the dancers, artists, and neighbors of Callejón de Hamel; Conjunto Folklorico; Fabrica de Tabacos en Pinar del Rio; the Tropicana Cabaret and its dancers; Hotel Nacional; Hotel Saratoga; El Gran Teatro de la Habana; El Floridita; Gregorio Fuentes; Marina Hemingway; Xanadú Mansion; Paladar Vistamar; José Rodríguez Fuster, his son, Alex, and the skilled workers and people of Jaiminita; Hotel Riviera and El Palacio de la Salsa; the Ochumaré dancers and Manuel Mendive; Alicia Alonso and El Ballet Nacional de Cuba; the Water Ballet dancers of Cuba; Haricub Farina de Trigo; Real Fábrica de Tabacos Partagás; Lilliam and all her helpers at La Cocina de Lilliam; Juan Moreira; Lancelot Alonso; Casa de los Abuelos in San Antonio de los Baños; the National Museum of the Revolution; José Antonio Orta and the International School of Film and Television in San Antonio de los Baños; El Cementerio de Cristóbal Colón; La Catedral, Havana; the people of La Casa de la Comunidad Hebrea de Cuba, particularly President Adela Dworin, Vice-President, David Prinstein and his wife and Jewish studies teacher, Marlen; the Santería Museum of Guanabacoa; the church of San Antonio de los Baños; Cardinal Jaime Ortega; La Calle Band; Clave y Guaguancó; Pablo Menéndez and Grupo Mezcla; Los Muñequitos de Matanzas; Ibrahim Ferrer; Lazaro Ros; Bamboleo and Vania Borges; Manolín, "El Médico de la Salsa"; Juan Formell and Los Van Van; Pablo Milanés Arias; Silvio Rodríguez; Chucho Valdés; Gonzalo Rubalcaba; Vocal Sampling; the Creole Choir of Cuba; and all the other Cuban musicians, dancers, artists, and people of Cuba who have welcomed me into their homes, workspaces, streets, fields, concert halls, and country, allowing me to share and experience their passions and spirit while photographing them.

I am particularly grateful to Jack Crager and Vivian Gill for their editorial and aesthetic expertise helping me organize and edit my collection of Cuba photographs.

Finally, I'd like to thank my longtime friend who is president, publisher, and founder of Skyhorse Publishing, Tony Lyons, my very talented editor, Julia Abramoff, and everyone at Skyhorse Publishing who has brought this book to life and recognized the importance and value of publishing my photographs of Cuba, to share this unique culture and spirit with a worldwide audience.

With special thanks for image scanning to Robert Scarola of County Graphics; Gabriel Bershadscky; and Brian Aderer of ProScanNY/www.proscanny.com.

For more information about Cuba and its artists, visit http://www.photosolutionsnyc.com/passagetocuba.